A Quiet Reve Since 1965

A Quiet Revolution

British Sculpture Since 1965

Exhibition Organized by
Mary Jane Jacob and Graham Beal

Edited by Terry A. Neff

Museum of Contemporary Art, Chicago
San Francisco Museum of Modern Art

Thames and Hudson, Publishers

Exhibition Tour

January 23 – April 5, 1987
Museum of Contemporary Art, Chicago

June 4 – July 26, 1987
San Francisco Museum of Modern Art

August 14 – October 4, 1987
Newport Harbor Art Museum,
Newport Beach, California

November 10, 1987 – January 10, 1988
Hirshhorn Museum and Sculpture
Garden, Washington, D.C.

February 12 – April 10, 1988
Albright-Knox Art Gallery, Buffalo

A Quiet Revolution: British Sculpture Since 1965 was
prepared on the occasion of the exhibition "British
Sculpture Since 1965: Cragg, Deacon, Flanagan, Long,
Nash, Woodrow," coorganized by the Museum of
Contemporary Art, Chicago, and the San Francisco
Museum of Modern Art.

Library of Congress Cataloging-in-Publication Data
 Bibliography : p.
 1. Sculpture, British – Exhibitions. 2. Sculpture,
Modern – 20th century – Great Britain – Exhibitions.
I. Jacob, Mary Jane. II. Beal, Graham William John.
III. Museum of Contemporary Art (Chicago, Ill.)
IV. San Francisco Museum of Modern Art.
NB468.QS4 1986 730'.942'074013 86-16325
ISBN 0-933856-24-5

© 1987 Museum of Contemporary Art, Chicago, and
San Francisco Museum of Modern Art.

Edited by Terry A. Neff, T.A. Neff Associates, Chicago;
Designed by Michael Glass Design, Inc., Chicago;
10,000 copies were typeset in Syntax by AnzoGraphics
and printed by Balding + Mansell.

Printed and bound in the UK

Lenders to the Exhibition

Contents

Foreword

One used to hear that sculpture is in trouble. And yet in the British Isles, as well as elsewhere, the opposite situation exists. It is perhaps too soon to analyze international differences and similarities regarding the renewal of interest in sculpture, but a study can be made of leading directions within individual countries.

As the essays in this book delineate, sculpture of great achievement has been a tradition in England for decades, a tradition that is flourishing today. This publication, which accompanies an exhibition jointly organized by the Museum of Contemporary Art, Chicago, and the San Francisco Museum of Modern Art, provides an international perspective, since the authors include scholars residing in the United States and England. We would like to acknowledge the expertise and energy of Mary Jane Jacob, chief curator of the Museum of Contemporary Art, and Graham Beal, chief curator of the San Francisco Museum of Modern Art, who organized the exhibition: our sincere thanks for their efforts.

We are pleased to bring this important view of British sculpture to other institutions in the United States; we thank our colleagues at the museums participating on the tour for their interest in joining us in its presentation: Kevin Consey, director, and Paul Schimmel, chief curator, Newport Harbor Art Museum; James Demetrion, director, Hirshhorn Museum and Sculpture Garden; and Douglas Schultz, director, and Michael Auping, chief curator, Albright-Knox Art Gallery.

We would like to express our gratitude to The British Council for their financial assistance for research during the early stages of this project and for a grant toward the production of this book. We would also like to acknowledge Michael Barrett, cultural attaché at the British Embassy, Washington, D.C., for his continuing interest and support. Major financial support was also made possible through a generous grant from the National Endowment for the Arts, Washington, D.C., a federal agency. Publication of *A Quiet Revolution* was also funded in part by a generous grant from the Robert R. McCormick Charitable Trust. The kind cooperation of the lenders was essential to mount and travel an exhibition of major works, and for their generosity we extend our thanks. Finally, we would like to express our deepest gratitude and appreciation to the artists who have shared their thoughts and their work, enabling us to bring them to an American audience.

I. Michael Danoff
Director, Museum of Contemporary Art, Chicago

Henry T. Hopkins
Director, San Francisco Museum of Modern Art

Introduction and Acknowledgments

Great Britain holds the position of being both an island of independent status and a part of the European continent and culture. *A Quiet Revolution: British Sculpture Since 1965* expresses this duality as seen in the situation of British art during the last 20 years: at once revolutionary in its stylistic manifestations, it has been reticent to enter fully into an open international dialogue. Developing quietly, in part in an insular way, many British artists have been more conscious of movements at home than abroad and innovations in postwar British sculpture can be construed as a series of reactions to the existing mode dominant locally. Beginning around 1965 the proliferation of experimental mediums, performance, and temporary installations with a nonobject emphasis arose in opposition to the prevailing formalist tendency that characterized the constructed, abstract sculpture of earlier in the decade, itself a reaction to the organic figurative and carving tradition that prevailed from the 1930s to the 1950s. By the same token the more traditional, image-evoking objects created since 1975 were at odds with the perceived idea-oriented tendencies in the art that preceded. So art criticism drew a lineage through the key figures of each movement — from Henry Moore to Anthony Caro to Richard Long to Tony Cragg — with artists and activity associated with each turn of style in Britain presented with little or no reference to international trends.

Yet, the international context does exist. Europe and the United States in the 1960s saw the emergence of radically different forms of art under the category of "sculpture" which, embracing anything that existed in three-dimensional space, was a flexible area for experimentation. Emerging full-force in the 1970s as Conceptual Art, Land Art, and Performance, British artists and artist groups like Art & Language, Barry Flanagan, Hamish Fulton, Gilbert & George, Richard Long, Bruce McLean, and others came into their own and were associated with Conceptual, Earthwork, and Arte Povera artists in Europe and the United States. Likewise, the genesis of British sculpture of the late 1970s and 1980s may be viewed as part of a general shift in direction during this period from concepts expressed in experimental, nonart materials, to objects in traditional mediums — painting and sculpture — with an emphasis on figuration or other

7

images. In this return to sculpture, prominence has been given to that which is an extension of Neo-Expressionist German and Italian painting; it can also be seen in the object appendages on the canvases of American new figuration artists affiliated with the expressionist painting style. But the new sculpture of the 1980s is nowhere as strongly developed as in Britain, where remarkable and extensive activity has given rise to artists such as Tony Cragg, Richard Deacon, Antony Gormley, Shirazeh Houshiary, Anish Kapoor, Richard Wentworth, Alison Wilding, and Bill Woodrow.

In spite of the relationships between British sculpture and the concurrent international scene, the development of style in Britain remains intrinsically bound to the recent art history of the nation. The reason for this is, first of all, the continuing strength of the sculpture tradition in Britain, especially during the last 50 years. Secondly, the British educational system plays a long-term and far more formative role in fostering artistic thought than elsewhere in Europe and the United States. Many of the recognized artists of the 1960s and 1970s have also been teachers. Schools have functioned as forums for the exchange of ideas and, since the 1960s, for questioning the nature of sculpture. It is no wonder then that the shift from style to style in Britain has been viewed as a series of rebellions of student to master — rebellions in which formalism overtook figuration; Conceptual, Performance, Land, and Process Art gave preeminence to ideas in rejecting formal abstraction; and recent sculpture has given renewed spirit to the very objectness of art so dramatically deemphasized by the Conceptualists.

It was with recognition of this dual position of British sculpture — its place nationally and internationally — that the Museum of Contemporary Art, Chicago, and the San Francisco Museum of Modern Art considered ideas for an exhibition. Three directions seemed plausible for investigation. One possibility was an exhibition of recent sculpture including British representatives in context with European exemplars, in the manner of the Kunsthalle Bern's "Leçons des Choses" (1982), which later appeared at ARC/Musée d'Art Moderne de la Ville de Paris under the title "Truc et Troc, Leçons des Choses." From our point of view, however, this approach seemed unmanageable in the scope and the amount of coverage fairness demanded; we felt a cohesive focus would be lost.

A second approach was an exhibition devoted exclusively to younger generation artists emerging in the 1980s. Many exhibitions have dealt with this phenomenon in British sculpture, beginning with "Objects & Sculpture" (Institute of Contemporary Arts, London, and Arnolfini Gallery, Bristol, 1981). Along similar lines were "Objects and Figures" (Fruitmarket Gallery, Edinburgh, 1982) and "Figures and Objects" (John Hansard Gallery, Southampton, 1983). In 1982 the first such exhibition occurred on the continent with a selection of five artists (Stephen Cox, Cragg, Deacon, Kapoor, and Woodrow) presented as "British Sculpture Now" at the Kunstmuseum Luzern. The following year a somewhat different group of six (Cragg, Deacon, Gormley, Kapoor, Wilding, and Woodrow) were chosen to represent Britain at the São Paolo Bienal under the title "Transformations: New Sculpture from Britain," which reinforced the impression that these artists were part of a group. Continuing this notion was a group show of three sculptors using organic shapes (Deacon, Houshiary, Kapoor) in 1985 at the Douglas Hyde Gallery, Dublin, and one of nine

sculptors at the Louisiana Museum, Humlebaek, Denmark, in 1986 (Edward Allington, Deacon, Houshiary, Kapoor, Julian Opie, Boyd Webb, Wentworth, Wilding, Woodrow). In our final estimation and with the opportunity for more perspective on the scene, we felt that to devote an exhibition solely to artists emerging since 1980 did not yet offer a sufficient level of accomplishment for a major museum show.

A third possibility, a more historical British exhibition, was the approach we chose. A review of the 1970s and 1980s was in part the subject of "The British Show" that traveled in Australia in 1985. The British Council's "Entre el Objeto y la Imagen: Escultura británica contemporánea" the following year dealt exclusively with issues in contemporary British sculpture in a survey of three "generations," beginning with the work of Anthony Caro, Michael Craig-Martin, Eduardo Paolozzi, and William Tucker, and continuing with a selected survey of sculpture, from Boyle Family, Long, Flanagan, Ian Hamilton Finlay, to Cragg, Deacon, Gormley, Houshiary, Kapoor, Wilding, and Woodrow.

While such a broad generational mix was instructive, we wanted to delve further into the ties between the Conceptualists and imagists of the last 20 years, pointing to the revolutionary achievements of the former and the development and accomplishments of the latter. No exhibition to date had set out to investigate the influential role that Conceptual and Performance Art have played on the current tendency in sculpture. While seeming to be formally in opposition to Conceptual Art, British sculpture since 1975, on the contrary, may be seen as not only a return to the objectness that constituted sculpture during the period of abstraction in the 1960s, but as also possessing a new sense of meaning and metaphor associated with the conceptual orientation of the 1970s. In a wave of enthusiasm for younger British sculptors and spurred on by a 1980s urgency to label the "new," we run the risk of proclaiming the innovations of today's sculptors at the expense of the revolutions of the Conceptualists. Deviating from the common dialectical history of British sculpture, and linking these two "generations," we have sought to focus on both their distinct directions and shared continuities.

In dealing with this 20-year period, the exhibition and catalogue serve complementary purposes. Selecting only six artists to feature in the exhibition, we strove to present those whose contributions to the period seemed most important in both quality of work and aesthetic point of view, showing each in a depth sufficient to document the range of their mature oeuvre, rather than surveying a number of artists active since 1965. We feel that the artists chosen express the thesis of continuity and change. Richard Long, with his walks, photographs of site sculpture, and gallery configurations, is a pioneer in achieving the balance between concept and form, object and nonobject, that is so striking a characteristic of so much recent British sculpture. Through found objects, natural materials, and now, traditional art mediums, Barry Flanagan has consistently challenged the dominant sculpture theories of the day. Through his sensitive exploration of wood — lumber and living trees — David Nash has increasingly been able to use minimalistic, geometric form to express underlying ecological concerns. Tony Cragg's art takes from Long its fragmentary forms, but uses for materials the detritus of contempo-

rary industrial society. Bill Woodrow, as well, uses cast-offs, not parts but whole items, which he converts into other equally recognizable things associated with our environment. Richard Deacon also uses industrial building materials, but fabricates abstract-looking forms that have metaphorical meanings linking them to the image-oriented art of the 1980s. This publication parallels the exhibition by including monographic essays and documentation on each of the six artists. It expands beyond this view, however, by placing these sculptors within their milieu through the contextual essays contributed by two distinguished and much-published English authors: Charles Harrison on British sculpture of the 1960s into the 1970s, and Lynne Cooke on the more recent developments of the 1970s to the present.

In realizing this exhibition and publication, we have been fortunate to have discovered early on our mutual interests and shared perspective on the period. Therefore, the Museum of Contemporary Art, Chicago, and the San Francisco Museum of Modern Art have embarked on their first joint venture of coorganization. We wish to acknowledge the role of the museums' boards of trustees and of the directors, I. Michael Danoff and Henry T. Hopkins, respectively, in supporting this collaboration. Special thanks are owed to a number of people within our institutions who have helped to make the exhibition and publication a reality: Tina Garfinkel, registrar, and Donna Graves, curatorial assistant, at the San Francisco Museum of Modern Art for arranging the loans and care of objects during the extensive tour; and to Terry A. Neff, T. A. Neff Associates, Chicago, for her essential involvement in the development of the concept of this publication, its editing, and production. The biographical documentation on the artists was written by Associate Curator Dennis Alan Nawrocki who, along with other Chicago staff, most notably Mary Anne Wolff and Robert M. Tilendis, and curatorial interns Anna Harding, Margaret Stone Drewyer, and Bonnie Rubenstein, ably carried out the research and made possible the realization of this publication.

We wish to extend to our contributing authors, Charles Harrison and Lynne Cooke, our thanks for taking this occasion to reflect on this history and share with us their scholarship and expertise. We wish also to thank Michael Glass for his thoughtful advice and excellent work in designing this publication, and Stanley Baron of Thames and Hudson, London, for his cooperative spirit and enthusiasm in arranging to copublish this book with our museums. We would also like to acknowledge our colleagues both here and abroad who generously shared their impressions and evaluations of contemporary British sculpture. The artists' galleries provided tremendous assistance in researching the exhibition and in this regard we would like to thank Anne and Anthony d'Offay of Anthony d'Offay Gallery, London; Barbara Gladstone of Barbara Gladstone Gallery, New York; Marian Goodman of Marian Goodman Gallery, New York; Nicholas Logsdail of Lisson Gallery, London; Hester van Royen of Waddington Galleries Ltd., London; Angela Westwater of Sperone Westwater, New York; and Donald Young of Donald Young Gallery, Chicago. And finally it is the artists to whom we are most in debt. Their cooperation has made possible this international venture just as their work has been its inspiration.

Mary Jane Jacob
Chief Curator, Museum of Contemporary Art, Chicago

Graham Beal
Chief Curator, San Francisco Museum of Modern Art

By Charles Harrison

Sculpture's Recent Past

I. "Certain Younger Englishmen"

". . . the whole world has been astonished to see the emergence of a British School of sculpture whose impact has been world-wide." The author of those words was Sir Herbert Read, the date 1963, and the occasion an open-air exhibition of contemporary British and American sculpture, held in Battersea Park, London (fig. 1).[1] The sculptors Read was referring to — Robert Adams, Kenneth Armitage, Reg Butler, Lynn Chadwick, Bernard Meadows — belonged to a "Middle Generation" of artists, one or two decades younger than the senior figures Henry Moore and Barbara Hepworth whose careers had been established in relation to European art before the war, one or two decades older than the "New Generation" which emerged in the 1960s after the center of the avant-garde had moved to New York.[2] In Read's view the "single genius" of Henry Moore had provided the initial impulse to which these artists had made a "vital response." Of course, in 1963 Read was no longer the avant-garde spokesman he had been 30 years earlier at the time when it was Moore's work that needed defending. A younger critic would at least have hesitated before comparing the "impact" of the English Middle Generation sculptors with "the equally surprising emergence of an indigenous school of painting in the United States" (i.e., the Abstract Expressionists), or before reproving the American exhibitors (Calder, Chamberlain, Ferber, Smith, and Stankiewicz, among them) for the relative absence in their work of "a specifically *plastic* sensibility." In the conclusion to his essay, Read struck a particularly conservative note: ". . . the best sculptors who are exhibiting here, however free in their fantasy, however experimental in their techniques, respect the limitations of a monumental art that should by definition be imposing, enduring and therefore compact." When this is taken alongside Read's denigratory reference to "a technique that is neither sculpture nor painting — it has been agreed to call it *assemblage*," it becomes clear enough that the critical barrier being erected was one designed to exclude from the pantheon the likes of David Smith (represented at Battersea by *Cubi IX* of 1961 [Walker Art Center, Minneapolis]) and Anthony Caro (represented by *Midday* of 1960 [The Museum of Modern Art, New York]).

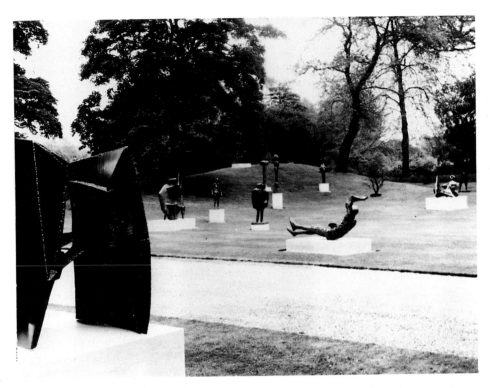

Fig. 1. General view: "Sculpture: Open-air exhibition of contemporary British and American works," Battersea Park, London, 1963

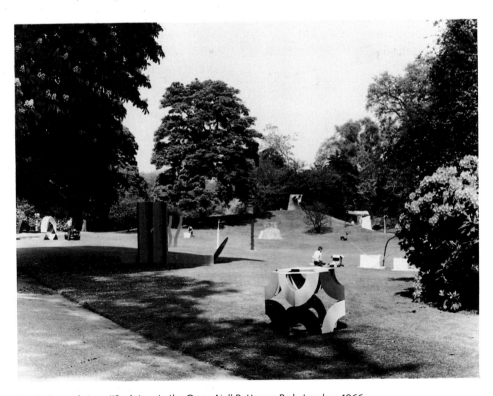

Fig. 2. General view: "Sculpture in the Open Air," Battersea Park, London, 1966

11

Three years later another exhibition of sculpture in the open air was held on the Battersea site (fig. 2). Though Moore was well represented, together with Barbara Hepworth and various members of the Middle Generation, the focus of attention on this occasion fell on the works of Caro and of some younger sculptors who had clearly been subject to his influence. If there was one factor that united this latter group of artists, it was their determined opposition to just that form of contained and imposing monumentality which Read had asserted as a necessary condition of quality in sculpture, and which was associated, above all, with the work of Moore. The 1966 show was "all-British" with the exception of a single work by Smith, included "as a homage to a great American sculptor whose death since the last exhibition still seems so untimely."[3] The catalogue introduction on this occasion was written by Alan Bowness, now director of the Tate Gallery but then a critic and university teacher of modern art history with a particular interest in British art. Bowness suggested that the exhibition offered a "confrontation" between generations of modern sculptors and concluded with an even stronger claim than the one Read had made: "It seems to me more than likely that we are witnessing in this country, here and now, one of the great epochs in the history of the art."[4]

Various points can be made in relation to this scenario. One is that the notion of a developing "British School of Sculpture" has been a persistent obsession of English critics and modern-period art historians since at least the early 1930s. Another is that the development of "British Sculpture" has tended to be seen in terms of separate generations of work, each categorically distinct from the last. A third point is that a kind of autonomy is nevertheless accorded to this development as a whole — as if "British Sculpture" were a kind of tradition-unto-itself, appropriately valued in its own terms and by reference to its own history and internal critiques. And yet another is that the combination of the first three factors appears to encourage the making of grandiose critical and art-historical claims, in Britain at least, for the achievements of successive generations of British sculptors.

The telling of art history in a linear and hermetic manner has lately become unfashionable, but it is the harder to avoid where a particular discipline — here "sculpture" — is under review, and especially where that discipline is surveyed in terms of a single national tradition. I hope at least to avoid the worst dangers of provincial rationalization by setting an account of the conditions of British sculpture in the 1960s and early 1970s, where relevant, in the context of problems and issues within modern art and Modernism as a whole. Given that undertaking, one point to be made about the "confrontation of generations" in the mid-1960s is that the possibility of a new kind of cosmopolitanism in sculpture was certainly a major issue for the younger of the generations concerned. A demonstrable continuity of style and of practical concepts connects Moore's sculpture with typical works of the Middle Generation. The categorical change associated with Caro's work of the 1960s, however, is not to be explained in terms of the traditional resources and references of modern British sculpture, except insofar as these defined the negatives of ambition at the time.

I do not mean to identify Caro as the sole initiator of a new tradition. It might be more apposite to explain the change in his work

around 1960 as representative of a shift in the determinations upon the practice of art, and to explain the success of that work in terms of an irresistible shift in the interests of criticism. One way to explain this shift — or at least to hint at its nature — is to note that it was around this time that "European" became a term signifying critical and curatorial disfavor, a term suddenly heavy with the threat of cultural downgrading. One clear measure of the division between generations which occurred during the late 1950s is the transfer of interest from European to American art.

There are many ways to explain why this should have happened, and should have happened when it did. The most powerful forms of explanation will be those that are built on the findings of political economy. In 1948 Clement Greenberg, a critic not now noted for his forays into the social history of art, observed that "the conclusion forces itself, much to our own surprise, that the main premises of Western art have at last migrated to the United States, along with the center of gravity of industrial production and political power."[5] In the later 1950s and 1960s, Modernism was reexported from New York to Europe "like a slow-release Marshall Plan,"[6] transformed, metropolitanized, and — at least as regards the functions of criticism — substantially professionalized. It has to be said, however, that though the mechanisms of the "American (Cultural) Invasion"[7] are traceable into the political and economic spheres, the American painting seen in London in the late 1950s was distinguishable by the undeniable authority of aesthetic quality and newness.[8] English painters of the Middle Generation,[9] still accustomed to looking to Paris as the metropolitan center of the modern, were for the most part wrong-footed in mid-career. For younger painters there was no such problem. The country they had already identified as the most attractive source of postwar mass-cultural entertainment and consumer novelties could now also be looked to for models of authentically modern high culture. The immediate consequences were discernible in the "Situation" exhibition of 1960, the criteria of inclusion to which were that paintings should be abstract and at least 30 square feet in area.[10] In a second "Situation" exhibition the following year, the compatibility of Caro's work was recognized by the inclusion of one of his recent abstract sculptures.[11]

In order to understand the shift that occurred in British sculpture in the 1960s, it is important to stress the priority of American *painting* in demonstrating Modernism's transatlantic migration. On the one hand the substantial implications of what had been done in New York during the later 1940s and early 1950s were not to be confined within the practical sphere of painting. On the other hand no comparable body of work in American sculpture was available to view. David Smith's work was virtually unknown in England until at least 1959[12] — the date of the second major exhibition of American painting at the Tate Gallery and of an important Pollock retrospective at the Whitechapel — and there was no substantial showing of his work in London until 1966. Anthony Caro initially saw Smith's work at first hand on a visit to America in 1959. His immediate response to that work was certainly a factor in his own decisive change of style and working methods, but some time before then it had already been made clear by the counter-example of Abstract Expressionist painting that the art of sculpture would have to be modernized according to some new set of models.

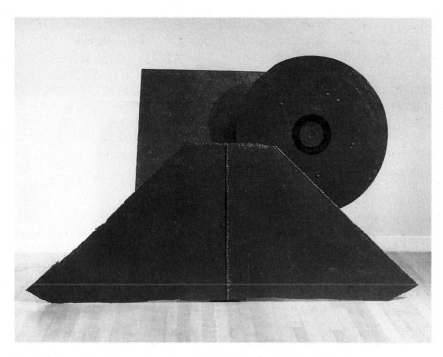

Fig. 3. Anthony Caro, *Twenty-Four Hours*, 1960, Trustees of the Tate Gallery, London

In 1956, when the exhibition "Modern Art in the United States" came to the Tate Gallery, the painter and critic Patrick Heron had written of his elation at "the size, energy, originality, economy and inventive daring of many of the paintings."[13] He continued, "Their creative emptiness represented a radical discovery, I felt, as did their flatness, or rather their spatial shallowness. . . . Also, there was an absence of relish in the matière as an end in itself. . . ." What Heron was recognizing in this response, typical of alert and sympathetic observers among British artists, was that the abstractness of American painting was of a new order from the forms of abstraction typical of previous European art. As well as the obvious bearing upon native styles and concepts of painting, there were clear critical implications for the future of sculpture. For example, it seemed in this new phase of Modernism that plausible cosmopolitan art was no longer to be made by veiling naturalistic references under tastefully agitated surfaces. Some quality in the work of Pollock and others of the Americans — maybe the palpable irrelevance to their work of certain conventional ways of reading-in meaning — generated a climate of impatience with that range of metaphorical references and naturalistic similes which had largely sustained British sculpture since the 1920s, and which had significantly underpinned its forms of abstraction.[14]

Though I suggested that Caro was not to be seen as the sole initiator of a new tradition, I referred earlier to a categorical change associated with his work. From 1953 to 1963 Caro taught part-time at St. Martin's School of Art in London.[15] During a period of significant change in his own work, his development acted as the focus for a group of younger sculptors, all born between 1934 and 1937, who were associated with the school first as students (variously between 1955 and 1962) and then as teachers: David Annesley, Michael Bolus, Phillip King, Tim Scott, William Tucker, and Isaac Witkin. Though Caro's contemporaries Eduardo Paolozzi and William Turnbull had for some while been producing sculpture that looked to recent Parisian art rather than to the native tradition dominated by Moore, and though Paolozzi was also teaching at St. Martin's from 1955 to 1958, it was in Caro's career that various of the different factors impelling practical and conceptual change seemed to meet around 1960. This was the year in which he made his first nonfigurative sculpture in welded steel (fig. 3), the year following a two-month visit to America, during the course of which he had formed friendships with Kenneth Noland and Clement Greenberg. Caro later spoke of the effects of this visit in terms conveying the all-important recognition that Modernism's transatlantic migration had involved a change of aesthetic: "There's a fine-art quality about European art, even when it's made from junk. America made me see that there are no barriers and no regulations. . . . There's a tremendous freedom in knowing that your only limitations in a sculpture or painting are whether it carries its intentions or not, not whether it's 'Art.'"[16]

Phillip King, who by 1960 was teaching alongside Caro at St. Martin's, has testified to the effect on other sculptors of the latter's apparently sudden abandonment of "bronze and all that. . . . His example was very stimulating. He was . . . at an early stage of his breakthrough and was very uncertain as to where he was going, communicating a kind of excitement that sculpture could go anywhere and be very open."[17] The notion of a "breakthrough" associated with Caro's work at this time was not simply the invention of

British interests. In 1965 Clement Greenberg published an article on Caro's work in *Arts Yearbook*.[18] He began, "'Breakthrough' is a much-abused word in contemporary art writing, but I don't hesitate to apply it to the sculpture in steel that Anthony Caro has been doing since 1960," and continued, "He is the only new sculptor whose sustained quality can bear comparison with Smith's. With him it has become possible at long last to talk of a generation in sculpture that really comes after Smith's." In his account of the "sustained quality" of Caro's work, Greenberg drew attention to the use of ready-made materials, to the "invasion of space," and to "an emphasis on abstractness, on radical unlikeness to nature." He also referred to the debt owed by Caro's work to pictorial art and asserted "its radical rejection of monolithic structure." As I suggested earlier, these qualities were the virtual opposites of those associated with the work of Moore and of the British sculptors who followed him most closely. Their explicit assertion as positive values presupposed an entirely different basis for judgment of sculpture than the one which had led Read to stress the priority of monumentality and compactness. Caro (who, it should be remembered, had worked as an assistant to Moore from 1951 to 1953) was now identified as the artist who had effectively terminated a European tradition – "compelled," in Greenberg's words, "by a vision that is unable to make itself known except by changing art" – and in the process qualified himself as the rightful successor to America's most distinguished modern sculptor. In 1967 his work was even included by the Los Angeles County Museum in an exhibition titled "American Sculpture in the Sixties."[19]

Certainly there was some strong compatibility in the 1960s between Caro's work and Smith's on the one hand and Noland's on the other – a compatibility recognized and strengthened by personal friendship. As certainly Greenberg was well placed to identify the particular virtues of Caro's work, the influence of his published deliberations and his personal encouragement and advice giving him some measure of responsibility for its development. But the real importance of the change in Caro's work was not so much that it signified identification with American art as that it asserted commitment to the cosmopolitan values of Modernism in its latest phase – a phase which it is tempting to refer to as "post-Pollock," since Pollock's work of 1946-50 seemed to set the standard for whatever was to follow. I do not mean to suggest that the impact of American painting cut British sculpture entirely clear of the European sculptural tradition. Nor was the European tradition in sculpture seen by all British sculptors and British critics as appropriately summed up in the work of Henry Moore, not even in the 1950s. Welding was practiced at St. Martin's before 1960, and considerable interest was then being shown in the constructed work of Picasso and Gonzalez and in the early work of Giacometti. As regards the technical characteristics of its fabrication, the new British sculpture of the 1960s had some strong precedents in much earlier European art. But it does seem to have been the case that the meaning and identity of sculpture were reconsidered in England in the 1960s and that the reconsidering was done largely by reference to concepts of Modernism first encountered with regard to American painting, and articulated in American criticism, specifically by Greenberg. When Caro first met Greenberg in 1959, the latter had just published an important essay, "Collage."[20] One passage in particular might well have served to draw

attention to possible practical and conceptual links between the "alternative" tradition of constructed sculpture and important developments in modern painting.

> The originally affixed elements of a collage had, in effect, been extruded from the picture plane – the sheet of drawing paper or the canvas – to make a bas-relief. But it was a "constructed," not a sculpted, bas-relief, and it founded a new genre of sculpture. Construction sculpture was freed long ago from its bas-relief frontality and every other suggestion of the picture plane, but has continued to this day to be marked by its pictorial origins. Not for nothing did the sculptor-constructor Gonzalez call it the new art of "drawing in space." But with equal and more descriptive justice it could be called, harking back more specifically to its birth in the collage: the new art of joining two-dimensional forms in three-dimensional space.[21]

This last definition seems tellingly apt in relation to Caro's typical work of the early 1960s (see fig. 4).

For some while in the 1960s, the effect of sculpture's strong conceptual dependence on painting was to depress interest in the expressiveness of its material qualities, and to encourage relocation of the ontology of sculpture in a psychological world of experiences, feelings, and states of mind. According to Tucker, ". . . sculptors learned from the Cubist painters that no material and no subject was sacred. Sculpture could be made from anything, about anything. Permanence consisted in the strength of the idea, not in the material."[22] "I'm fed up with objects on pedestals," Caro declared in 1961. "I'd like to break down the graspability of sculpture. Sculpture is terrifically tangible, but a painting, however concrete, is partly in the realm of illusion."[23] In 1967 Tim Scott published a commentary on some notes by William Tucker. Tucker had asserted that "Sculpture is a proposition about the physical world, about a finite order (completeness), and by implication about our existence in the world. . . ." Scott responded, "Sculpture acts by displacement; it is the *state* of being, the *state* of feeling, the *state* of experience, the *state* of physical awareness and sensation, the *state* of confrontation by physical phenomena; not these things themselves or an interpretation of them."[24] (For the sculptors of Scott's and Tucker's generation, this relocation of sculpture in favor of the psychological provided a novel means to think about the significance of physical properties, but without implying that these properties were of secondary interest. In anticipation of the later substance of this essay, it may be noted now that the implications of this conceptual shift were to be taken further by sculptors of a slightly younger generation. Among these, some, like Richard Long, were students at St. Martin's in the mid-to-late 1960s when Scott and Tucker were among those teaching there. For a few of these younger artists, a more complete identification of "sculpture" with "psychological state" was considerably to diminish the status of specific physical properties in the conceptual hierarchy of sculpture.)

By the early 1960s certain characteristics were central to advanced Modernist work in painting and sculpture alike: avoidance of the contained plastic image; pursuit of abstraction to an extent that entailed the purging even of metaphorical reference to things in the

world; as regards the "morality" of practical procedures, a tendency to value the effects of improvisation over the achievement of planned ends;[25] and as regards conditions of spectatorship, the placing of priority on intuitive apprehension over kinaesthetic response. In the most "professional" criticism of the time, these characteristics were identified as necessary conditions of quality in art. Once he had effected the appropriate change in his working procedures and in his concept of what kind of thing a sculpture could be, Caro very quickly carried with him both the sympathies of Modernist critics on either side of the Atlantic and the interests of those younger sculptors in England whose response to American painting had already been decisive.

A break had been created in the "line of succession" of British sculpture and a new agenda of concerns set for prospective practitioners of the art. In 1960, at the end of his apprenticeship as a sculptor, Phillip King had visited the Documenta exhibition at Kassel. He later described the European sculpture he saw there as "dominated by a post-war feeling which seemed very distorted and contorted. . . . It was somehow terribly like scratching your own wounds – an international style with everyone showing the same neuroses."[26] In contrast the American painting shown at the same exhibition seemed to offer a "message of hope and optimism, large-scale, less inbred." A year later, King's contemporary William Tucker responded to a question about the tradition on which current work was based: "Not a sculpture tradition. The precedents are probably in painting and poetry."[27] This sudden sense of freedom from sculptural precedents – quite specific to the two or three years either side of 1960 – was shared among the members of the relatively small community based around St. Martin's. No adequate explanation of the development of British sculpture over the past 25 years can be given without some acknowledgment of the importance of that moment.

The change in the direction of British sculpture was made public with far less than the usual delay, thanks in part to the interest of Bryan Robertson, then director of the Whitechapel Art Gallery. A substantial exhibition of Caro's recent work was staged there in 1963, and it was immediately clear how sympathetic a venue this was to the nature of the new work. In a text written for the catalogue, the American critic Michael Fried drew attention to the significance of "syntax" (i.e., the nature of the relations between discrete parts) in the visual quality of Caro's work, and also to the "achieved weight-lessness" of the sculptures – a quality that, as Clement Greenberg noted, "belongs, distinctively, to the new tradition of non-monolithic sculpture which has sprung from the Cubist collage."[28] Two years later the Whitechapel staged an exhibition of work by the "New Generation" of sculptors associated with Caro and St. Martin's: Annesley, Bolus, King, Scott, Tucker, and Witkin (fig. 5). Both exhibitions attracted considerable critical interest. By 1966 each of the New Generation sculptors was represented by a major London gallery and each had been given at least one one-person show.[29] The Whitechapel staged retrospectives of Scott (see fig. 6) and King in 1967 and 1968, respectively. A still more telling measure of success was the readiness of New York galleries to exhibit the new British sculpture. Richard Feigen showed Tucker in 1965 and King in 1966. In the latter year Witkin showed at Elkon, Bolus at Kornblee, and Annesley at Poindexter. Scott, the youngest of the group, showed with Law-

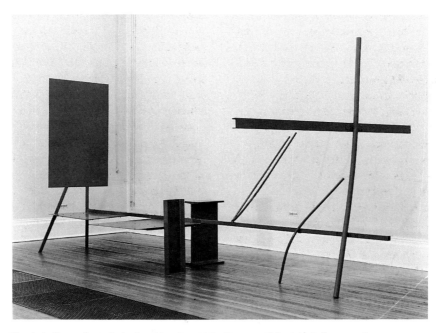

Fig. 4. Anthony Caro, *Early One Morning,* 1962, Trustees of the Tate Gallery, London

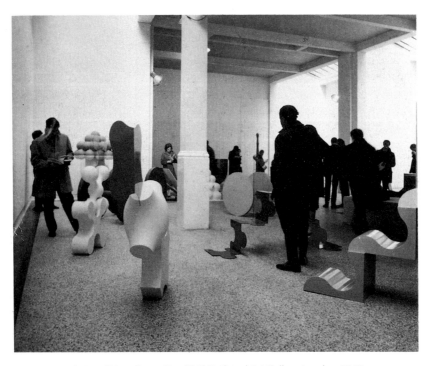

Fig. 5. General view: "New Generation," Whitechapel Art Gallery, London, 1965

rence Rubin in 1970. Interviewed for the British journal *Studio International* late in 1967, Clement Greenberg appeared to confirm that the claim Alan Bowness had made the previous year was not to be dismissed as mere insular partisanship: "I think certain younger Englishmen are doing the best sculpture in the world today – sculpture of originality and character. I'd also mention range; variety of effect. That's what makes for 'big' art."[30] American painting and British sculpture had come together, it seemed, with the blessing of the highest critical authority, to constitute the advanced Modernist art of the time.

II. "No Public Realm"

Though it was inevitable that the names of the New Generation sculptors would remain associated one with another, there was no great homogeneity in their work overall, nor was a debt to Caro as easily discernible in King's work or Tucker's as it was, say, in the welded metal sculpture of Bolus (see fig. 7) or Annesley. During the 1960s King seemed the most interesting of the group, and until 1969 the most distinctive of his sculptures were based on relatively simple volumetric forms: cones, thick slabs, and box shapes (see fig. 8). Much of his early work was made in plastic or fiberglass. Tucker also used fiberglass for much of his work of the mid-1960s. Scott made considerable use of glass, perspex, and acrylic sheet. For uncommitted observers and for younger students, however, the advanced sculpture course at St. Martin's did purvey some strong sense of

agreement not simply about the importance of sculpture, but also about the kinds of practical concepts and critical terms appropriate to the business of teaching, discussion, and evaluation. As regards the climate of debate in general and the occasional semiformal "Sculpture Forum" in particular, opinions tended to differ widely among witnesses divided by a mere four or five years in age. Bruce McLean is one of various alumni who have recorded their disenchantment: "The St. Martin's sculpture forum would avoid every broader issue, discussing for hours the position of one piece of metal in relation to another. . . . Twelve adult men with pipes would walk for hours around sculpture and mumble!"[31]

The pace of change from enthusiasm to skepticism was surprisingly rapid. Even as the sculpture of Caro and the New Generation was being acclaimed on both sides of the Atlantic, those who dissented or felt excluded from the conceptual ambience of St. Martin's were already beginning to view it as the enclave of a doctrinaire and self-protective practice. This needs to be explained, especially in view of the importance attached to the "breakthrough" of around 1958-62.

The apparent element of exclusiveness or defensiveness is certainly not to be accounted for simply in terms of the dispositions of the individuals concerned, nor as a closing of ranks in the face of some withdrawal of critical support. It was rather, I think, a symptom of the broader historical conditions of modern art at the time. A practice so powerfully determined by transatlantic Modernism was bound to take on board many of the current problems of Modernism

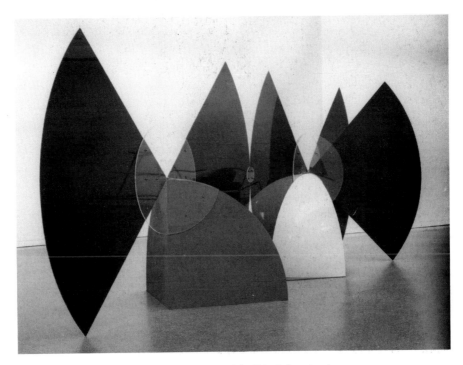

Fig. 6. Tim Scott, *Quinquereme*, 1966, Trustees of the Tate Gallery, London

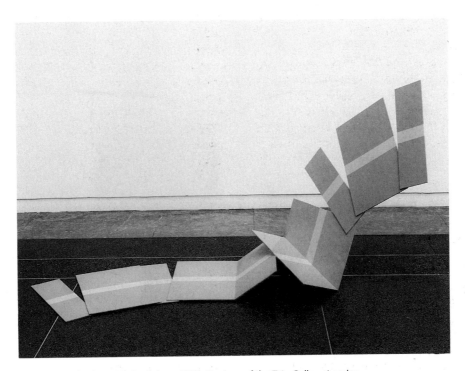

Fig. 7. Michael Bolus, *11th Sculpture*, 1963, Trustees of the Tate Gallery, London

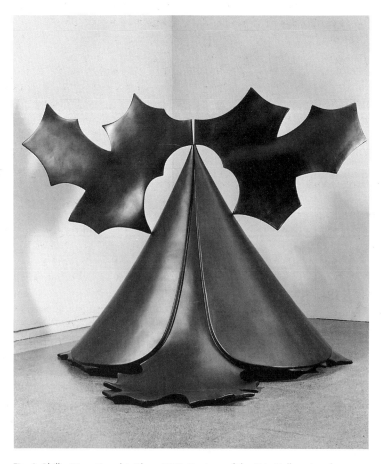

Fig. 8. Phillip King, *Genghis Khan*, 1963, Trustees of the Tate Gallery, London

itself, and thus sooner rather than later to become subject to that hardening and dogmatizing of taste and expressiveness which had begun to beset American abstract painting and its attendant criticism – begun, I would now say, in the immediate aftermath of Pollock's unmatchable achievement. It is certainly true that Caro and his friends established a climate of critical interest in the best of American Modernist painting (which in the early 1960s was still arguably the best American painting of the time) and in the best of American criticism (which was arguably still being written by Greenberg and by such younger disciples as Fried). It is also true that Caro himself was able to benefit from that element of coherence within the Modernist tradition which apparently allowed a well-tried set of aesthetic protocols to be satisfied in the face of *ad hoc* compositional procedures. But the space left in Modernism for sculpture to exploit turned out not to have been as large as promised. In its very faultlessness, Caro's work represents a kind of terminus. By the later 1960s it was becoming clear that all art produced within the now-prescriptive decorum of Modernism was bound to become subject to that mechanism in its production which reduced the area of significant practical problems to problems of design, and the problems of attendant criticism to matters of aesthetic tuning.

This is a judgment made with hindsight. It is most unlikely that any of those involved would have assented to such a view at the time (and improbable that they would assent to it now). But determining conditions are determining conditions and they tend to rule over the possibilities of expression in art. If an air of defensiveness did indeed come to permeate the practical and critical environment of the former New Generation during the later 1960s, it may have been because it transpired that transatlantic Modernism had reached the shores of Britain as a virtually exhausted resource and that "big" art was not after all within their collective grasp. I do not mean to reduce the work and careers of half-a-dozen different artists to a single pattern. There has been considerable variety within King's and Scott's work over the past 20 years, for instance, and Tucker's work has developed along lines different from both. If there has been a limitation common to the work of all, it has been more than merely stylistic. One way to suggest the nature of this limit might be to observe that neither the Modernist criticism nor the Modernist art of the later 1960s and early 1970s appeared able to admit the possible conceptual conditions of its own failure.

This implies a loss of realism and of critical imagination. Neither the autonomy of a practice nor the expressive quality of its

products can be taken for granted, nor are they to be established by appeals to authority. The grounds of autonomy have to be struggled for, found, and established in relation to continuing conditions and circumstances, while the expressive quality of art is always a matter for open inquiry. A distinction between generations in the mid-1960s can be made in relation to the issue of sculpture's autonomy and of the terms on which it was established. The artists of the New Generation, though they deliberated at length over the means of construction of sculpture, tended to take for granted its value as a practice and as a form of experience. The emerging sculptors of the later 1960s, on the other hand, were both more casual and more open-minded about how sculpture was to be made and about what it was to be made from, but treated its means of exhibition – the social, geographical, and psychological conditions associated with the art – as matters critical to the nature of the enterprise. In the litany of Modernist criticism of sculpture, "environmental" had been a term resonant with disapproval. It could be said – and was by many in the later 1960s – that the generation of a climate of distaste around such issues was merely a means to protect a conceptually fragile form of art against the full force of their implications.

I have deliberately couched the preceding paragraphs in a dissenting voice, aware that other accounts are feasible. The area of possible dispute needs to be properly defined (and will be filled out in practical terms in the next section). It should first be stressed, however, that much carping at the cosmopolitan modernization of British sculpture – an achievement rightly associated with St. Martin's – came from those left marginalized in their provincialism elsewhere: the self-appointed guardians of British art's naturalistic fussiness, the devotees of an arch semiabstraction, or those beset by the fallacy that nontrivial modernization of art could be achieved by means of an "interface" with technology. It is no part of the aim of this essay to justify the protests of insular, conservative, or superficial opinion. The case for the virtues of full-blooded Modernism needs to be given its due. Just as the work of Noland in the early and mid-1960s made most other abstract painting look small-town and concocted, so Caro's contemporary abstract sculpture and, perhaps more emphatically, the brightly artificial confections of King and Scott exposed as hopeless anachronisms a whole range of overworked sculptural analogues for man, machine, or beast, for the forces of nature, for the underlying structure of the universe, and so on.

With that acknowledgment made, an important matter of historical interpretation and of critical judgment remains to be decided – a matter as important to the valuation of British sculpture in the recent past as it is to assessment of the Post-Painterly Abstraction of the 1960s or the New Expressionism of the 1980s. The view here offered of the conditions of British sculpture in the later 1960s is based on the assumption that the high period of Modernist art, which had opened in France in the 1860s, closed in America in the early 1950s; that the possibility of a first-order expressive art was significantly exhausted by the Abstract Expressionists, and by Pollock in particular; and that subsequent art in the Modernist tradition staggers under claims for a critical expressive content which become increasingly hard to sustain. There was, as it were, a progressive loss of moral strenuousness in Modernist art after Pollock.[32] If this as-

sumption is valid, it is likely to follow that criticism committed to the continued vitality of Modernist art in the 1960s and 1970s will have tended to overestimate its expressive qualities, and to misrepresent the academic attenuation of style as critical change and newness. (In this connection consider the North American abstract painting of the later 1960s and early 1970s – Edward Avedisian, Darby Bannard, Jack Bush, and Gene Davis, for example – and its interpretation in Modernist criticism.) It is also likely to follow that some significant development in art post-Pollock will be found to have been characterized by acknowledgment of *limits* on the possibility of expressiveness, though one would not expect such a development to be acknowledged as significant by observers of a Modernist persuasion. (In this connection consider so-called Minimal Art and its reception in Modernist criticism.)

According to the view advanced here, the art of the past thirty years has offered two alternative modes of practice, or modes of conceiving practice. The first – identified with the Modernist mainstream – has been predicated on the values of expression, sensation, spontaneity, newness, and integrity of effect, has been supported by the dominant critical order, but has involved the reduction of aesthetic problems to the discrimination of formal effects by highly attuned ("sensitive") observers. The second mode rests on the presupposition that such values as expressiveness, sensation, spontaneity, and newness have become irredeemably conventionalized, and that maintenance of art's critical function requires that this conventionalization be acknowledged – as it was, for instance, in Jasper Johns's work of the later 1950s and early 1960s. In the first instance practical priority is placed on the relative novelty and individuality of formal and visual effects within a range determined by the continuity of the Modernist tradition. In the second instance priority is placed rather on the critical function of the work, both in revising the available terms of description of works of art and in questioning those patterns of response to the art object that are supposed to define the observer's psychological experience. Fulfillment of this latter function by some works of so-called Minimal Art led the Modernist critic Michael Fried, in a notorious article in *Artforum*, to accuse the likes of Donald Judd and Robert Morris of a concern with the theatrical at the expense of the aesthetic.[33]

Fried was an ardent champion of Caro's work,[34] and a welcome and informed visitor to St. Martin's during the 1960s. At the time his was also the most prominent representation of the elaborated Modernist view of art and of its recent history,[35] and he did much to establish the theoretical terms of reference according to which the new British sculpture was assimilated to the Modernist canon. According to this view – which is in clear contradistinction to the one offered above – the mainstream of art after Pollock involved a further elimination of the residues of figurative techniques, a more radical abstraction in assertion of art's unlikeness to other things and in defense of the autonomy of its quality. Art's essential function was the more decisively exposed as the expression of feeling in terms of a medium progressively reduced to its essentials. This was the supposed purport of authentic Modernist art, in which the possibility of meaning and quality in experience was continually struggled for and renewed. As regards sculpture, the example of painting helped to purge certain compromising associations with architecture (the tend-

ency to environmental or monumental effect)[36] and with the theater (the tendency to rhetorical or dramatic expression, notably through the use of the figure) and thereby brought about a purification of the sculptor's resources of expression. Thus Fried could write of two sculptures by Caro, *Deep Body Blue* and *Prairie*, "In the radicalness of their abstraction both have more in common with certain poetry and music, and certain recent painting, than with the work of any previous sculptor. And yet this very radicalness enables them to achieve a body and a world of meaning and expression that belong essentially to sculpture."[37]

It may be noted that while poetry and music are acceptable cognates for sculpture as conceived in Modernist theory, architecture and theater are not. This may be because experience of the former is seen as private and contemplative whereas the occasions of the latter are typically public. Certainly the form of sculpture that Caro initiated in Britain is predicated on a belief in the privacy of the encounter between spectator and work of art:

> Of course there are some wrong settings for sculpture. Just as it would be meaningless to play a quartet in the marketplace so there are some quite unsuitable sites for certain sculptures. I prefer my sculpture to be seen in a tranquil and enclosed space. Almost all sculpture, I guess, needs to be indoors — or enclosed in some way. . . . Up to now, all my sculpture (however large) is un-public.[38]

Through the association with music, the requirement of tranquility, and the assertion of an "un-public" function, Caro here sig-

naled the identification of his work with a distinct critical and aesthetic tradition, the Modernist tradition, according to which the significance of art lies in its preservation of spiritual as against utilitarian values. Opposition to this view of art's significance has normally been expressed on the grounds that it entails the provision of special conditions — physical, social, and economic — for a special audience. Democratic aspirations and Modernist styles have rarely been easy to reconcile in the face of the actual conditions under which art is encountered and consumed.[39]

The view of sculpture articulated by Fried and by Caro does seem to presuppose the availability of relatively specialized circumstances, physical, social, and psychological, for the realization of an expressive potential. In fact, Caro seems to have suffered from few doubts about the means of presentation of his abstract sculpture in the 1960s, perhaps because he was in a relatively strong position to control viewing conditions. For some of the younger sculptors, however, the ill-adjustment of private content to public context may have had something to do with the apparent disappointment of early hopes. William Tucker (see fig. 9) drew the connection in "An Essay on Sculpture," published in January 1969.[40] He referred to "the rich possibilities of a new subject-matter, new materials and the consequent re-appraisal of the kind of articulation sculpture might have," possibilities which had remained "largely untapped after the heroic period of Cubism, until recent years." He continued:

> If the bright morning of those hopes has somewhat dimmed, it may well be because neither the artists themselves, nor those

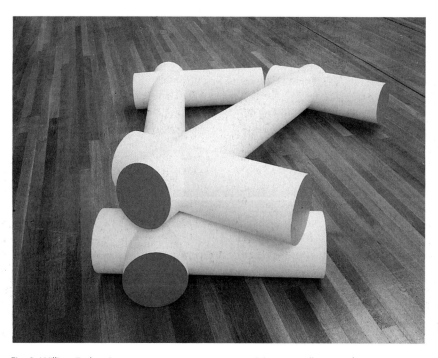

Fig. 9. William Tucker, *Series A no. 1*, 1968-69, Trustees of the Tate Gallery, London

who made themselves responsible for publicizing and distributing the work, recognized the nature of the revolution that had occurred. The scale and availability of the new work was public, but its content was private. Society had not asked for it, except in the non-world of galleries, museums and circulating exhibitions. The sculptors themselves were hostile to the problems of public communication, rightly suspicious of the motives of those public organizers whose mission it is to cram new feet into old boots. Sculpture in public places, sculpture and architecture, sculpture for schools and hospitals, playground sculpture, festival sculpture, sculpture in gardens, sculpture as environment: anything to make the new work tame and acceptable, to drain off its real power to subvert a comfortable world-view. And sure enough new armies of bronze generals and marble nymphs disguised in steel geometry and vermiform plastic have emerged to reap the harvest of a dead tradition, a temporary and invented public art. For there is no public realm in our time to which a public sculpture might give visual purpose.

For the aspiring British sculptors of the next generation, the notion of a "public realm" to be addressed in sculpture was still more remote or vexed with difficulty. Nor were they likely to identify either with the kinds of concerns Tucker was expressing or with his implication that New Generation sculpture was invested with "real power to subvert a comfortable world-view." What they were confronted with in the later 1960s was the apparent success of New Generation sculpture, the prevalence of its exhibition, and its theoretical compactness with the dominant aesthetic order. Of those associated with St. Martin's as students and new teachers in the mid-to-late 1960s — a category that includes Barry Flanagan, Richard Long, Bill Woodrow, and Richard Deacon[41] — more than one publicly expressed either some strong dissent from that aesthetic order or some skepticism about the need for specialized viewing conditions, or both. Some attempt to reconcile working conditions with conditions of exhibition was made by one diverse group of sculptors who occupied the premises of a former brewery at Stockwell Depot, London, opening their studios there to the public for the first time in May 1968.[42] In an article called "The Concerns of Emerging Sculptors," one of their number, Roland Brener (see fig. 10), criticized the New Generation sculptors for having "lapsed into a form of sculptural rhetoric."[43] He continued:

> Art can evolve only to a predictable point within an established idiom and the gallery type situation is in itself restrictive enough to limit sculptural possibilities. The New Generation sculptors accepted this limitation and have not up till now questioned or analysed their mode of exposition. The (theoretical) concern with "realness" and "openness," the attempt to free sculpture from a descriptive function and associative connotations fail if the work relies for its success on the specialized environment made for it. The contrived social and environmental situation in which it works best is its own contradiction.

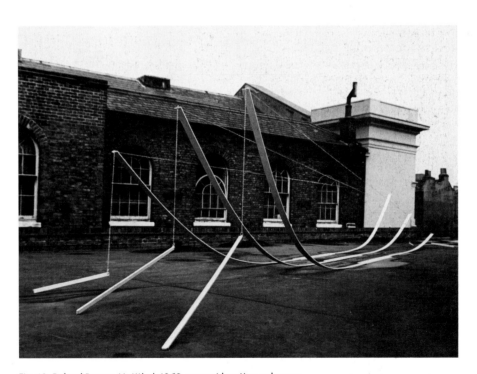

Fig. 10. Roland Brener, *Untitled,* 1968, present location unknown

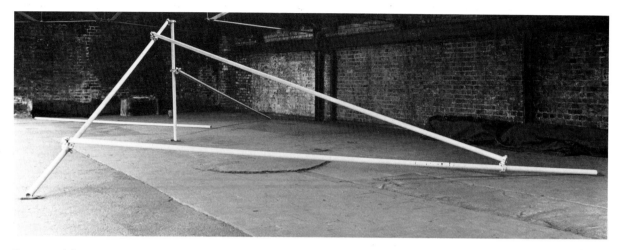

Fig. 11. Roelof Louw, *Untitled*, 1968, present location unknown

Brener's article was printed in the journal *Studio International* in January 1969. This was a special issue devoted to "Some aspects of contemporary British sculpture" scheduled to coincide with a large retrospective exhibition of Caro's work at the Hayward Gallery in London. The issue included coverage of the sculpture course at St. Martin's; Tucker's "Essay on Sculpture"; a symposium on Caro's work by David Annesley, Roelof Louw, Tim Scott, and William Tucker; features on "Colour in Sculpture" and on the sculptors at Stockwell Depot; and an article by the present author called "Some recent sculpture in Britain" which featured the work of Brener, Flanagan, Long, Louw, and McLean. With the sole exception of William Turnbull, whose steel sculptures of 1963-66 bear a superficial resemblance to Caro's more austere works of the mid-1960s,[44] all those sculptors accorded any significant coverage were or had been associated with the sculpture department at St. Martin's as students or teachers or both. Publication of this material drew down on the heads of the editors the accusation that British sculpture had been identified to a quite unwarranted extent with this single school.

If the accusation was justified, however, it was not because the issue lacked variety, a fact that served as testament to the diversity by then associated with the name of St. Martin's. Nor was it because dissenting views had been deliberately excluded in the celebration of a distinct line of succession. During the symposium, Annesley eulogized about Caro's work in relation to the painting of Ron Davis, Kenneth Noland, Jules Olitski, and Frank Stella. Louw responded with exasperation:

The way you go on, I feel completely oppressed by Caro's sculptural criteria. . . . It's like being swamped with it. I think it's a question of finding something that is distinctly different from his criteria. There is this "New Generation" image associated with Caro that persists in English sculpture, and in terms of the sculpture being done *here* now is perhaps not such a good thing.[45]

Though Louw is the exact contemporary of Bolus, King, and Witkin, he did not attend St. Martin's as a student until the years 1961-65. He was not included in the "New Generation" exhibition of 1965, nor was his work evidently compatible. As one of those working at Stockwell Depot in the later 1960s (see fig. 11), he shared in a critical reaction against the hermeticism of recent British sculpture and in that concern for the interaction of sculpture and context which developed in part as a consequence.

There were other factors within the broader conditions of art, however, which served to fuel this and related concerns. During the course of the 1960s, it became increasingly evident that a strong American alternative had developed to the Modernist mainstream as defined by Greenberg and Fried — or rather, perhaps, that Modernism itself had bifurcated along lines such as I suggested earlier, and that its dominant professional forms were no longer to be identifed with Post-Painterly Abstraction and constructed sculpture. Exposure in London was relatively piecemeal and haphazard, reflecting changes in the export policies of American dealers and agencies and in the

interests of individual curators, rather than the chronological sequence of events in New York. In the early 1960s the Robert Fraser Gallery exhibited the work of Pop artists such as Oldenburg and Warhol. In 1964 the Whitechapel staged large retrospective exhibitions of Johns (whose work Greenberg had referred to pejoratively as singing "the swan song of homeless representation")[46] and Robert Rauschenberg (whose work Fried was to denigrate as "theater").[47] Some attentive readers had been alerted to the existence of an individual and often dissenting voice by Judd's criticism published in *Arts* between 1959 and 1965. In his essay "Specific Object" in the latter year, he characterized "present three-dimensional work" in terms that implied that sculpture "made part by part, by addition, composed," had been practically and conceptually superseded.[48] In the same year *Artforum* became sporadically available in London and was immediately adopted as required reading by those British artists and critics with any serious interest in modern art.

The first of Robert Morris's "Notes on Sculpture" appeared in *Artforum* in 1966, as did the earliest of Robert Smithson's mannered self-justifications.[49] Morris was concerned to prise the concept of sculpture loose from its association with the qualities of painting since Pollock:". . . it should be stated that the concerns of sculpture have been for some time not only distinct but hostile to those of painting. The clearer the nature of the values of sculpture becomes the stronger the opposition appears."[50] Like Judd, Morris was concerned to reestablish the priority of "shape" over "syntax" and in the third set of his "Notes on Sculpture" struck the same tone of overt antagonism towards the notion of an improvised art for private contemplation. With regard to "the forms used in present-day three-dimensional work," he wrote:

> Such work which has the feel and look of openness, extendibility, accessibility, publicness, repeatability, equanimity, directness, immediacy, and has been formed by clear decision rather than groping craft would seem to have a few social implications, none of which are negative. Such work would undoubtedly be boring to those who long for access to an exclusive specialness, the experience of which reassures their superior perception.[51]

"Notes on Sculpture, Part 3" was published in *Artforum* in the summer of 1967 in an influential special issue on "American Sculpture." Besides contributions from Robert Smithson and Sol LeWitt and articles on David Smith, Oldenburg, and Mark Di Suvero, the issue included Michael Fried's sustained attack on Minimal Art, "Art and Objecthood," which asserted the value of Caro's sculpture as "a fountainhead of anti-literalist and anti-theatrical sensibility" in contradistinction to the works of Judd, Morris, and other Americans. Lines of demarcation had thus become clearly drawn in the artistic culture of the later 1960s, and drawn with specific regard to the nature and valuation of sculpture from both sides of the Atlantic. Symptomatic of the gradual internationalization of this debate was the publication by *Studio International* in April 1969 of a special issue on "Aspects of art called 'minimal,'" with contributions from Judd, Smithson, LeWitt, Dan Flavin, and Carl Andre.[52] In the same month British audiences were finally able to view relevant American works at first hand when The Museum of Modern Art's mixed survey "Art

of the Real" opened at the Tate Gallery, with works by Andre, Judd, LeWitt, Morris, Smithson, and Tony Smith, among others.[53]

I do not mean to suggest that the appearance of sculpture by younger British artists changed in the later 1960s or early 1970s in response to the impact of American Minimal Art. In fact, comparatively little sculpture was produced in Britain that emulated the styles of Judd, Morris, LeWitt, or Andre, and for obvious reasons, what there was of it hardly deserves to be recalled. The point is rather that younger British sculptors had already strong grounds for interest in such issues as were at stake in the *Artforum* special issue. Many of those explicit critical divisions and theoretical arguments which were occasioned by the Minimal artists' competition for the avant-garde center stage in the mid-1960s were easily enough interpreted in terms of controversies endemic to the development of British sculpture over the same period. If my earlier suggestions are valid, these controversies on both sides of the Atlantic were generated by common problems — by a kind of "crisis of Modernism"[54] — experienced at a deep level.

Fig. 12. Glyn Foulkes, *St. Martin's-in-the-Fields*, 1968, "Sculpture then seemed a vast empty field, and we had just climbed over the gate" (David Annesley)

III. "Everything Else But Sculpture"

As time passes it becomes increasingly clear that the moment of the later 1960s represents a nodal point of some significance, not simply in the history of artistic styles, but in more general aspects of the cultural and political life of the West. The idea of a "Postmodern" or a "Postmodernist" art has gained currency over the past decade and has been applied to various forms of painting and sculpture — not to

mention those artistic practices that can be included in neither category – with various degrees of theoretical justification, but always with the implication that a certain cultural regime is drawing to a close. It is surely still an open question whether we have been witnessing a change in the historical character of our culture or merely a redirection of intellectual and artistic fashion. If the former, however, we may have to look back over at least the past 25 years for an adequate understanding of the relationship between Modernism and its cultural succession. Central to any analysis of this relationship must be an inquiry into the forms of objects variously designated as artistic and into the kinds of relations supposed to obtain between these objects and interested spectators. What cognitive and other functions are works of art – for our present purposes works of sculpture, specifically – supposed typically or necessarily to fulfill, and how have these functions changed (if they have changed)?

In an interview of 1974, Caro looked back to the moment of the early 1960s:

> It was a very exciting time. We would be going to one another's studios, or into the sculpture school; there'd be work to look at, work that would call your own work into question. . . . All of us were questioning the assumptions by which sculpture had said "I'm Sculpture." Anything was possible in those years. It wasn't really the material that was important. What was important was the examination of what sculpture could be to you in your life.[55]

Whatever the positive legacy of this questioning and this examination – and it was certainly considerable – four particular practical and theoretical assumptions were left intact in the wake of the New Generation's early success. The first, already mentioned, was the assumption that sculpture rightly claimed for itself viewing conditions that emphasized its hermetic integrity, its radical unlikeness to other things. The paradigm viewing space was the white-painted gallery, empty of all possible distractions. The second assumption was that the spectator's interest in processes, procedures, and techniques of fabrication was properly subordinate to the whole effect of the finished work. How a piece was put together was a matter of lower critical priority than what it felt like to be in its presence. The third assumption was that sculpture was properly made out of rigid materials and had one stable and authentic physical form. Although it had been a principle of Caro's teaching that sculpture *might* be made of anything,[56] and although Tucker affirmed that "There is no longer any resistance in the traditional limits of sculpture, Imitation and Material,"[57] the technical novelty of New Generation work in the 1960s was generally restricted to those procedures of welding, bolting, molding, and turning of metals, plastics, and wood that were already well-established means of manufacture – if not always for objects within the area of fine art. The fourth assumption was that the integrity of a sculpture was a matter of the syntactical coherence of its disparate parts. One sculpture might have two or more physically separated components, so long as these were bound together by some sense of the rightness of the total configuration – though it was far from clear how this "rightness" was to be defined.

This last assumption was of some importance to the character of New Generation sculpture in relation both to American Minimalist work and to the interests of emerging British sculptors. The nature of its implications makes clear how the other assumptions were interconnected in practice. Once sculpture was no longer predicated on the integrity of masses, a basic question which had to be addressed was how different components were or should be or could be related to one another, in what dimensions and across what kind of space (see fig. 13). How were separate parts to be brought together, visually and conceptually, to form one work, if not by literal adhesion? For Judd, Morris, and Andre, the answer lay in the repetition of identical or similar units. This was a means to preserve "wholeness" in the perception of a single extensive work. It was also a solution that entailed recognition of the literal nature of the ground plane – or, for reliefs, the wallplane – as the defining physical limit of three-dimensional work. For Caro the solution seemed to reside rather in the achievement of a basically pictorial sense of interconnectedness between discrete parts. Thus works such as his *Prairie* of 1967 (fig. 14) are effective insofar as the self-sufficiency of a perceived composition suppresses interest in the actual juncture of literal parts.[58] This, as Greenberg had noted in 1965, involves treating the ground in the same way as the picture plane had been treated in Cubist collage; that is, as if it were a merely notional level in relation to which other surfaces are defined and arranged.[59]

So long as single sculptures could be viewed in ideal conditions, this dependence on pictorial integrity posed no great problem. Once more than one work was shown in the same space, however, or where sculpture had to compete with the unsympathetic details of a busy environment, there was always a risk that the formal integrity of any single work would be lost and its separate components be reduced in perception to the status of accidental objects. Under such circumstances aesthetic collapse could be immediate and complete.[60] Caro has remained master of the post-Cubist mode he developed in the 1960s, but it proved a terminus for those who followed him. The sculptural tradition he initiated in Britain had to become conceptually conservative to continue. There remained the problem of how to extend sculpture physically and notionally without loss of integrity. This issue could be satisfactorily addressed, it seemed, only by those prepared to abandon both the additive and constructive mode and the assumption of coherence which was its justification.

In the most interesting new sculpture of the later 1960s, this and the other three basic assumptions were variously subjected to practical critique. Both Flanagan and Long were producing independent work while still associated with St. Martin's as students. By 1965 Flanagan was making idiosyncratic standing objects by filling cloth "skins" with plaster or sand. The identity of such works was very clearly established in terms of the properties of certain nonrigid materials and of the procedures by means of which these were manipulated into certain configurations. In his first one-person exhibition, in August 1966, Flanagan included a "sculpture" made simply from poured and scooped dry sand. A year later he installed three separate works for the purposes of photography prior to their exhibition at the Biennale des Jeunes in Paris. The identity of the resulting arrangement led Flanagan to question the relationships between the autonomy of individual sculptures, the autonomy of individual parts of sculptures, and the autonomy of a given "exhibition" in which they were conjoined.

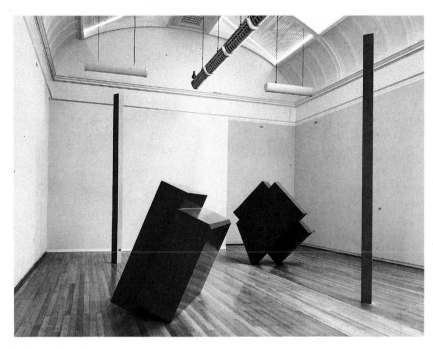

Fig. 13. Phillip King, *Call*, 1967, Trustees of the Tate Gallery, London

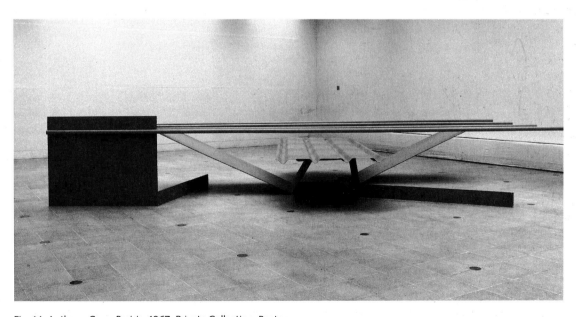

Fig. 14. Anthony Caro, *Prairie*, 1967, Private Collection, Boston

The ideal state is when each object commands an equal attention to the next, due to its very own identity/separation as an object. When not in this ideal state the observer (accepting the whole convention) uses his faculties to edit out any distractions and confusions to maintain a positive relationship within that convention. As soon as any one object loses its autonomous identity by statement and intention things begin to happen; the whole situation is affected and the nature of "exhibition" altered.[61]

The three sculptures concerned — *4 casb 2 '67*, *ring l 1 '67*, and *rope (gr 2sp 60) 6 '67* (pl. 44) — have remained together since. Two further points should be noted beyond those Flanagan himself was in a position to make at the time: the first is that the spectator's acceptance of "the whole convention" is by no means to be taken for granted; the second is that other and more inexorable factors than "statement and intention" may lead to loss of the autonomy of sculptural objects.

Richard Long arrived at St. Martin's from the west of England in 1966 already interested in the association of landscape with sculpture and in the use of materials specific to certain sites. From the first his work out-of-doors was characterized by the discreteness of its presence in relation to the chosen location. His avant-garde single-mindedness was noticed within the college, and by 1967 his work was attracting considerable interest outside. That December he "installed" a work to the northeast of London. This consisted, in his own description, of "16 similar parts placed irregularly surrounding an area of 2401 square miles. Near each part was a notice giving the information. Thus a spectator could only see one part (no information being given to locate the others), but have a mental realization of the whole."[62] With the notion of a sculpture as something possibly "realized" in the mind, Long put his work, deliberately and strategically, beyond reach of that minimum requirement for sculpture which had effectively regulated even the most experimental work at St. Martin's until then.[63]

Though both Flanagan and Long arrived at their respective concepts of sculpture through idiosyncratic routes, various factors were contributing at the time towards a relaxation of the "material-character/physical object paradigm" of art.[64] John Latham (see fig. 15) was among those teaching part-time at St. Martin's in the years 1966-67[65] and his own work had for some time been directed at the critique of precedents and the revision of the practice of art in line with a belief that "The world inferred has no things, as immutable solids . . . , it has only event patterns of relative stability."[66] Latham and Flanagan shared an exhibition in Wales in 1965, at a time when Flanagan was newly interested in the ideas of Alfred Jarry and in Pataphysics, the "science of imaginary solutions." In the autumn of the next year, Latham played a considerable part in an international "Destruction in Art" symposium held at a venue close to St. Martin's. Flanagan became involved, together with Yoko Ono, who was then working in London. In England as elsewhere in the 1960s, there was a rapid growth in "fringe" activities of the kind associated with the idea of a "counter-culture" and with the development of "arts laboratories" as meeting places. These activities were pursued in a world in which film, music, performance, poetry, and art were seen as the

Fig. 15. John Latham, *Art and Culture*, 1966-69, The Museum of Modern Art, New York, Blanchette Rockefeller Fund

subjects of an overlapping interest and culture, rather than as the strictly defined practical and intensional categories they remained in Modernist theory. Flanagan had attended Caro's sculpture class at St. Martin's for three months in 1960. In 1963, before his enrollment as a full-time student in the sculpture department, he wrote to Caro,

> . . . the Friday evening evening classes at St. Martin's were good meat for my imagination. These classes prompted the writing of poetry, a play, film scripts, songs, the purchase of cine equipment, and work on a means to translate movement and atmosphere into music.
> I might claim to be a sculptor and do everything else but sculpture. This is my dilemma.[67]

Flanagan printed this letter in a magazine he coedited at St. Martin's in 1964-65.[68] The point he was thus aiming to make public was one to which many of his contemporaries would have been likely to give assent. Even as the 1965 "New Generation" exhibition announced the domination of British sculpture by the aesthetics of transatlantic Modernism, the physical and conceptual autonomy of the art was coming under attack from a variety of directions.

Among the bases of Modernist theories of art are a belief in the necessity of specialization within individual art forms, and a belief in the autonomy of aesthetic experience. That both items of faith were laid open to question in the Bohemian fringes of the mid-to-late 1960s — in London as in New York or Paris — was not so much a cause as a symptom of diminution in the cultural authority of Modernism. An adequate account of the reasons for this diminution lies well outside the scope of this essay. I have suggested that loss of "moral strenuousness" in Modernist art after Pollock may have been one contributing factor, though this loss itself stands in need of explanation. The deployment and implication of Modernist theory in the cultural politics of the Cold War was certainly another factor.[69] One long-term effect of this implication was to generate distrust on the part of "left-wing" intellectuals during the 1960s towards virtually all claims for "high art." During the 1960s the category "left-wing intellectuals" included the great majority of all intellectuals interested in art, while the most powerful theories of high art were associated with American art and criticism. At the same time the anti-Americanism normally associated with socialism in Britain and Europe was considerably aggravated by reactions to U.S. involvement in Vietnam.

Under the prompting of these and other conditions, younger British artists in the later 1960s were relatively emancipated from that conviction of the authority of American art which had seemed a virtual requirement for serious work in the previous decade. It was a symptom of this emancipation that the tradition associated with St. Martin's ceased to be the virtually exclusive source of coherence in the development of British sculpture which it had been during the period of American domination. This said, however, it should be noted how many artists in the British avant-garde of the past 20 years have been associated with St. Martin's at some point in their careers: to the names of Flanagan, Long, Woodrow, and Deacon from the present exhibition, Gilbert & George and Bruce McLean might be added by virtue of notoriety at least. It may well have been

the case that the relative professionalism of the relationship with American Modernism established at St. Martin's provided younger artists with a clear ground upon which to make their divergent moves and have them seen as such. Well-ramified as it was, the term "sculpture" was available to them not so much to designate a category of three-dimensional artistic objects as to claim a sort of aesthetic privilege for certain types of enterprise and activity as against others. Thus in 1967 McLean designated as "Floataway Sculpture" some pieces of chipboard and linoleum thrown into a river.[70] Two years later Gilbert & George dubbed themselves "Living Sculptures," proceeding to perform what they referred to as "Interview Sculpture," "Nerve Sculpture," and so forth. Richard Long used the term to refer not only to arrangements of turf or stone or wood in landscape locations, but also to the evidence of subtractive activities — depressions left by walking in long grass (pl. 63), a cross marked out by picking the heads of daisies — and to those configurations marked out only by his own passage across country (see pls. 65-67, 71). This obstinate attachment to the category of sculpture may have served initially to express a spirit of ironic and avant-gardist detachment from the macho ethos of the St. Martin's sculpture department. It has since come to serve a normal if less defensible strategy: the insistence that how the artist means his work to be regarded should be accepted as defining what that work categorically is.

In September 1967 Flanagan and Long exhibited together with Jan Dibbets (then a student at St. Martin's on a British Council scholarship from Holland), and John Johnson (who was doing work similar to Long's at the time) in a little-noticed show at the Galerie Loehr in Frankfurt.[71] (Among the European artists included was Konrad Lueg, alter ego of the dealer Konrad Fischer, who was to give Long his first one-person show in Düsseldorf the next year.) This was one of a series of more-or-less coincident manifestations of what was to emerge, within the next two years, as a widespread, informal movement — a movement that briefly united disparate factions from both sides of the Atlantic into what seemed at the time a single cosmopolitan avant-garde. In Italy during the same month, Arte Povera was launched with a small exhibition at Galleria la Bertesca in Genoa, to the accompaniment of a short manifesto promising terrible reprisals against the oppressive system. Process Art was in the air in New York by at least September-October 1966, when Lucy Lippard organized a show of "Eccentric Abstraction" at the Fischbach Gallery.[72] Soon after this, Robert Morris was playing impresario to a new "Anti-Form" movement in American sculpture.[73] Two further components of the new avant-garde mélange were the subject of shows at the Dwan Gallery, "Language" in 1967 and "Earthworks" in 1968. In Germany, Joseph Beuys, a veteran of the Fluxus movement of the 1950s, had for some while been producing strange, obsessive assemblages and picturesque, brownish dog-eared things. He had a cult following at the Staatliche Kunstakademie Düsseldorf, where he had been teaching since 1961, but was not much known outside his country until 1968, when he was included in "Documenta 4" at Kassel and was featured as the doyen of a local movement at "Prospekt," an avant-garde dealers' showcase in Düsseldorf.[74] By the next year he was accorded widespread recognition as a progenitor, while several of his former pupils were included in major survey exhibitions.

The first of these large surveys came in 1969, the year of public and international recognition of the new tendency — at least of its recognition as avant-garde. The curatorial initiatives came from Europe. "Op Losse Schroeven" ("Square Pegs in Round Holes") opened at the Stedelijk Museum in Amsterdam in March, the same month as "When Attitudes become Form" opened at the Kunsthalle Bern. Flanagan, Long, Louw, and McLean were included in both exhibitions.[75] In September of the same year, a revised version of the "Attitudes" show traveled to London. Some idea of the wide catchment area of these surveys is given by the coverall subtitle of the latter: "Works - Concepts - Processes - Situations - Information." No one seemed very sure quite what they were dealing with. This was understandable. One feature that united the best of the widely disparate new work of the later 1960s was its critical disengagement from formally based concepts of style. Such concepts had served well enough to categorize the mainstream of Modernist painting and sculpture up to this point, and normal art criticism and curatorship had tended to presuppose their continued relevance for the purposes of grouping and demarcation. With this security undermined, those slow on their feet were left grasping at straw categories, or listening anxiously for gossip with the ring of authority and authenticity about it. The following are among the many labels variously tried on for the late 1960s avant-garde or for its component parts: Post-Object Art, Multiformal Art, Non-Rigid Art, Concept Art, Conceptual Art, Idea Art, Ideational Art, Earthworks, Earth Art, Land Art, Organic-Matter Art, Process Art, Procedural Art, Anti-Form, Systems Art, Micro-Emotive Art, Possible Art, Impossible Art, Arte Povera, Post-Studio Art, Meta Art.

Some large claims were made for the new movement and for the implications of the work. This is Grégoire Muller, introducing the "Attitudes" show:

> For all those polemicists who, from the point of view of the sociology of art, fight against the traditional concepts of the museum, the gallery, the work of art . . . this movement is a godsend. The majority of the artists in this exhibition are, for other reasons, united with their position; their work is made everywhere or anywhere, in newspapers, on the walls of towns, in the sand, in the snow . . . some of these "works" can be redone by no matter whom, others are untransportable, perishable, unsaleable, still others invisible and known solely through documentation. . . .
> With this new movement art is liberated from all its fetters.[76]

Such paeans ring hollow enough now, but in 1969 the association of an international artistic avant-garde with the prospect of substantial change still seemed plausible to many — to many of those, at least, who had not noticed the combination of rampant idealism and individualism also associated with the movement, qualities encapsulated in the instruction to "Live in your head."[77]

A host of international surveys followed in the next three years. One feature of these shows was that artists were generally invited to install their own works. In some cases the components were so apparently haphazard that curators can have had little confidence in their ability properly to arrange them; in others "installa-tion" was supposedly conceptually and practically indistinguishable from "realization"; in still others the artist's work entailed doing a special "piece" relating to the specific environment or "space," to local political or sociological conditions, or whatever. The bringing together of artists from several countries and continents led to a rapid exchange of information, and to the establishment of an international network of contacts and friendships. Brief though it was, there may never have been so potentially cosmopolitan a moment in the history of art. Flanagan and Long were included in a significant number of these shows, Louw and McLean in a few. Gilbert & George were taken up in 1970.

Though hindsight has modified the picture, and though some overt incompatibilities were evident even then, it seemed at the time that the art of the heterogeneous new movement could at least be defined on the grounds of its unlikeness to immediately previous work. Firstly there was its distinctive independence from the art of painting. In 1967 Robert Morris had asserted of painting that "The mode has become antique."[78] Such exceptional forms of wall-based two-dimensional work as were included in the surveys of the new avant-garde seemed designed to prove this rule. Whatever interests they offered to view, these were not compatible with the priority which Modernist theory had placed on the expression of feeling in visual form.[79] It seemed that "sculpture" — or "three-dimensional work" — had now prised itself conceptually loose from painting, leaving the latter to fulfill a highly specialized and possibly redundant aesthetic function. Secondly, insofar as an aesthetic object was offered to view in the new "three-dimensional work," this was not established in terms of some single, necessarily fixed and physically stable configuration. The possibility of change of state was a feature of the ontological character of the art. Thirdly, identification of the "work" on the part of the spectator was not simply a matter of response to an achieved order; imaginative reconstruction of the artist's procedures and activities was often inseparable from the perception of that order. Fourthly, at least from a theoretical point of view, no privilege attached to any material or medium as against another. Indeed, the avant-garde tendency in the later 1960s and early 1970s was to avoid just those materials with which the sculpture of the recent past had been identified.

As regards this last characteristic, the continuing tendency of some British sculptors, Richard Long and David Nash among them, has been to locate the physical activity of sculpture within a world separated from the kinds of metropolitan context associated with the development of Modernism. This separation is not so much a matter of distance from the business of the art world (a distance no avant-garde artist can afford to maintain) as of a programmatic abstinence from the use of certain forming techniques and a consistent avoidance of certain materials. To a concept of sculpture as the willful and expressive exploitation of malleable material, they counterpose a more passive view, predicated on a kind of reconciliation with the natural world. This entails that normal processes of growth, weathering, and so on be admitted, and even accorded a necessary role, as forming agencies in the artifacts of human culture. In such work the defeated social idealism of the later 1960s perhaps finds a continued expression. If so, we might view work such as Cragg's and Woodrow's as presenting the other side of the same coin, the critique of

modernity achieved in their cases through the aesthetic recuperation of urban detritus. Though the associations of this material and of its history remain accessible in the work, their meaning is critically transformed by incorporation within the range of signification of sculpture.

Certainly the most interesting new British sculptors of the 1970s and early 1980s have in common a sense of disengagement from celebratory concepts of modernity. We should not, however, take this as the essence of radicalism. A complex and critical relationship with concepts of modernity has characterized authentic Modernist art since Manet's time, at least insofar as modernity was considered in terms of scientific and technological progress and attendant social change. If we are to identify Postmodernism in art, it will have to be on other grounds. So what form has the legacy of the 1960s taken in subsequent art? I would suggest that two particular conditions have had determining effect upon avant-garde art since the moment of around 1967-72 and upon the concerns of attendant criticism and theory. The first is the realization that once the authority of any given aesthetic rationale is undermined, claims for the status of artistic objects are revealed in all their fragility and contingency. The second, which follows hard upon the heels of the first, is the recognition that the production of works of art and the production of rationales for works of art are mutually implicated moves in a game — a serious game, in which the conditions of play are always changing, so that the values of forms of accomplishment and competence are never stable for long. This is not to say either that competence is irrelevant to quality in art, or that no constant features are picked out by such terms as "sculpture." The point is rather that neither can be prescribed.

It was by the Conceptual Art of the later 1960s that the mutual implication of art and language was demonstrated to the art world itself. Conceptual Art represented an extreme position within the general climate of dissent from Modernist concepts of the art object, and thus a greater destabilizing potential as regards the world of aesthetic business-as-normal. Those of its proponents who were not simply followers of avant-garde fashion formed a kind of militant arm of the wider late-1960s movement. The Art & Language group was formed in Coventry, England, by four artists whose collective experience included an early interest in Minimal Art and in the implications of its theory, and a disenchanted exposure to the advanced sculpture course at St. Martin's.[80] Publication of their journal *Art-Language* commenced in the spring of 1969.[81] The development of Art & Language's publications and works for exhibition since that date, through enlargements and contractions of membership, has constituted what is virtually a distinct tradition – a tradition in which limits on the possibility of expressiveness in art are acknowledged as conditions of realism. The awkward presence of Art & Language within the context of British art has perhaps served to highlight locally that general tendency to polarization within modern art which I would trace back to the 1950s. Over the past decade and a half, and particularly since the widespread celebration of a renewed figuration, a "New Expressiveness" in both painting and sculpture, modern work has seemed to divide qualitatively over the issue of its own historical continuity. While some forms of art appear to offer an uncomplicated restoration of eternal themes and pleasures, others, by the manifest artificiality of their representational modes, signify that ironic awareness of the indirectness of all expression which was the most telling legacy of the art of the 1960s. The two forms are not easy to distinguish on the mere basis of style and appearance, but morally they are widely distinct. The question of where we should look for the authentic art of our time is not sensibly to be addressed without considering how the art of the past two decades should be viewed and interpreted. The recent history of sculpture – and of the claims made for sculptural work – is of critical interest in this respect.

Notes

1.
This and the following quotations are from Herbert Read, "Introduction" to *Sculpture: Open-air exhibition of contemporary British and American works* (London County Council, Battersea Park, 1963).

2.
The term "Middle Generation" was first used by the painter Patrick Heron for an exhibition of work by himself, Roger Hilton, and Bryan Wynter (all artists associated with St. Ives in Cornwall) at the Waddington Galleries in May 1959. "It expressed the awareness of painters aged between 30 and 45 in 1956 [the year the exhibition "Modern Art in the United States" was shown in London] that they were no longer the youngest generation. They had lost valuable years in the war, had been laboriously building something out of the remnants of modern art left in Europe in the late forties, and now had to come to terms with American painting" (Alan Bowness, "The American Invasion and the British Response," *Studio International* 173, 890 [June 1967]: 290).

3.
Alan Bowness, "Introduction" to *Sculpture in the Open Air* (Greater London Council, Battersea Park, 1966).

4.
Ibid.

5.
Clement Greenberg, "The Decline of Cubism," *Partisan Review* 15 (Mar. 1948): 366-69.

6.
The phrase is Michael Baldwin's from his script for "Beaubourg," a television program for the Open University, "A315: Modern Art and Modernism; Manet to Pollock," TV 32. (The Open University, Milton Keynes, 1983.)

7.
This is a conflation of the titles of two relevant articles: Bowness (note 2); and Patrick Heron, "A Kind of Cultural Imperialism?" *Studio International* 175, 897 (Feb. 1968): 62-64.

8.
Two large exhibitions at the Tate Gallery were of particular importance in alerting British audiences to the quality of "first generation" (Abstract Expressionist) American painting: "Modern Art in the United States" (Jan. 5-Feb. 12, 1956), and "New American Painting" (Feb. 24-Mar. 22, 1959).

9.

See note 2.

10.

"Situation" was held at the R.B.A. Galleries in London in September 1960. The members of the organizing committee were Lawrence Alloway, Bernard Cohen, Roger Coleman, Robyn Denny, Gordon House, Henry Mundy, Hugh Shaw, and William Turnbull. The exhibitors were Gillian Ayres, Bernard and Harold Cohen, Peter Coviello, Denny, John Epstein, William Green, Peter Hobbs, House, John Hoyland, Robert Law, Mundy, John Plumb, Ralph Rumney, Richard Smith, Peter Stroud, Turnbull, Mark Vaux, and Brian Young.

11.

"New London Situation" was held at the New London Galleries in 1961 and included Caro's painted steel sculpture *The Horse* (Collection of Mr. and Mrs. David Mirvish, Toronto), completed that year.

12.

Though there was a considerable representation of American sculpture in the Tate's 1956 show "Modern Art in the United States," no work by David Smith was included. The first considerable showing of his work in England came in August 1966, when The Museum of Modern Art's touring retrospective arrived at the Tate Gallery.

13.

Patrick Heron, "The Americans at the Tate Gallery," *Arts* 30, 6 (Mar. 1956): 15-17.

14.

The organizers of the "Situation" exhibition had excluded the St. Ives painters from consideration on the grounds that works should be "without explicit reference to events outside the painting – landscape, boats, figures" (from Roger Coleman, "Introduction" to "Situation" catalogue, 1960). In such terms the younger artists of the 1960s recognized that division between the generations which the older artists had sensed at the close of the previous decade (see note 2).

15.

In 1963-64 and during the spring of 1965, Caro taught sculpture at Bennington College, Vermont. He continued teaching part-time at St. Martin's on his return to London, with a break in 1967. Many of those first subject to his teaching at St. Martin's had enrolled in evening classes. The main business of the sculpture department was the provision of a three-year course leading to the award of a diploma. Alongside this an "advanced sculpture course" had developed in response to the conservatism of the official syllabus during the later 1950s. At a time of government reorganization of art education, the school's application for accreditation as a postgraduate center for sculpture was rejected in favor of the Chelsea School of Art (where both David Nash [1969-70] and Richard Deacon [1977-78] were to complete their studies). The advanced course at St. Martin's therefore remained "vocational" and relatively independent of institutional requirements. As a consequence of this, and of its growing reputation, it attracted many students from abroad. In the early and mid-1960s, during a period of relative financial ease, the tendency was for promising ex-students to be taken on as part-time tutors, thus maintaining continuity and a line of succession.

16.

In Lawrence Alloway, "Interview with Anthony Caro," *Gazette* (London) 1 (1961): 1.

17.

Phillip King, "Phillip King talks about his sculpture," *Studio International* 175, 901 (June 1968): 300.

18.

Clement Greenberg, "Anthony Caro," in *Arts Yearbook 8: Contemporary Sculpture* (1965); reprinted in *Studio International* 174, 892 (Sept. 1967): 116-117.

19.

As quoted by Philip Leider, the reason given was "the high quality of the work he made in this country and the influence he exerted on the new American sculpture" (Philip Leider, "American Sculpture at the Los Angeles County Museum of Art," *Artforum* 5, 10 [Special Issue, Summer 1967]: 80). Leider commented, ". . . one looks about in vain for the Caro-influenced sculpture. For the truth is that most of Caro's influence has been in England, among a promising group of younger English sculptors. . . ."

20.

Originally published as "The pasted-paper revolution," *Art News* 57, 5 (Sept. 1958). Greenberg restored his own title when printing the essay in substantially revised form in his *Art and Culture* (Boston: Beacon Press, 1961).

21.

Quotation from the original 1958 version, reprinted in Francis Frascina and Charles Harrison, eds., *Modern Art and Modernism: a critical anthology* (London and New York: Harper and Row, 1982): 107.

22.

William Tucker, "An Essay on Sculpture," *Studio International* 177, 907 (Jan. 1969): 13.

23.

Anthony Caro in Alloway (note 16).

24.

Tim Scott, "Reflections on Sculpture: A commentary by Tim Scott on notes by William Tucker," in *Tim Scott: sculpture 1961-67* (London: Whitechapel Art Gallery, 1967).

25.

"I cannot conceive a work and buy material for it. I can find or discover a part. . . . Rarely the Grand Conception but a preoccupation with parts. I start with one part, then a unit of parts, until a whole appears. . . . The order of the whole can be perceived but not planned. Logic and verbiage and wisdom will get in the way. I believe in perception as the highest order of recognition. My faith in it comes as close to an ideal as I have. When I work there is no consciousness of ideals – but intuition and impulse" (David Smith, "Notes on My Work," *Arts* 34, 5 [Feb. 1960] reprinted in *First* 2, a magazine published in 1961 by members of the advanced sculpture course at St. Martin's and edited by William Tucker, p. 34). "This whole operation for me doesn't come out of a concept in the mind, it comes out of some vague idea, plus the stuff" ("Anthony Caro, interviewed by Andrew Forge," *Studio International* 171, 873 [Jan. 1966]: 6-9).

26.

King (note 17).

27.

William Tucker, statement in *First* 2 (note 25): 23. In an editorial in the same issue, Tucker wrote, "The problems here implied for sculpture are immense and serious, but open. Everything has yet to be done, and soon" (p. 4).

28.

Greenberg, "Anthony Caro" (note 18): 117.

29.

Annesley, Waddington Galleries, 1966; Bolus, Waddington Galleries, 1965; King, Rowan Gallery, 1964; Scott, Waddington Galleries, 1966; Tucker, Grabowski Gallery, 1962, Rowan Gallery, 1963 and 1966; Witkin, Rowan Gallery, 1963, Waddington Galleries, 1966.

30.

Edward Lucie-Smith, ed., "An interview with Clement Greenberg," *Studio International* 175, 896 (Jan. 1968): 117. That this was not a conclusion recently arrived at is demonstrated by a letter addressed in February 1964 to Frank Martin, head of the sculpture department at St. Martin's. The advanced sculpture course was threatened with closure and Greenberg, who had visited the department the previous October, now responded to a request for support:

St. Martin's under the present dispensation should be one of the prides of England, and not just because some of its faculty and some of its graduates are producing the most distinctive, the strongest new sculpture done anywhere in the world at this time. . . .

No other art school I know of can match what St. Martin's is doing in fruitfulness. No other art school I know of can achieve such results of such importance either pedagogically or artistically. No other art school manifests a spirit nearly so invigorating and at the same time mature; no other art school demands so much of its students.

All this . . . has . . . to do with the ambitious seriousness St. Martin's appears to instil in its students, and with the entire absence of artiness and dilettantism in the atmosphere of the school. . . .

The letter was published in facsimile in *Going* 1 (1964): 8. *Going* was a magazine printed and published by the St. Martin's School of Art Students Union.

31.

Quoted by Nena Dimitrijevic in *Bruce McLean* (London: Whitechapel Art Gallery, 1981).

32.

I have attempted elsewhere to fill out this view of the development of Modernist art since Pollock. See the following articles: "Modernism and the 'Transatlantic Dialogue,'" in Francis Frascina, ed., *Pollock and After: the critical debate* (London and New York: Harper and Row, 1985): 217-32; and "Expression and Exhaustion: Art and Criticism in the Sixties," *Artscribe* 56 (Feb.-Mar. 1986): 44-49, and 57 (Apr.-May 1986): 32-35.

33.

Michael Fried, "Art and Objecthood," *Artforum* 5, 10 (Special Issue, Summer 1967): 12-23.

34.

As well as the article cited in note 33, see Michael Fried, "New Work by Anthony Caro," *Artforum* 5, 6 (Feb. 1967): 46-47; "Two Sculptures by Anthony Caro," *Artforum* 6, 6 (Feb. 1968): 24-25; "Caro's Abstractness," *Artforum* 9, 1 (Sept. 1970): 32-34; and "Introduction" to *Anthony Caro* (London: Arts Council of Great Britain, Hayward Gallery, 1969).

35.

See in particular Michael Fried's *Three American Painters: Kenneth Noland, Jules Olitski, Frank Stella* (Cambridge, Massachusetts: Fogg Art Museum, Harvard University, 1965).

36.

"When it's sculpture, it's to be looked at. Sculpture, for me, is something outside of which you are. It's not something you can get inside; it's not architecture or environment. I put this limit on sculpture and I think that by doing so, I gain more freedom, not less" (Anthony Caro in Phyllis Tuchman, "An Interview with Anthony Caro," *Artforum* 10, 10 [June 1972]: 57).

37.

Fried, "Two Sculptures by Anthony Caro" (note 34): 25.

38.

Anthony Caro in Tuchman (note 36).

39.

The classic formulation of this dilemma is to be found in Walter Benjamin's address, "The Author as Producer"; for an edited version see Frascina and Harrison (note 21): 213-216. See also Art & Language, "Author and Producer revisited," in Charles Harrison and Fred Orton, eds., *Modernism, Criticism, Realism: alternative contexts for art* (London and New York: Harper and Row, 1984): 251-59.

40.

Tucker (note 22).

41.

Flanagan attended as a student 1964-66, Long 1966-68, Woodrow 1968-71, and Deacon 1969-72. The two former were in the "advanced" course, the latter in the three-year diploma course. Flanagan taught part-time at St. Martin's from 1967. Both Woodrow (1971-72) and Deacon (1977-78) spent time as postgraduate students at the Chelsea School of Art. Deacon also attended the Royal College of Art as a student from 1974 to 1977, where he was the near contemporary of Tony Cragg.

42.

Sculptors working at Stockwell Depot in 1968-69 were Alan Barclay, Roland Brener, David Evison, Roger Fagin, John Fowler, Gerard Hemsworth, Peter Hyde, and Roelof Louw.

43.

Roland Brener, "The concerns of emerging sculptors," *Studio International* 177, 907 (Jan. 1969): 25.

44.

Turnbull showed with the Middle Generation sculptors at the Venice Biennale in 1952. His work of the 1950s was marked by an interest in Giacometti, and later in Brancusi, which served to distinguish it from those working in a line of clear succession from Moore. In the later 1950s and early 1960s, his interest in a totemic and animistic kind of sculpture distinguished him from Caro and the New Generation. Despite their superficial resemblance to other contemporary British works, his abstract, painted sculptures of the mid-1960s were actually closer in spirit to his own painting, and to the work of Barnett Newman, by which he had been considerably affected.

45.

"Anthony Caro's work: a symposium by four sculptors," *Studio International* 177, 907 (Jan. 1969): 20.

46.

Clement Greenberg, "After Abstract Expressionism," *Art International* 6, 8 (Oct. 1962): 28.

47.

Fried, "Art and Objecthood" (note 33): 21.

48.

Donald Judd, "Specific Objects," in *Arts Yearbook 8: Contemporary Sculpture* (1965): 74-82.

49.

Robert Smithson, "Entropy and the New Monuments," *Artforum* 4, 10 (June 1966): 26-31.

50.

Robert Morris, "Notes on Sculpture," *Artforum* 4, 6 (Feb. 1966): 40.

51.

Robert Morris, "Notes on Sculpture, Part 3," *Artforum* 5, 10 (Special Issue, Summer 1967): 29. "Part 2" was published in *Artforum* 5, 2 (Oct. 1966): 20-23, and "Part 4" in the same journal in April 1969 (7, 8): 50-54.

52.

Material for the April 1969 *Studio International* was largely assembled by the American writer Barbara Reise, who had published a two-part "exposé" of "Greenberg and the Group" the previous year (*Studio International* 175, 900 [May 1968]: 254-57, and 175, 901 [June 1968]: 314-315). The editors of *Studio* were not unaware of the advantage to be gained by importing a faction-fight started in American publications. Judd's "Complaints part I," published in the *Studio International* special issue (177, 910 [Apr. 1969]: 82-84), was in part a response to adverse criticism from Greenberg (especially his essay "The Recentness of Sculpture") and to Fried's "Art and Objecthood." Judd also addressed their estimation of Caro:

> Caro is a conventional, competent second-generation artist. I don't understand the link between Noland and Caro, since wholeness is basic to Noland's work and Cubist fragmentation is basic to Caro's. I think Caro had his first show in New York in December 1964. Di Suvero first showed his somewhat similar but far better sculpture in October 1960; by 1964 di Suvero had a tiresome number of followers and Caro's work looked like that of just another of them. . . .

Judd had the excuse of provocation, but the concluding imputation was certainly unjust.

53.
Tate Gallery, April-June 1969. "The Art of the Real" was a crowded and incoherent exhibition which did little to satisfy those impatient for a representative showing of Minimal Art in England — and even less to interest those inclined to dismiss it.

54.
The phrase is taken from Noam Chomsky; see his *Reflections on Language* (London: Fontana, 1976):

> Suppose that the social and material conditions that prevent free intellectual development were relieved, at least for some substantial number of people. Then, science, mathematics and art would flourish, pressing on towards the limits of cognitive capacity. At these limits . . . we find various forms of intellectual play, and significant differentiation among individuals who vary little within the domain of cognitive capacity. As creative minds approach the limits of cognitive capacity, not only will the act of creation be limited to a talented few, but even the appreciation or comprehension of what has been created. If cognitive domains are roughly comparable in complexity and potential scope, such limits might be approached at more or less the same time in various domains, giving rise to a "crisis of modernism," marked by a sharp decline in the general accessibility of the products of creative minds, a blurring of the distinction between art and puzzle, and a sharp increase in "professionalism" in intellectual life, affecting not only those who produce creative work but also its potential audience. . . . It may be that something of the sort has been happening in recent history (from an excerpt published in Harrison and Orton [note 39]: 263).

55.
Anthony Caro, from an interview with Noel Channon, broadcast on Granada Television, Sept. 1974; printed in Diane Waldman, *Anthony Caro* (Oxford: Phaidon, 1982): 34.

56.
See, for example, the (somewhat euphoric) testimony of David Annesley as given in the *Studio International* symposium (note 45):

> . . . other people said, "Oh, you can do that Tony? I mean is it all right to do that?" He said, "Yes, you don't have to look at all that other stuff, enough time for that later, that's all been done. Let's look at some of these new things. How about making sculpture out of feathers? Can we make it out of a balloon? Ooh, would it be nice out of cushions?" All these lovely ideas he had. "What can you do with it? Can you make it out of anything? What are the rules? Are there any rules at all?" It was like he was jumping around in a thousand different directions at once. . . .

57.
Tucker in Scott (note 24).

58.
Though the immediate impression conveyed by *Prairie* is of a visually integrated whole, one element (composed of one of the four horizontal and parallel poles, the vertical plate which supports it, and another smaller plate joined to this at floor level) is physically separate and free-standing. Realization of this comes as something of a surprise. Caro has paid tribute to the role of his assistant in the making of the sculpture:

> *Prairie* is not merely an artwork — but my goodness, it's a work of engineering. Underneath *Prairie*, inside *Prairie*, is first of all a cradle which holds the wings together. The wings are two separate parts; they're held together underneath; and on top of that sits the corrugated steel and they're held together on top, to stop them flopping down, by a single tie. The whole thing comes to pieces, it's all spiggoted. It was clever of Charlie to make that, terribly clever of him to think out how

that would work . . . (Anthony Caro, interview in Waldman [note 55]: 50-52).

59.
See Greenberg, "Anthony Caro" (note 18): "By opening and extending a ground-hugging sculpture laterally, and inflecting it vertically in a way which accents the lateral movement, the plane of the ground is made to seem to move too; it ceases being the base or foil against which everything else moves, and takes its own part in the challenge to the force of gravity."

60.
This seemed to be a particularly important issue as regards Phillip King's work of 1966-68, in which he tried out various means to extend his sculptures spatially by making them of separated components. Some of the results appeared dangerously close to architectural and environmental installations. The impression created by individual works varied dramatically according to viewing conditions. His *Call* of 1967 (Tate Gallery, London) seemed plausible in its occupation of a single bay of the Whitechapel Art Gallery during his retrospective there in 1968, but the same sculpture had previously failed completely to hold its own outside the British pavilion at the Venice Biennale. Since the experimental and interesting *Blue Blaze* of 1968 (Collection of Mrs. John D. Murchison, U.S.A.), King has largely relied on actual physical integration to hold individual works together.

61.
Barry Flanagan, "From notes '67/8; dating from observations made in March '67 about three sculptures for Paris Biennale," *Studio International* 177, 907 (Jan. 1969): 37. The color photograph of the three works was reproduced, together with a statement by Flanagan, in *Studio International* 174, 892 (Sept. 1967): 98-99.

62.
Quoted in Charles Harrison, "Some recent sculpture in Britain," *Studio International* 177, 907 (Jan. 1969): 32.

63.
A story current at the time told of Caro confronted by an arrangement of twigs in the exhibition hall of the St. Martin's sculpture department. A conversation ensued. Caro: "What's this?" Long: "It's one part of a two-part sculpture." Caro: "So show me the other half." Long: "It's on top of Ben Nevis." [Ben Nevis is a mountain in Scotland.] Caro: "So how can I assess it when I can't see all of it?" The story is no doubt apocryphal. It is representative, however, of a host of similar conversations which certainly did take place in art schools all over Britain during the later 1960s and early 1970s. At one point, in 1971, a government official was required to rule that only "tangible visual art objects" would be acceptable for submission for the diploma in Art and Design, at the time the national qualification awarded for satisfactory completion of a three-year course of study (see "Some Concerns in Fine Art Education," *Studio International* 183, 937 [Oct. 1971]: 120-22, and 183, 938 [Nov. 1971]: 168-70). The question whether "not producing objects" entailed "not working" was one that bedeviled and divided British art education for some years after.

64.
"On the Material-Character/Physical-Object Paradigm of Art" is the title of an article by Terry Atkinson and Michael Baldwin, published in *Art-Language* 2, 1 (Feb. 1972): 51-55. The article was written in response to the publication of Richard Wollheim's lecture "The Work of Art as Object" in *Studio International* 180, 928 (Dec. 1970): 231-35 (see also the edited reprint in Harrison and Orton [note 39]: 9-17). Wollheim had asserted that ". . . for the mainstream of modern art, the appropriate theory is one that emphasizes the material character of art, a theory according to which a work is importantly, or significantly, and not just peripherally, a physical object." Atkinson and Baldwin commented, "If the statement is supposed to be retrospective, it's not so bad: we have been stuck with reism etc. Assume, however . . . that there is some predictive intent behind it. . . . What we may have here is a law-like

statement which has been immunized against possible future experience insofar as, if an experience does not fit, so much the worse for the experience – rather than 'so much the worse for the law-like statement.'"

65.

The termination of Latham's part-time contract at St. Martin's coincided with his response to a request from the library for the return of *Art and Culture: Critical Essays*, Greenberg's collected essays. Latham returned a small phial of liquid distilled from chewed-up pages of the book. Some of the chewing had been done by sculpture students. The phial with its container – *Art and Culture* – is now in the collection of The Museum of Modern Art, New York.

66.

John Latham in "Where does the collision happen; John Latham in conversation with Charles Harrison," *Studio International* 175, 900 (May 1968): 259.

67.

Letter of June 7, 1963, printed in *Silâns* 6 (Jan. 1965): unpag.

68.

Silâns was a duplicated magazine edited in the St. Martin's sculpture department by Barry Flanagan, Alistair Jackson, and Rudi Leenders and circulated internally. Sixteen issues were published between September 1964 and June 1965.

69.

For discussion and a bibliography on the relations between Modernist critical theory and Cold War cultural policy, see Frascina (note 32).

70.

See Harrison, "Some recent sculpture in Britain" (note 62): 31.

71.

The other exhibitors were Bernhard Hoke, Konrad Lueg, Charlotte Posenenske, and Peter Roehr. The exhibition was organized by Paul Maenz.

72.

Artists included were Alice Adams, Louise Bourgeois, Eva Hesse, Gary Kuehn, Bruce Nauman, Don Potts, Keith Sonnier, and Frank Lincoln Viner.

73.

Robert Morris's article "Anti Form" was published in *Artforum* 6, 8 (Apr. 1968): 33-35.

74.

"Prospekt" was coorganized by Konrad Fischer. Long's first one-person show was running concurrently at Fischer's gallery in Düsseldorf. This conjuncture must have helped to get Long's name spread around the international art community.

75.

The other exhibitors in "Op Losse Schroeven" were Anselmo, d'Armagnac, Boezem, Bollinger, Buthe, Calzolari, Dekker, Dibbets, van Elk, Engels, Hoke, Icaro, Jalass, Kaks, Koetsier, Mario and Marisa Merz, Nauman, Panamarenko,

Prini, Ryman, Simonetti, Viner, Weiner, and Zorio. The other exhibitors in "When Attitudes become Form" were Andre, Anselmo, Artschwager, Bang, Bark, Berry, Beuys, Boetti, Bochner, Boezem, Bollinger, Buthe, Calzolari, Cotton, Darboven, De Maria, Dibbets, van Elk, Ferrer, Glass, Haacke, Heizer, Hesse, Huebler, Icaro, Jacquet, Jenney, Kaltenbach, Kaplan, Kienholz, Klein, Kosuth, Kounellis, Kuehn, LeWitt, Lohaus, Merz, Morris, Nauman, Oldenburg, Oppenheim, Panamarenko, Pascali, Pechter, Pistoletto, Prini, Raetz, Ruppersberg, Ruthenbeck, Ryman, Sandback, Saret, Sarkis, Schnyder, Serra, Smithson, Sonnier, Tuttle, Walther, Wegman, Weiner, Wiley, and Zorio. Victor Burgin was included in the London showing.

76.

Grégoire Muller in *When Attitudes become Form* (Kunsthalle Bern, 1969). Original in French, present author's translation.

77.

Printed as an opening slogan on the title page of the *Attitudes* catalogue.

78.

Morris, "Notes on Sculpture, Part 3" (note 51): 25. Morris continued, "Specifically, what is antique about it is the divisiveness of experience which marks on a flat surface elicit."

79.

For example, whatever visual delights may have been offered at the time by the works of, say, Daniel Buren, Sol LeWitt, Robert Ryman, Mel Bochner, or Hanne Darboven, they were not such as to compete on equal ground with the paintings of Kenneth Noland, Jules Olitski, or Larry Poons.

80.

The original members, Terry Atkinson, David Bainbridge, Michael Baldwin, and Harold Hurrell, had variously collaborated in the two years previous to the formal constitution of Art & Language in 1968. Baldwin had visited New York while a student in 1966 and had been interested in Judd. Atkinson went to New York the next year and made contact with LeWitt, Andre, and Smithson. Both were then associated with Coventry College of Art, which became the principal British center of interest in Minimal and Conceptual Art and art theory. Bainbridge studied in the sculpture course at St. Martin's in the early 1960s. The nature of his relationship with the ethos of the institution is suggested by the title of an article he contributed to *Silâns* 8 (Feb. 1965): "The Artist/Intellectual as an Ineffective (Hypocritical?) Idealist." Hurrell worked briefly as a part-time tutor in the St. Martin's sculpture department. Bainbridge and Hurrell jointly staged the "Hardware" show at the Architectural Association, London, in February 1967.

81.

Art-Language 1, 1 was published in May 1969, with the subtitle "The Journal of Conceptual Art" (a designation dropped from all subsequent issues). Contributors included Dan Graham, Sol LeWitt, and Lawrence Weiner.

By Lynne Cooke

Between Image and Object: The "New British Sculpture"

History, I think, is probably like a pebbly beach, a complicated mass, secretively three-dimensional, and very hard to chart what lies up against what, and why, and how deep. What tends to get charted is what looks manageable, most recognisable (and usually linear), like the wiggly row of flotsam and driftwood, and stubborn tar deposits.[1]

The year 1981 witnessed the public debut of what is currently the latest wave of British sculptors to receive national and international acclaim. Their launching occurred over two exhibitions, and was rapidly followed by a third. Tony Cragg's solo show at the Whitechapel Art Gallery in London shortly preceded "Objects & Sculpture" (fig. 16), an exhibition held jointly at the Institute of Contemporary Arts in London and the Arnolfini Gallery in Bristol, which included works by Richard Deacon, Antony Gormley, Anish Kapoor, Jean-Luc Vilmouth, and Bill Woodrow.[2] And early in 1982 Shirazeh Houshiary and Alison Wilding showed together at Kettle's Yard Gallery in Cambridge.

From the beginning this grouping has been a loose one, with commonality determined not primarily by aesthetic positions but by similarities in age, training, and situation. All of these artists were born within a decade (and after 1948); all were trained in London art colleges; and all (with the exception of Cragg, who moved to Wuppertal in 1977 but nonetheless has remained in close contact, and Vilmouth, who returned to France in 1985) are resident in London. These affinities are reinforced in many instances by close personal friendships which were forged during their student years. That all but Wilding and Gormley are represented by the Lisson Gallery in London has also contributed to this closeness, reinforcing the tendency to regard this latest wave as a "new generation" following a line of succession in British sculpture from World War II, at the apex of which stand Barbara Hepworth and Henry Moore.[3]

At present the key figures are generally acknowledged to be Cragg (in many respects the most influential figure and a bridge to

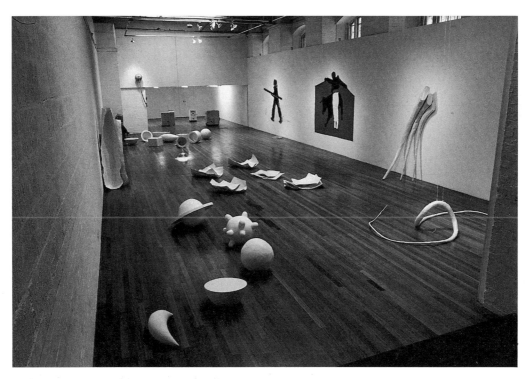

Fig. 16. General view: "Objects & Sculpture," Institute of Contemporary Arts, London, 1981

the previous generation: it might be said of him, as Willem de Kooning did of Jackson Pollock, that "he broke the ice" — a tribute that implies no fealty to his style or subject matter but pays homage to his seminal position as a rallying point), Woodrow, Deacon, Kapoor, Houshiary, Gormley, and Wilding.[4] Several other sculptors, for various reasons, sometimes of their own choice, are more peripheral, including Edward Allington, Boyd Webb, Richard Wentworth, and Vilmouth. That the sobriquets under which these artists have come to be known and discussed — "The New Sculpture" or "New British Sculpture" — are so bland attests to the diversity of the group, to their eluding reduction to a common denominator.

Their public debut in 1981 coincided closely with the launching in the international arena of groups of painters from Italy, Germany, and the United States. Exhibitions like the Venice Biennale of 1980 and "A New Spirit in Painting" held at the Royal Academy in London in 1981 provided the context in which the new art was received and discussed. "A New Spirit" mixed painters from various generations and countries, including such venerable figures as Philip Guston, de Kooning, and Picasso, whose work was currently undergoing review, in an endeavor to give some historical lineage to what appeared to be a sudden efflorescence of figurative, gestural painting. A more focused exhibition quickly followed in Berlin in 1982: "Zeitgeist,"

which set out to "investigate what in the field of contemporary painting and sculpture touches the nerve of our time," this title providing in the words of one of the selectors "a *metaphor* for all those artistic proposals of today that signal *a deep founded change of direction in visual art.*"[5] Emphasis was once again clearly given to painting. And within the depleted ranks of sculpture, it was an object-based mode of sculpture that predominated. In sculpture as in painting, there seemed to be a return to what are widely regarded as traditional and orthodox idioms after the plethora of new modes that dominated the 1970s, modes that are discussed under various rubrics, ranging from "the dematerialization of the art object" to an "expanded field" for sculpture. In many cases this reembracing of traditional art forms has been accompanied by the use of traditional materials and techniques, traditional styles, and, often, a familiar figurative iconography.

Many of the painters featured in these exhibitions have also made three-dimensional work: Georg Baselitz, Sandro Chia, Francesco Clemente, Jörg Immendorff, Marcus Lüpertz, Mimmo Paladino, A. R. Penck, and Julian Schnabel, among others. Almost inevitably the sculpture conforms more closely, in its forms, style, and imagery, to their painting, than to any of the sculptural modes of the previous decade. Much of the work of these painter-sculptors em-

ploys a monolithic, totemic, or monumental format; a subjective expressionist mode of handling; figurative imagery; and frequent recourse to overpainting to embellish or further elucidate the subject.[6] Simultaneously, a number of older sculptors were relinquishing the various media and modes that they had employed during the 1970s in favor of an object-based, figurative art. Among the British sculptors shown at "Zeitgeist," Barry Flanagan exhibited bronze hares whose playful antics as cricketeers and acrobats marked a sharp contrast with his works of the mid-1970s in which found forms, stones, and rocks were minimally altered by the carving of austere marks and archetypal symbols such as whorls and spirals. Bruce McLean, by contrast, transformed his former performance- and conceptually based sculpture into large paintings in which he again parodied the pretensions of the art world and jibed at the precepts underlying much recent art. The large photographic works of Gilbert & George, too, marked a shift in direction – in their case away from the solipsistic content of much of their work of the previous decade which concentrated almost exclusively on the "Living Sculptures" themselves – to an art that addressed a wider range of themes, including nationalism, patriotism, racism, sex, and death.

The works of the New British Sculptors shown in 1981/82 and after bear no closer resemblance to that of their elders, Flanagan, McLean, and Gilbert & George, than they do to that of most painter-sculptors. To date, casting and carving have played only a minimal role, and generally, as in the case of Wilding, they are used in conjunction with other techniques. And only Cragg and Gormley have employed the motif of the human figure, though references to a wide variety of other types of imagery inform much of this work.

Exhibitions like "A New Spirit in Painting" and "Zeitgeist" contributed in the early 1980s to the return of painting to the forefront of art world and critical attention. They contrast sharply with two exhibitions held at the end of the 1970s which surveyed European art of the previous era. "Europe in the Seventies: Aspects of Recent Art," which opened at The Art Institute of Chicago in 1977 and then toured the country, was the first extensive show of European art from this decade to be seen in the United States. "Kunst in Europa na '68" at the Museum van Hedendaagse in Ghent in 1980 similarly surveyed the period, but for a European audience. Two features of these shows are important, and typical of the times: the almost total absence of painters, and the inclusion of British sculptors such as Flanagan, Gilbert & George, and Richard Long alongside their continental counterparts in what was patently an international movement. In both exhibitions the focus was accorded those art works employing various new media, or new forms which had developed in the late 1960s as part of an attempt to escape the confining strictures of the art gallery as a physical, social, and economic site, and the fettering conventions deemed inherent in painting and sculpture.

In terms of generations, the counterparts to the New British Sculptors are the groups of Italian, German, and American painters who have come to the fore in the 1980s; they include respectively Sandro Chia, Clemente, Cucchi, and Paladino; Walter Dahn, Jiri Dokoupil, Rainer Fetting, Helmut Middendorf; and Eric Fischl, David Salle, and Schnabel, among others. That ambitious painting abroad should be matched in Britain by sculpture, not painting, is telling but not uncharacteristic. It does, however, raise a number of questions:

the appropriateness, given the current stress on national groupings, of discussing this art within a specifically British framework; the extent to which it may be seen as an independent phenomenon, the product of a specific nexus; and the terms in which its "newness" may be interpreted, or said to reside.

"Objects & Sculpture" was thus a seminal show, one that warrants close scrutiny for the keys it provides to an understanding of this new wave of British sculpture. Unlike Cragg's show at the Whitechapel Art Gallery (and at the Arnolfini in the previous year), and the Houshiary/Wilding exhibition in Cambridge, "Objects & Sculpture" was accompanied by a substantial catalogue, one that included statements by the artists as well as an introduction by the selection committee. In their preface the selectors argued that the eight artists whom they had chosen constituted neither a school nor a movement. No shared ideas and no common positions united them as a cohesive group. After noting that "truth to process" was more important than "truth to materials," they concluded that "Materials seem here to be open to any necessary manipulation in the working out of a particular notion or idea."[7] Yet, quite properly, attention was ultimately placed on the nature of the content in this work. They stressed that the referential had gained precedence over the formalist, and that associational rather than didactic or interrogative means were employed to elicit this content:

> The work is neither figurative nor abstract, nor could it simply be termed as abstracted. It *is* associative, and in some cases is also symbolic or metaphorical. . . . [And it] seem[s] to refer both to *objects* in the world, and to *sculpture* given some status as a category of special objects separated from the world.

In the statements made by the artists, these points are reiterated and developed. Kapoor, for example, stressed, perhaps even overstressed, the metaphysical aspects of his work in an endeavor to preclude its being read in formalist terms: "I have no formal concerns. I don't wish to make sculpture about form – it doesn't really interest me. I wish to make sculpture about belief, or about passion, about experience, that is, outside of material concern."[8] The works that he exhibited (fig. 17) were small constellations, or pairs of simple forms, made from heaped powder and chalk whose vivid shimmering color and pristine surfaces precluded touching for it would have not only violated the form physically but, metaphorically, transgressed the sanctity of the devotional image. The generic title, *1000 Names*, indicated that all were part of a larger whole, a whole which could never be known in its entirety, but only intuitively grasped through its manifestation in specific instances, in transient works which had to be reconstructed anew, from powder, for each showing.

By contrast, Deacon's catalogue statement commenced with a factual account of the making of a series of drawings in 1978, moving on to describe the manner in which he began to relate these forms to elements in Rainer Maria Rilke's poetry. This connection influenced the development of his subsequent sculpture, in particular the way in which forms took on associations relating to apertures and bodily organs. Yet rather than expanding on this content, Deacon's account – and it typifies the moment – stressed the processes and materials that determine the final form of the sculpture. While abjuring an

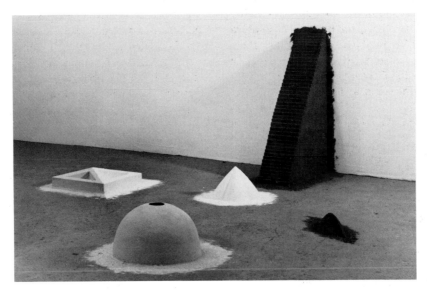

Fig. 17. Anish Kapoor, *1000 Names*, 1981, Courtesy Lisson Gallery, London

exclusive preoccupation with form, the three untitled sculptures which he exhibited were, compared with much of his later work, quite restrained in their imagery and reticent in their associations (see pls. 27-31). It is telling that all were untitled, for subsequently titles have played an important role in amplifying, guiding, and enriching the metaphorical meaning.

In his extensive statement, Gormley was much more forthright in discussing the ways in which ideas, material, and substance (object/image) interrelated; he emphasized a way of working in which the process again contributed directly to the content of the sculpture, exemplified through his use of bread:

> I came to bread as a material, because it's something that's with us all the time, like bottles and knives, coats and socks. At first I used it simply as a material—I cut it with a saw and made it into compositions usually circular but sometimes with an edge of one slice. . . . I'd been working with bread for about two years before it became obvious to me that it was ridiculous to be treating it as if it were wood. I mean in the sense of sawing it up. So I started using my teeth, thinking much more about bread as a food substance.[9]

Although Gormley's work at this time utilized a number of materials, two pieces were included that were made from this staple food: *Breadline* (1981, Collection of the artist), literally a line of bite-sized pieces of sliced bread laid out on the gallery floor; and *Bed* (fig. 18), in which a cubic "catafalque" of stacked slices of Mother's Pride processed white bread bears the negative imprint of the artist's body eaten away in two half molds.

Vilmouth, who made no catalogue statement, showed a number of sculptures which differed substantially from his previous work in that they incorporated found materials and objects, and a saucy wit. The best of these, *Flying Saucer*, also called *Walking on the*

Moon (1981, Collection of the artist), was a nice conceit: a metal lampshade was suspended several inches above the floor so that it drenched the two plastic cereal-packet figures below in a relentless, searing light.

Woodrow's catalogue statement to "Objects & Sculpture" rooted his art very directly in the circumstances of his life. He opened his account with a reference to the materials, his basic starting point at that moment:

> My choice of objects is dictated, I think in the first instance by what is available, what I come across in the streets, on dumps. . . . One of the things that excited me when I started using these found domestic goods was that there was this whole area of material that I'd just been walking past. Just everyday stuff that I hadn't considered as material. . . . Basically though, all the objects simply present material, and as far as I'm concerned, any material has a potential for manipulation, to be made into something other than its active form at the time you find it.[10]

And he concluded that he was not making didactic statements about contemporary consumer society: "I'm obviously aware that these sort of connotations do exist in various pieces of my work." Nevertheless, of greatest significance for him, at that moment, was his relationship with the material as such:

> What I find more interesting about the work, is that these items are material for me that is found in my environment, it's not recovered in any sense, it deals directly with my life and the majority of my experiences, whereas walks in the countryside and rural atmospherics don't play a very large part in my life.

Woodrow's contribution to the exhibition included a number of washing machines, from the "skin" or outer surface of which he

had cut and formed a new item: a guitar (pl. 114), bicycle frame (pl. 113), and a chainsaw (pl. 115). While the relationship between the "host" object and the newly created one was perfectly clear in physical terms, their conceptual relationship was enigmatic, bizarre, and provoking. The artist's statement offered no clues.

Taking the works of these five artists, together with the statements in the catalogue by artists and selectors, certain salient concerns emerge. The preoccupation with process, with the methods of making, is crucial not merely to the appearance of the final form but to the content of the sculpture. Materials are generally chosen which are "to hand," found conveniently or readily available at low cost. These sculptors seek an "inclusive" art, that is, an art that addresses a wider range of issues rather than purely formalist or aesthetic questions, but which never has recourse to didactic or expostulatory means, conjuring this meaning through metaphor, metonymy, and association. Although in most cases their work betrays a sophisticated understanding of the formal language of sculpture, formal exploration was never an end in its own right but was always held in service to an overriding ideal: the search for a metaphysical content. Though these preoccupations were shared, each artist interpreted them in personal ways such that few formal affinities resulted and no stylistic cohesion. Similar preoccupations underpinned the works which Wilding and Houshiary exhibited at Kettle's Yard Gallery shortly after.

In most cases the forms of the works that were shown in 1981 and 1982 were relatively new in the artists' oeuvres, whereas the underlying preoccupations were deeply rooted, often stemming back to the sculptors' student years. The first group of Deacon's organically shaped sculptures, including the two laminated untitled

wooden works exhibited at this time (see pls. 27-29), were made only after his return from the United States in 1979. In his twin-tubs, Woodrow cut his first object from its host; this continues to be his preferred practice. Wilding's preoccupation with a bipartite sculpture, one form of which often creates a perimeter or demarcates the terrain, physical and psychological, inhabited by the other, was first realized in *Untitled* (1980, Arts Council of Great Britain), and Kapoor's first powder pieces were made in 1980 after his return from a trip to India. If it can be said that these sculptors' mature idioms were first realized at this moment, their aesthetics, the means by which they sought to realize their ideas, and the underlying precepts can be traced through the works they made in the later 1970s. Ultimately it is because their individual aesthetics spring from a long period of maturation in this communal soil that affinities in approach can be traced.

English art colleges have played an unusually important role in the formation of most British artists, a role with possibly no counterpart abroad. British students often spend up to six or seven years attending art school, though rarely continuously at one institution. A general "foundation" year is followed by increasingly specialized undergraduate and postgraduate courses, in the best of which students are subjected to intensive and challenging scrutiny by a staff of largely professional artists, many of whom teach only on a part-time basis. In the mid-1970s two schools were widely considered the most lively seedbeds for sculpture: the Royal College of Art and St. Martin's School of Art, both of which are in London. Woodrow and Deacon attended St. Martin's; Cragg, Deacon, Vilmouth, Wentworth, Webb, and Wilding were at the Royal College, though not all at the same time.

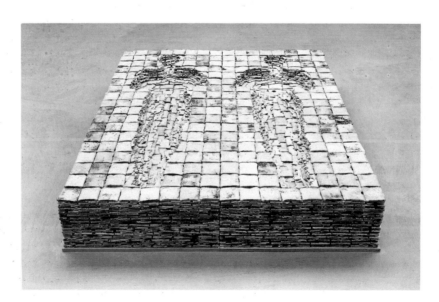

Fig. 18. Antony Gormley, *Bed,* 1980-81, Collection of the artist

St. Martin's was the seat of a mode of abstract constructed sculpture centered on the work and aesthetic of Anthony Caro and a number of associates, including Phillip King, William Tucker, and Tim Scott, all of whom taught in one of the two sculpture courses that the school offered. Their work, which had first gained international acclaim in the early 1960s, was based on a Modernist conception of sculpture which owed much to the writings of Clement Greenberg, the influential American critic. It defined sculpture as autonomous, hermetic, and radically abstract, by which was meant not only non-referential, but separate and different from other classes of objects. "Rightness of form" was the measure not only of the formal resolution of a work, but of its quality.[11]

Yet St. Martin's witnessed some of the most trenchant and hostile debates of the late 1960s for it also spawned a number of younger sculptors, sometimes said to comprise the next generation, who completely rejected this Modernist notion in favor of a greatly expanded definition of sculpture, one that rapidly manifested itself in a wide variety of guises from conceptual to performance to land- and site-based activities, as seen in the work of Gilbert & George, Flanagan, Long, and McLean, among others.

At the Royal College the situation was somewhat different in that its staff seems to have maintained a stronger commitment to sculpture as material realization than was found in much of the conceptual, performance, and texturally based work stemming from St. Martin's by the end of the 1960s. And in contrast to Caro and his epigones, they affirmed that the meaning and content of the art work was determined as much by the conditions of consumption (that is, by its socio-cultural context and attendant discourses) as by displays of sensibility and "rightness of form."

The Royal College was more "open" and less dogmatic in approach, but perhaps of greater importance was the fact that Peter Kardia, who taught at both colleges, seems to have had a particular impact on a number of students who attended this school, including Deacon, Cragg, and Wilding. Kardia's considerable impact lay in the manner in which he subjected students to a rigorous mode of self-questioning, one in which any type of activity had to be stringently evaluated and defended, and the precepts on which it was based closely defined. Thus individual responsibility rather than allegiance to any particular vanguard aesthetic or position became the basis for art-making. It may have been Kardia's attributing of responsibility to the student for his or her actions, ideas, proclivities, and presuppositions — without, however, permitting a lapse into subjectivity or speculative effusion — that contributed to the individuality of these artists and to their tendency to share ideas and theoretical premises rather than formal or stylistic idioms. He seems also to have fostered that propensity to regard the process, the actual execution, as a crucial factor in the genesis not only of the final form but of the content of the sculpture. For he placed greater weight on an analysis of the creative process than on the form of the finished object. In his concentration on the means and the underlying precepts, Kardia avoided that tendency to vassaldom, the creation of a "baronial fief" as Richard Deacon termed it, which pervades much art-school training.

Yet the impact of Kardia's teaching, in particular, and of the courses in which these students trained cannot be divorced from the wider context in which they were working. Although major exhibitions of international sculpture were relatively rare at this time, retrospectives were held of Donald Judd's sculpture at the Whitechapel Art Gallery in 1970 and of Robert Morris's work at the Tate Gallery in 1972. Joseph Beuys's work and an accompanying action were first seen in London at the Institute of Contemporary Arts in 1974, but generally speaking it was art magazines that were responsible for keeping artists abreast of developments abroad.

Minimal Art had relatively little direct effect in Britain. The first half of the 1970s was dominated by Conceptual and Performance Art, and by sculpture in an "expanded" sense of the term, including installation, land, and site-specific works, much of which first received wide public attention through an exhibition entitled "When Attitudes become Form," held at the Institute of Contemporary Arts in London in 1969 after being shown on the continent. In its London version it included several British artists such as Flanagan and Long, together with European and American artists, in what was clearly a cosmopolitan phenomenon. In 1972 Anne Seymour surveyed in depth a number of British artists working in this arena, in an exhibition titled "The New Art," which she organized for the Arts Council of Great Britain at its major forum, the Hayward Gallery. Seymour discerned two distinct approaches among these British artists: those who worked directly with materials and means, such as Long and Gilbert & George, and those who, like Michael Craig-Martin and Art & Language, employed cognitive means. Her distinction corresponded fairly closely to the two categories, ontological and epistemological, which Robert Pincus-Witten elucidated in his discussion of American Postminimalism, reaffirming the fact that this art was not a peculiarly British phenomenon.[12] Seymour's prediction that art would never again be the same was, however, soon challenged.

Within three years the gauntlet was thrown down by William Tucker, responding to an invitation from the same patron for a sculpture show in the same venue, but this time with an international axis. Tucker's show, "The Condition of Sculpture," purported to survey both meanings of this ambiguous phrase: the current state of health of the art, and its innate or proper character. His conclusions, set forth forcibly in the catalogue text, asserted the continuing centrality and vitality of the Modernist conception of sculpture, which he defined as inherently object-based, subject to gravity, and revealed by light.[13] Its health was measured in what he referred to as an "opinionated selection" of the work of some 40-odd sculptors, mainly from North America and Britain, most of whom worked within that mode of abstract constructed sculpture deriving from David Smith and Caro. With this partisan exhibition the lines of demarcation were firmly drawn; for the remainder of the decade, all other forms of sculpture were on the defensive.

These polarities were reinforced the following year when the British Council sent a vast show, "Arte Inglese Oggi 1960-1976," to Milan. In the two-volume catalogue, Performance, Conceptual Art, and film, as "alternative developments," were rigorously separated from painting and sculpture which occupied the first volume. Yet, in practice, such distinctions were far more difficult to sustain. Though Flanagan, for example, was included in the section devoted to sculpture, and Long and Gilbert & George were not, it was Flanagan who had been among the first to assert that the debates were not prin-

cipally about categories and definitions: "It's not that sculpture can be seen as more things and in new ways within an expanding convention, but that the premise of sculptural thought and engagement is showing itself as a more sound and relevant basis for operation in the culture."[14]

In 1976-77 the backlash continued, firstly with a heated public controversy over the purchase by the Tate Gallery of Carl Andre's untitled sculpture from the "Equivalents" series (the "bricks affair," as it came to be known),[15] and secondly, with a major exhibition of British sculpture in Battersea Park.[16] This show comprised only object-based sculpture, excluding all land and site-specific work, while the catalogue reinforced this conservative stance with a virulent dismissal of all new idioms.

If the competing claims for sculpture were violently polarized by such events, to younger artists the situation seemed more complex and shifting. In 1977 the recently formed magazine *Artscribe* (which paid greater attention to indigenous issues and less established artists than did its counterpart, the more internationally and politically oriented *Studio International*) published an article titled "A New Wave in Sculpture."[17] Ben Jones, the author, selected ten sculptors with an average age of thirty whom he felt heralded a new flowering in British sculpture. With hindsight this selection seems completely off the mark in that the majority of those artists were but pale shadows of sculptors several years their senior who were closely affiliated with Tucker's Modernist platform. Nonetheless, this article provides a useful index to several of the most lively debates of the day: namely, a concern with a process-based art, and/or a mode of sculpture rooted in allusion to landscape, the natural, and the organic.

Theoretically Richard Long's art should have stood at the confluence of these two strands; in practice it did not. For by the early 1970s, Long's work had become increasingly interpreted in terms of an atavistic archetypal content, with the artist assuming the mantle of spiritual wanderer. Allusions to a rural, pastoral tradition, often couched in a language of almost Georgian naïveté, were gradually replaced by a more universal statement, one in which the concept of the timeless, unchanging order of nature was preeminent.[18] References to prehistoric artifacts, like menhirs and leylines, introduced a megalithic symbolism and an engagement with cosmic forces fully in keeping with the way in which the stone sculptures in the gallery or the photographs of stone and stick circles and lines in remote, untouched sites postulated not a linear, historical sense of time but chthonic time, the time of the earth's functioning. All evidence of contemporary, and especially of urban, existence was therefore eliminated. By establishing this ahistorical temporality, and by eliciting a symbolic order from chaos and formlessness through the imposition of pure geometric forms, Long was felt to have posited an alternative to modern man's sense of alienation. The grandeur and monumentality in works such as *Slate Circle* (1979, Trustees of the Tate Gallery, London) or the photo-sculpture *Stones in the Sierra Nevada, Spain* (1985, Anthony d'Offay Gallery, London) attest to the shift in his work from a pastoral mood and a concern with the *genius loci* in which a harmonious unity between man and nature is intimated (as seen for example in *England* [1968], a photograph of a field in which a cross has been formed by picking off the heads of daisies) to a heroic statement centered on the notion of a sacred site or a site with mystical meaning, a *locus consecratus*.

Although Long's work distinguished itself by its growing preoccupation with the sublime and the monumental, he nonetheless remained at the heart of a group of sculptors who were variously involved with landscape, natural cycles, and organic form. Roger Ackling, Hamish Fulton, and David Tremlett, along with David Nash and Nicholas Pope, were its major exponents. Those who were not involved in walks or in making site-specific works garnered their raw material from the rural environs in which they lived. All chose to reside outside London in a desire for a more sympathetic environment and in order to effect a closer unity between their art and their life; Nash's sentiments might be endorsed by all of them: "I feel very removed from nature by the culture I'm living in. . . . We have a culture that looks at nature through windows — mainly out of *car* windows . . . to me nature and reality are synonimous [sic]."[19]

This fusion of aesthetic and ethical tenets contrasted with the approach to Land Art found abroad, especially in the United States where artists like Robert Smithson and Michael Heizer created vast earthworks which were criticized as being not only strongly ego-based but ecologically unsound. By contrast, a Zen-like acceptance of the one-ness of man and nature, mystical communion, and a celebration of the natural order underlay the works of most of the English artists whose work drew on landscape.[20]

Yet the methods he employed in his gallery-based sculpture, made from different types of stone and wood, brought Long into close association with another tendency gaining currency in Britain in the late 1970s. He neither imposed on his raw material nor metamorphosed it, but simply arranged it in lucid configurations directly on the ground. What proved so influential was the extreme economy and the direct exposition: the straightforward approach to gathering and presenting the material, the simplicity of structuring, and the literal assertion of the facticity of matter. Long's method formed a telling contrast to that neutralizing of both process and material which informed the work of Caro and his associates — for whom only the final product was of importance — as well as to the elaborate constructions and tableaulike pieces constructed by many local artists working with installation and site-specific modes. In responding to Long's methods but divorcing them from his enveloping aesthetic, younger artists like Cragg and Deacon in many respects finally came closer to the position, though not necessarily the work, of Carl Andre. Although Andre had been deeply inspired by his contact with the English landscape, which he described as "one vast earthwork,"[21] he was acutely aware of the implications of using any particular material, whether industrially fabricated steel plate or bales of hay. Although the sources of his early works were, by his own account, "Gift, theft, purchase or refuse,"[22] by the mid-1960s he was focusing increasingly on material that he purchased; thus his timber, like his metal, came in standardized units and so was divested of rural and organic associations. While his work had achieved notoriety in England through the Tate "bricks affair," it had not been widely seen prior to the retrospective held at the Whitechapel Art Gallery in 1978. Through the catalogue as well as two extensive interviews published in *Artmonthly*, Andre's ideas became thoroughly disseminated.[23] In these interviews the American perceptively and articu-

lately discussed his work in a variety of ways that drew on psychoanalytical, Marxist, and aesthetic theories. Both the sophistication of his ideas and his clear understanding of the assumptions and premises implicit in his practice were in striking contrast to the idealism, naïveté, and romantic sentiments that imbued much British land/nature-based art. They must have struck a sympathetic cord with many of Kardia's former students who shared his conviction that art works do not speak for themselves.[24] Moreover, in Andre's metal floor sculptures, there was a logical inevitability about the final configuration, in that it was determined by the form of the individual unit: in Long's work, by contrast, a symbolic image was imposed on the irregularly and randomly shaped elements.

Barry Flanagan shared something of Andre's concern to permit the material to determine not just the structure, but the composition itself, the principal difference being that he worked with amorphous matter like sand and rope or with found forms. By the mid-1970s lumps of stone, seemingly casually chanced upon and scarcely registering the traces of the artist's hand, had replaced those materials – dyed cloth and poles (that were more branches than stretcher parts), the raw matter of painting – which he had formerly hung in free-standing "teepees," or leaned against the gallery wall. If the degree of manipulation in these early works was minimal, the selection of the raw material, by contrast, was highly significant: "The convention of painting always bothered me. There always seemed to be a *way* of painting. With sculpture, you seemed to be working directly, with materials and with the physical world inventing your own organisations. . . . What I like to do is to make visual and material inventions and propositions."[25] This statement of 1969 implies a degree of conceptual investigation in relation to the art work per se that was largely eliminated by the substitution of natural found matter, like stones, in place of man-made materials. By the mid-1970s Flanagan had not only reduced the sense of *invention* but almost all evidence of *intervention*. By means of an extremely disarming self-effacement, he diverted attention to the natural, the organic, and often, the archetypal, as seen in works like *Lamb/fish* of 1975 (pl. 52).

It was Flanagan's attitude to materials, especially as manifest in his works of the late 1960s, which had continuing relevance to the burgeoning generation of sculptors of the 1980s, whereas it was the materials and motifs that he employed from the mid-1970s that linked him with younger sculptors like Nash and Pope who worked with natural materials and organic connotations.

Yet to confine the discussion of this mode of process-based activity to its British protagonists is misleading, for it was part of a much wider phenomenon, one that included certain artists associated with Arte Povera, such as Giuseppe Penone, in addition to Joseph Beuys. It also had a strong basis in the United States in certain types of Postminimal work, notably that of Eva Hesse, and in the writings of Robert Morris, a major exponent of this position in the late 1960s.[26]

From the early 1970s Deacon had been using combinations of materials as varied as plaster, linoleum, and chicken shit, subjecting them to an extensive set of manipulations. In *Stuff Box Object* of 1971–72 (pl. 21), he described the elaborate transformation which he had imposed on an array of matter taken over from a friend.[27] By 1974 he had begun to feel dissatisfied with this kind of performance-based manipulation of material, partly because his own person seemed to be getting in the way of the work and so becoming a distraction, and partly because he had begun to be interested in the objects that resulted, no longer regarding them as merely the by-product of an activity. Consequently, he began to construct objects (see pl. 22), in legible, though not necessarily simple, open configurations from material that was cheap and readily available – for example, plaster, and wood found in dumpsters and demolition sites.

Tony Cragg has recalled the enormous variety of material that he explored during the 1970s and the importance that this had for his subsequent work:

> I had the chance as one can in England to study for quite a long time: I was seven years in art schools and in that time I consider I did an enormous amount of work, not as finished work, but as parts of things: [it included] a lot of change in the materials, cutting, collecting, moving, arranging, sticking together and just experiencing the physical world . . . even now I use parts that I used fifteen years ago. . . . [Take] a work like *Taxi* which has got drawing all over it. The first works which were made with drawing all over were made, I think, around 1974 and that was . . . exactly the same way of making the work. It looked very different. They weren't really put together so that one would feel it was a sculpture, they were all parts of things I made in my studio every day.[28]

As seen in his untitled cubic stacks (see pl. 7), made for various exhibitions from the mid-1970s, the materials tended to be whatever was to hand, inexpensive and readily available. If convenience and economy played a large part in the selection of this scrap, when incorporated into sculpture it retained little sense of its former identity, though it bore all the signs of having had a former life. Despite the fact that it was largely recovered from local sites, it was not regarded as carrying urban connotations as such. It was felt to be quite anonymous – simply stuff.[29]

But what was done to the material gradually began to acquire greater importance. From simply laying it out in grids or in cubic configurations, Cragg began to shape or shift it in ways that were more elaborate, without, however, transforming it, as seen in *Metal Can and Wood* (1976, Private Collection). In this sculpture a can has been sliced horizontally into layers and then reconstructed so that it sandwiches pieces of wood between each part. Image and structure, object and abstract form, are separated and abutted in a sculpture that is disarmingly simple in form yet rich in content.

Bill Woodrow's work of the early 1970s was concerned with documenting human activity in nature or with bringing the landscape into the gallery via works made from combinations of photography and found forms, like sticks (see pl. 106). When, in the late 1970s, he resumed working after a few years of relative inactivity, Woodrow eschewed the overtly rustic implications and natural materials of his earlier sculpture in favor of material he salvaged from the streets near his studio. In several pieces he took objects gathered from his local environment (hair dryers and a broken vacuum cleaner), encased them in concrete, and then excavated them as if in some archaeological enterprise (pls. 108, 109). This was an ironic reversal of the type of salvaging and sanctifying that underpinned

Long's activity. In another work a number of bicycle frames were unraveled to make a large pinwheel "drawing" on the gallery wall (pl. 112). Prior to the works made with the twin-tubs (see pls. 113-115) which he exhibited in "Objects & Sculpture," Woodrow did not construct new images; instead he confined himself to the references inherent in the original material; meanings accrued through the dialogue between process, the handling of the materials, and form.

In the context of the late 1970s in Britain, Woodrow's rejection of rural or pastoral associations was not particularly unusual but his equation of the discarded appliances and other found man-made goods with the kind of lengths of used timber and sheet metal and linoleum that Deacon and Cragg scavenged from their environment as neutral stuff was both radical and singular. Indeed, most of the wood employed by sculptors in the late 1970s came neither from demolition sites nor even from the lumberyard. Many artists gathered wood from the forest, the shoreline, and the countryside, attracted as much by its associations with a "natural state" as by its structural properties and/or ready availability.[30] For both Pope and Nash, who were discussed together in the *Artscribe* New Wave arti-

cle under the subheading "Rural Seclusion," and who had been included in Tucker's "The Condition of Sculpture" — albeit somewhat incongruously — wood was their preferred material.[31] In the work of each, a respect for the inherent properties of the material, a sensitivity to organic form, and something approaching an equivalent for a craft-based technique can be discerned, though the manner in which these precepts is interpreted varies substantially from one to the other.

Nash has made various kinds of site-specific works: objects located in the context of a forest which use the tree itself, almost entire, such as the running tables and ladders (see pl. 101); and tree plantings which will be fully realized only after many years (see pls. 89-91). Since his move to Wales in 1967, he has always worked with fallen trees, preferring not to destroy living ones. Yet he readily engages with the subsequent life of the material, often employing wood while it is still green, as seen in *Three Clams on a Rack* (pl. 87), in which the inevitable cracking of the undried material has determined the final form of these rudimentarily carved wooden balls. Like Long and Hamish Fulton, Nash wishes to leave the barest imprint of his gesture on nature, but unlike them, his notion of touching it only

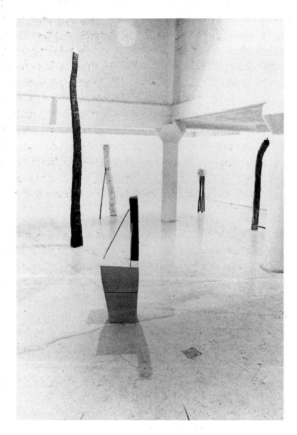

Fig. 19. Nicholas Pope, Installation at Garage Gallery, London, 1976

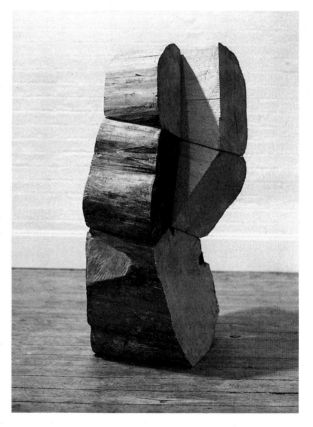

Fig. 20. Nicholas Pope, *Round Pile*, 1979, The British Council, London

enough to give it life includes bringing constructed and carved objects into the world.

Nicholas Pope's work, which has consistently been directed to a gallery context, explores a variety of material given minimal shape and form. Two formal types dominated his oeuvre of the later 1970s. Pillars of stacked units, which often became so precarious that a prop was required (see fig. 19), in time took on a horizontal orientation in lines of similar units placed closely together, as found in *Birch Wood Line* (1979, Ray Hughes Gallery, Brisbane, Australia). The second group comprised monolithic, volumetric sculptures; when in wood they were constructed by packing together split logs, as seen in *Round Pile* (fig. 20); when in chalk or stone they took on simple organic shapes from a rough carving which left the traces of the tool clearly evident. If his debts to Long and Flanagan are patently clear in the composing and structuring of these works, Pope nevertheless has wrought further changes within an aesthetic based on the natural and the organic. A statement that he made about his work in 1980 is symptomatic – both in its neutral, "objective" tone, and its concentration on "fact" alone, the materials and the handling – of many contemporaneous statements by artists of widely different persuasions:

> *Wilderness Block* [Collection of the artist] is just squat and square. . . . There are just a few clawings at it, although large areas were pitched off. The marks left are far and few between but they, the points and planes of its sides, are very clear. It is made from Forest of Dean stone, which contains a good deal of silica. This tends to reflect light and gives it a rich red colour.[32]

Yet Pope's conclusion, " . . . above all they are concerned with aesthetics," plays down the extent to which associations relating to the natural and organic formed a considerable part of the discourse in which such sculptures were received.[33] In his recent works he has exploited metaphorical correspondences between the organic and the biomorphic in ways that parallel the desire for a more inclusive art found in the works of the so-called "New British Sculptors."

In a plethora of forms and guises, landscape has constituted the dominant tradition in British art since the 18th century. It is therefore not surprising that many writers should have linked these recent manifestations with earlier instances. If Long's work has been compared with the pastoral and picturesque as found in the paintings of Richard Wilson, for example, and Fulton's with a Wordsworthian sensibility, more abstract art like that of Pope and Flanagan can be seen within a broad tradition that includes Hepworth, and ultimately goes back to prehistoric and paleolithic works.[34] In their concern for an art that was based on archetypes and on a harmonious interrelationship between man and nature – one that encompassed not merely a physical but a spiritual kinship – the work of these British artists from the mid-1970s has numerous parallels abroad. Yet in Britain this is a particularly resilient tradition and one which in the 1980s continues to attract new converts, as seen in the work of the young sculptor Andy Goldsworthy, an advocate of a philosophy similar to that of his mentor, Nash. Goldsworthy's sculpture consists of minimal, mostly very small and ephemeral interventions in the landscape, interventions that are recorded in equally beautiful photographs (see fig. 21).[35] As with so much of the work in this vein, it runs the danger of whimsicality and preciousness, of a rarefied escapism that confuses lyricism with inconsequentiality.

To many sculptors of the ilk of Gormley and Deacon, this idyllic, rustic art not only failed to correspond to their actual experience, which was urban, but it was romantic or naive in its unproblematic assumptions about such notions as "nature" and "culture," the country and the city. To them such constructs need to be treated critically rather than embraced wholeheartedly as givens.[36] Gormley's *Natural Selection* (1981, Trustees of the Tate Gallery, London), a line of lead-covered objects, alternatively natural and man-made and so ordered that they ascend in size progressively as if classified according to some scientific canon, explores man's relationships with the objects that comprise his social context. At the center of this enfillade lie an egg and a grenade, almost identical in form; it is an eloquent juxtaposition that throws into relief the nostalgic and fictive character of those claims that glorify the "natural" and the "organic" as unproblematic notions. Gormley's piece is typical of that which came into prominence in the early 1980s in that it is neither discursive nor didactic: it operates through visual as much as verbal conjunctions and depends on references inherent in the materials, process, and forms as much as in depicted imagery in order to convey its meaning.

This desire to construct meaning through process, materials, and form has been central to Richard Deacon's work from the time he again began to make objects, after a year abroad in the United States in 1979 during which he confined himself to drawing (see pl. 26). Through his drawings he had gradually evolved a more organic morphology of simple, potlike shapes, quite different from his earlier rectilinear, angular structures (see pl. 22). In seeking three-dimensional counterparts to these organic forms, he began to use materials like metal, wood, or linoleum, much of which he had acquired second-hand in sheet form or in thin strips, and to employ laminating and riveting, techniques that were more specialized than basic skills. Deacon styles himself a "fabricator," in contradistinction to a carver or modeler, and regards his methods not solely as a tool to realize the image but as an essential part of the expressive content of the sculpture:

> I also think that putting one thing on top of another and joining them together by a piece that goes through them has connotations as does laying one thing on top of another and gluing them together repeatedly. Those activities of construction have parallels with the ways in which we understand things in the world as having reference or meaning, whether as something applied to them or built up or hidden. I think all those things are part of those constructive processes. I also think that making has some profound relationship to language. One of the prime functions of language is to describe or reform the world. It is something that is neither yours nor mine, but is ours and lies between us and all this stuff out there. Making is not dissimilar.[37]

Albeit loosely, such attitudes linked Wilding, Gormley, and Deacon at the beginning of the decade. By exploring these means more stringently and by relying on metaphor rather than symbol or

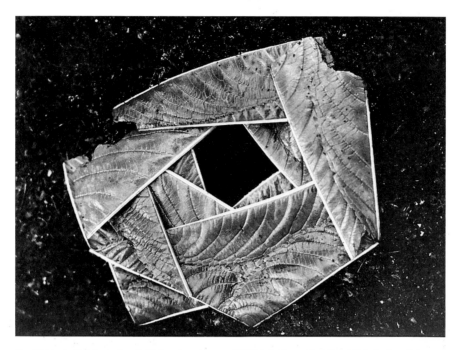

Fig. 21. Andy Goldsworthy, *Split Foxglove Leaves*, 1977, Arts Council of Great Britain, London

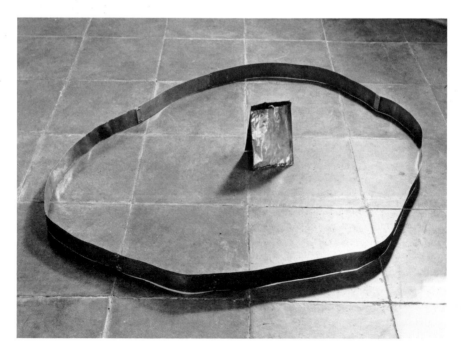

Fig. 22. Alison Wilding, *Untitled*, 1980, Arts Council of Great Britain, London

archetype, they were able to enrich the content of their art in ways that made it possible gradually to adopt a mode of working that resulted in permanent and fixed objects in place of the installations and symbolic or literary tableaux that they had made during their student years. Although Wilding acknowledged that "The making and doing processes . . . [are] always the mainspring of the work," hers, as theirs, is not a hermetic or materialistic ideal for "whilst firmly placed in our world the sculpture should take us out of it."[38] By establishing a binary relationship between the two components that comprise many of her works, such as *Untitled* (fig. 22), she manages to maintain a relatively modest scale for the monolithic component but to commandeer a large arena or space by means of the second element, and thus to effect a separation that affirms that the piece belongs to the world of sculpture, the category of art, and not to that of small objects. Yet by means of the forms, materials, and techniques, she relates the sculpture back to the world of objects, experiences, and states of mind.[39]

Anish Kapoor similarly has been able to effect a transition from the physical and literal to the metaphysical in the series of works he began in 1980 under the generic title *1000 Names*. The coating of these small, simple shapes with a brilliant pigment which spilled over onto the floor created a nimbus around each element so that the whole seemed to hover in space like a constellation. This impression of dematerialized, luminous form was central to Kapoor's quest for an art that was not about physical being but about spiritual states. Through works that seemed disembodied but nevertheless occupied space, that were compelling to the eye but resistant to the touch, that seemed to exist only as color and light, with no texture and surface, he was able to realize sculpture that addressed the metaphysical and the mystical.[40]

None of these sculptors, therefore, made a direct or abrupt transition from a multipartite, or multimedia, impermanent and environmental mode of sculpture to one based increasingly on the fixed, autonomous object. And even when they did create autonomous objects, these were not composed in relational terms with an internal syntax among the numerous parts, as was the work of Caro and many of his associates. While they tended toward simple, lucid, and often unitary forms, this did not preclude the sculptures' having several different and contrasting viewpoints, unlike that which pertained in Minimalist sculpture. Although their works clearly declared their existence as separate elements in the world, as sculpture they were not hermetic, but sought an inclusive, often metaphysical, content that extended far beyond the realm of aesthetics. It was this arena that the selectors of "Objects & Sculpture" alluded to, albeit somewhat tentatively and vaguely, when they described the work as "neither figurative nor abstract, nor could it simply be termed as abstracted."[41]

While such an account, however nebulous, clearly pertained to the sculpture of Deacon, Kapoor, and Gormley, and could have been extended to include Wilding and Houshiary, it was not applicable to the sculpture of Woodrow and Vilmouth; nor could it serve for much of Cragg's recent work. A different set of ideas and conventions has been brought to bear on this work; the series of wall-drawings that Michael Craig-Martin began in 1978 (see fig. 23) relates to this aesthetic.

Fig. 23. Michael Craig-Martin, *Picturing: Iron, Watch, Pliers, Safety-Pin*, 1978, The British Council, London

Craig-Martin had been included in Anne Seymour's seminal exhibition of 1972, "The New Art," and his work continued to remain close to the paramount conceptual debates of the decade concerning the nature and status of art and of the creative process. In appearance, however, it stood somewhat aside, its distinctiveness perhaps deriving in part from the unusual nature of his formation: born in Dublin, educated in the United States, but maturing as an artist in Britain where he immigrated in 1966. Over the years Craig-Martin has made several works that have the peculiar quality of both capturing the ethos of that moment, and yet being also prophetic. *An Oak Tree* (1973, National Gallery of Australia, Canberra) is one such example. A glass of water on a shelf was exhibited in the bare gallery accompanied only by a leaflet containing a short interview with the artist in which he "explains" to a bewildered interviewer that the object in the room is not in fact a glass of water but an oak tree. Though its principal subject was the creative act conceived as a process of transformation – indeed, likened to the act of transubstantiation – the epigrammatic brevity and visual finesse of this work, so much at odds with the dry and labored character of the bulk of contemporary Conceptual Art, gave it a talismanic quality.

The wall drawings of 1978 are also replete with that aphoristic brevity which is a hallmark of Craig-Martin's work, yet the balance has now shifted, for as the artist stated, "there is much more of a visual dynamic than a conceptual one."[42] The underlying ideas can no longer be extracted in any direct fashion from their formal realization, nor can they be fully articulated verbally but only experienced visually. Whereas previously he had established a contradiction between experience and belief, now experience itself proved contradictory.

Contour drawings of commonplace, often domestic, objects such as a ladder, gun, globe, light bulb, table, and scissors, drawn in a simple outline style of the kind that is found in children's books and in diagrams, were overlaid on top of each other to form a composition of miscellaneous yet contiguous elements. Each image maintained its own perspective but sacrificed its relative size in favor of a uniform scale. From this composite a slide was made which was projected onto the wall of the gallery at a size determined by the available surface, and the outline traced in black tape. As Craig-Martin pointed out: "The final state of the work is temporary, transparent, immaterial, yet the experience is of overwhelming presence. When the exhibition ends, the tape can be pulled off the wall and rolled into a ball. It leaves no trace."[43] The result was a precarious equilibrium between the competing, contradictory claims of illusionism and abstraction, between the depicted object and the inviting abstract spaces, between seeing and naming. The fact that the subject matter was so banal and familiar – anonymous, standardized, mass-produced objects – was crucial in directing attention to the interplay between visual and verbal knowledge, between conceptual and experiential understanding.

In 1978 Craig-Martin also published an article, really a series of maxims, under the title "Taking Things as Pictures," in which the notion of picturing formed the core of a series of statements that, like sword-thrusts, parry many of the issues raised by the reintroduction of a figurative imagery, issues that underlie the work of some of the next generation of figurative sculptors. His text concluded with the following statement:

> Language, signs, and pictures are not just aspects of our experience of the world./They are intimately related to how and what we experience, and what we understand by that experience./They are also crucially dependent on one another. Names, pictures and signs would be impossible without each other.[44]

Craig-Martin's suppression of the associative potential of this imagery in favor of the conceptual content as it related to issues of art/illusion/reality was very much of its time, even if the means by which he explored these issues were singular. It distinguished him from the next generation of British sculptors such as Cragg, Woodrow, and Vilmouth. In forms as well as subject matter, their sculpture on occasion betrays certain affinities with the work of the older artist but they seek a more inclusive and wide-ranging content. The transition to a different type of content, which occurred around 1980, was initially manifest in Cragg's work: it may be gauged by a comparison of *New Stones – Newton's Tones* (pl. 9), *Red Skin* (pl. 10), and *Britain Seen from the North* (pl. 12).

In his first solo show at the Lisson Gallery in 1979, Cragg characteristically exhibited a wide range of works in different media. In most cases, such as the untitled work comprising a long composite photograph of a quarry which had beneath it a stone from that quarry together with a cement cast of the stone, the governing ideas were not particularly original though their explication was often striking on account of their succinct expression, a feature of all Cragg's work. Yet one piece stood out as different, a piece that carried substantial implications for his future: *New Stones – Newton's Tones*. Fragments of discarded plastic objects like detergent bottles and children's toys had been color-sorted after being gathered from the surrounding neighborhood, then laid out on the floor in a rectangular format in accordance with the spectrum, red bits at one end moving through orange and yellow to green then blue and lastly purple. If at first this work seemed little different from Cragg's previous sculptures, given the method of composing and selecting material, in other respects it marked a turning point. The title, like the form, alludes to Long, but now the stones are "new," in that they are composed of an unprecedented, if ordinary, material. Unlike those works that Cragg had made from wood, linoleum, and other matter culled from dumpsters, this "found" material refused to be read simply as "stuff." Its original identity so forcibly asserted itself as to create a heightened tension between the form – those norms of the sculptural language that were drawn upon in its format and structuring – and the subject matter.

For his Whitechapel exhibition of 1981, Cragg developed this tension further in a number of wall-drawings that constructed such images as a flag (pl. 13) and a crown from similarly sorted shards. But now the material was not only at odds with the sculptural conventions, but with the propriety and decorum normally accorded these motifs: a dual irreverence. *Britain Seen from the North*, the key piece in the show, used a myriad of elements to suggest with acerbic

wit the state or values of the nation. If the works in this exhibition were deliberately devised to be considered together as part of an encompassing statement, this was neither wholly negative nor one-dimensional, as has sometimes been suggested. *Everybody's Friday Night* (pl. 14), made from three different-colored wood panels surrounded by jaunty motifs, such as sunglasses, musical notes, or a record which had been cut out from them, sounded a lighthearted note.

Cragg's sculpture could not, however, be confined easily to a single or homogeneous set of concerns, as other works made at this time attest. Later that year, for example, in a survey exhibition "British Sculpture in the Twentieth Century" also held at the Whitechapel Art Gallery, he exhibited *Five Bottles* (1981, Private Collection), a line made from five variously colored discarded plastic containers. The pastoral sentiment that informs Long's lines of stones and twigs has been replaced by a more rebarbative provocative spirit. The attentiveness with which Cragg selected his works for exhibition was particularly evident here. In the context of this show, such a "modest" work made an enormous impact, challenging many of the received notions and comfortable presuppositions that then governed much contemporary British sculpture. By contrast, in a solo exhibition held at the Lisson Gallery the previous year, Cragg had presented another group of plastic bottles but this time each lone bottle on the floor was accompanied by a vast silhouette in shards of the same color on the adjacent wall. On this occasion the issues raised seemed to be primarily aesthetic, having to do with questions of picturing and the relationship between the art work and the model, between illusion and reality; they were set forth with a cool panache that recalled Jasper Johns's Savarin and ale cans as well as his painted flags and numbers.[45] Where in *Red Skin* the silhouetted image had occupied the floor, the conventional locus of sculpture, the wall drawings entered a new and ambiguous terrain, that of picturing.

It was this unwillingness to be tied to a single kind of content as much as the inclusiveness of Cragg's references that was remarkable. Less influential, though nonetheless a key aspect of his work, is his concern with the character of the exhibition, the intellectual and physical context in which the works are received. In 1981, in a catalogue for an exhibition held in Wuppertal, he set forth his governing ideas:

> Simple processes – with materials no one else wants – ideas that interest me – images I like – made where people let me make them – rooms, walls, floors: the physical frame – emotional responses, intellectual responses – elegant works, ugly works, humorous works, beautiful works, decorative works – works in which I learnt from the materials – works like pictures – meanings I intended – meanings which surprise me – personal references, political references, cultural references, no references – as straightforward as I can make it.[46]

It is the breadth of connotation and the diversity in content that separate Cragg's work from that of the previous generation – whether the stone circles of Richard Long or the wall-drawings of Michael Craig-Martin. Yet his recognition of the ways in which the context and attendant discourses shape this content sets him apart from many of his peers, for whom an autonomous poetic content is primary. In these respects he constitutes a bridging figure.

Although mundane objects had been used in the formal vocabulary of many British artists in the 1970s, until the 1980s they had generally shied away from an allusive, metaphorical content. In his early years Richard Wentworth, for example, frequently employed everyday objects in works that explored notions of representation and signification. In *DEE DOUBLE OH AAH* (c. 1975, Collection of the artist), the subject of the sculpture is evoked in two distinct ways: phonetically in the title and physically on the wall through those appurtenances like locks, hinges, and the handle which accompany the central component, the (absent) wooden support. By the end of the decade, his art had reached an impasse, by his own account, and when in the early 1980s new works such as *Toy* (fig. 24) appeared, they marked a telling reorientation in his thinking, as the critic Fenella Crichton noted: "With great precision Wentworth gives things that small but intrinsically poetic shove which enables them to speak to us not only about the language of art, but also about the world in which we live."[47]

The galvanized tub and sardine can that comprise *Toy* are familiar standardized objects but their conjunction effects a mode of visual rhyming and associational punning that is not merely witty, but richly suggestive in its multiple interlocking meanings. The fact that *Toy* was executed during the Falklands War, and soon after the British Navy sank the Argentine warship *Belgrano* (to wildly enthusiastic jingoistic applause at home) provides an additional range of reference that, subsequently, it would be difficult to discern. Yet this is but one set of connotations, no single one of which is essential to its meaning. Etymology fascinates Wentworth. Not surprisingly, it informs his work in various ways, above all in the titling which, for him, plays an important role in any sculpture.[48] In his work the visual and verbal establish a mutually informing but often contradictory relationship; metaphor is the key mode and poetic discourse the outcome.[49]

This notion of putting ordinary things together in such a manner that the results have a striking resonance far beyond what could rationally be presupposed also lies at the heart of Boyd Webb's work. Like Wentworth, Cragg, and Woodrow, he starts with a number of objects and materials that are virtually to hand: a sheet of linoleum, a globe, or a hank of cotton wool. From them he constructs a scenario which he photographs so that the artifice and the metamorphosis that he brings to bear on his subjects become crucial components in the final piece.[50] Where his works of the later 1970s invented bizarre and absurd situations that remain insidiously beguiling, his work of the 1980s has suppressed those truncated narratives in favor of a more impacted, condensed image, one that no longer implies a "before" and "after," but is somehow immutably fixed, "given." In *New Rules* (fig. 25), for example, the firmament seems to buckle in order to hold fast the small but squashed earth, whereas the other two celestial bodies, flattened forms incongruously reminiscent of slices of fruitcake, float languidly in the stratosphere. The title seems to allude – obliquely – to both the image and the props, which include a globe, a bespeckled sheet of some material, and, of course, the in-

Fig. 24. Richard Wentworth, *Toy*, 1983, Arts Council of Great Britain, London

Fig. 25. Boyd Webb, *New Rules*, 1985, Courtesy Anthony d'Offay Gallery, London

famous fruitcake. Webb's works suggest that even if seeing is not believing, it is, however, far more compelling than knowing.

From the beginning of the 1980s, Woodrow too began to explore this area where the familiar and the ordinary transpose by way of new conjunctions and gain new meaning, a poetic content. Following his initial forays with the simple cubic mass of a washing machine, he quickly realized that virtually any found object could act as a host to new offspring. As in *Crow and Carrion* (1981, Arts Council of Great Britain, London), made from two "dead" (broken) umbrellas, the results were often delightfully witty although his purpose was always serious. A rare visual deftness underlies the best of Woodrow's work, whether it consists, like *Crow and Carrion,* in a metaphorical/metonymic ellipsis or, as in *Electric Fire With Yellow Fish* (1981, Private Collection), in the kind of startling combination found here – is the fish cooking or warming itself? – that is capricious and intriguing but never merely adventitious.

From using only references that were inherent in the original material and in the process itself, as found in the embedded vacuum cleaner in *The Long Aspirator* (pl. 109), Woodrow extended his range of allusion by means of the creation of new images and the use of

cryptic conjunctions, first seen with the washing machines of 1981. From there the types of imagery and association rapidly expanded, though always relating to his personal experience even if indirectly, whether via his immediate environment or what he experiences second-hand through the mass media. Comments or, more properly, asides, and allusion rather than critique provoked by contemporary society and its values underpin much of his work. Thus, both the ways in which meaning is constructed, as well as the type of meaning, have changed gradually over the past few years: " . . . as the work developed, things became not *more* Surreal, in the sense of shocking, but a lot of things became poetic in the sense that they weren't such a simple statement as the *Twintub with guitar.*"[51]

This concern with a kind of content that is conveyed by metaphor, by an interchange between visual and verbal allusion, and by modes that are often identified with poetry has not been confined to those sculptors working with representational imagery. At the beginning of the 1980s, process imbued the resulting form with allusions and meaning beyond its literal and formal appearance, as in the work of Wilding, Deacon, and Gormley. Subsequently, however, gradually the potential for meaning to reside in form as such, rather than to

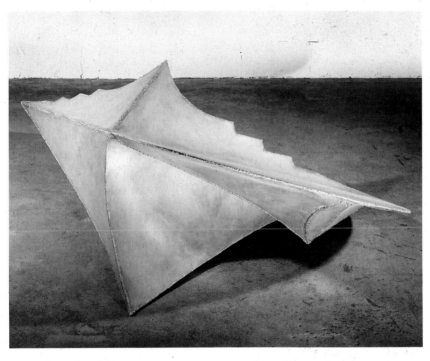

Fig. 26. Shirazeh Houshiary, *Himma*, 1985, Courtesy Lisson Gallery, London

derive principally from the act of making, has gained in importance; object has become synonymous with image. Deacon balances the two, combining connotations derived from process with a visual lexicon in which synaesthesia plays a crucial role. Certain titles like "Falling on Deaf Ears" emphasize this aspect, others such as "On the Face of It," and "This, That and the Other," with their colloquial idioms, root the work in the familiar and the immediate rather than in the arcane and the exotic. For Deacon "poetry isn't made of a particular language, there isn't a poetic language which constitutes poetry. Poetry is made of ordinary language, the same stuff we use when we are talking to each other. What gives meaning to poems is the way in which the words are held together in particular circumstances or particular lines. . . . That surface obviousness with an underlying depth is similarly found in sculpture."[52]

At the other end of the spectrum within this group, Houshiary's work demonstrates a preoccupation with the way in which abstract form can signify, but used to paradoxical ends. In works such as *Himma* (fig. 26), she has attempted to undermine form (not dematerialize it as does Kapoor) by deconstructing its lucid identity and defying its legible objecthood:

A vertical picture (image, idea, concept, thought) is fixed and dominating. A horizontal thought is not fixed, but suspended in the air.

If an object/image is symmetrical about a vertical axis it tends to be fixed. My quest is to unfix the image, to go beyond the materiality of things. The works tend to rest on a point, on an edge, or suspended on arches over the earth, floating.

The works are about fragmenting the whole – there are echoes, but nothing is whole. The danger of an archetype is that it can fix the image to earth. The danger is removed – by fragmentation, broken shapes, openness. Asymmetry "breaks the mind" (in the sense that geometry is "of the mind"). Horizontality makes it harder to arrive at an image – there is never that moment of confrontation given by verticality. . . . The quest is to perceive the dialogue between the hidden and the visible.[53]

Houshiary's subtle statement epitomizes the manner in which many of these younger British sculptors have gained a sophisticated understanding of the formal language of sculpture, but employ it to

ends fundamentally different from those of Caro's generation. It also demonstrates that the differences between those who work with an "abstracted" vocabulary, such as Houshiary and Deacon, and those who make representational imagery, like Cragg and Woodrow, are neither fundamental nor absolute. There is considerable overlapping and parity from the straightforward attitude to process which Woodrow and Houshiary, for example, share, according little significance to the means of making in their own right, to the similarities in approach to material that may be found between Houshiary's metal sculptures and Cragg's plywood pieces. In both cases the choice of material is determined less by its associative or expressive qualities than by considerations of structural convenience.

As the statements by both the artists and selectors in "Objects & Sculpture" attest, initially it proved difficult to formulate this new kind of content, and to develop the most appropriate verbal syntax. Critics, too, were at first hesitant. John Roberts, for example, was fairly typical, in that he hailed the show as a landmark but related the work to a late 1970s mode of process-based activity:

> . . . an excellent overview of the New Object Tendency, advancing as it does a real optimism for the future of object-based work outside of the constructed/welded mainstream. . . . Woodrow is really a process artist, as much interested in drawing attention to the production of the found object itself as in ways of transforming it into something imaginative.[54]

Within a year, however, his interpretation of Woodrow had radically altered as he came to see his work in terms of a social critique:

> His sculpture . . . doesn't try to lead us back to reclaim an essential beauty, — there is nothing picturesque about the work, — but to reclaim something far more basic: economics . . . by linking the found object with the recycled object Woodrow makes a more serious point: the circle of production from factory to studio, a parasitic mode of production, plays on the modern artist's own sense of usage about his function and status. . . . [Woodrow] is actually dealing with the results of a specific historical process. . . . Woodrow is not only excavating a lost technology but surveying a discredited materialism.[55]

Cragg's work too was interpreted along similarly narrow lines, as witnessed by the critic Michael Newman's account of his Whitechapel show:

> Taken together, these [works] could be regarded as a commentary on national pretention and decline, an accurate reflection of the feel of British life at that particular historical moment. The tension between the configuration and the fragment is now translated into the social domain where the configuration represents a dominating mediated image and the fragments the raw immediacy of the street.[56]

The partiality of these approaches reflected in part the degree to which a socially relevant art had been a primary consideration for many critics and certain artists during the later 1970s. And though others like Germano Celant, the influential apologist for Arte Povera,

stressed the collapse of univocal meaning in Cragg's art and underlined its imaginative poetic vein,[57] these aspects were increasingly ignored — so much so that by 1983 that frame of reference epitomized in the writings of Newman and Roberts — albeit in less dogmatic and extreme terms — had become the standard form of interpretation, as seen in the following statement from the catalogue to "Transformations," a group exhibition of six of these sculptors for the São Paulo Bienal in 1983:

> . . . Cragg and Woodrow brought the detritus of conspicuous consumption into the gallery, rearranging, re-classifying and transforming it into emblems of the post-industrial age, in which information comes to us not through direct experience, but through the electronic media of the video and TV screen.[58]

A combination of factors might be adduced for the ubiquity of this form of interpretation, and for the preeminence initially accorded those artists working with figurative imagery, notably Cragg, Woodrow, and Vilmouth. Not least was the fact that in the late 1970s, the widespread preoccupation with an art that was socially relevant had been interpreted, in Britain particularly, in terms of an art that was socially committed and critical. The work of both Cragg and Woodrow was appropriated to fit these needs. Negative factors also contributed, with local conditions again playing an important role. In Britain, especially, a formalist aesthetic had become so deeply entrenched, even in its debased academic guise, that an object-based abstraction of almost any kind was widely regarded with suspicion. Thus at first it proved difficult for many to discern the broader, often metaphysical, content embodied in the abstract morphology of Deacon, Wilding, and Houshiary.

By mid-decade the situation had gradually changed, partly in response to the larger body of work now available by each of the artists, and partly in response to the shifting contexts and discourses that shaped its reception. This change in climate has not been a purely local affair, as witnessed by the reinterpretations currently being made of Minimalism, for example. The exclusively literalist, materialist readings of the 1960s are giving way in the face of recent linguistic theory which largely undermines phenomenological positions by arguing that language is inherently metaphorical. Above all, the much-vaunted demise of Modernism has opened the floodgates to more inclusive and eclectic critical approaches.

What distinguishes these British sculptors as a group from their predecessors of the 1970s is their preference for metaphor over symbol, and for poetic ellipsis rather than literary and discursive content, together with their methods of entwining visual and verbal allusions into a densely impacted image. Yet the results are not uniform. On the one hand there are those like Woodrow and Cragg for whom meaning may be suggested but not determined, for they regard the context as inevitably inflecting and conditioning the final reading. By likening his works to "an open narrative that can be read in many directions," Woodrow indicated the sense in which the term "poetic" is employed in many of these cases: it is a colloquial sense. By contrast, others like Deacon and Wilding seek to fix references more precisely, often through a taut interplay between image, material, and title. The result is something less close to our familiar vernacular

usage of the term "poetic" than to the Renaissance concept of the *impresa*, a knot of words and images in whose complex structure a wealth of meaning and allusion could be hidden or discovered, expressed in the guise of a unique *concetto*, a single act of thought.[59] Distinctions between abstraction and figuration have little place here, for all are involved with the construction of image as well as object.[60]

The works shown by this group of sculptors around 1981 emerged as new avenues of approach rather than as a fundamental change in direction. In each case their roots lay in the period around 1978; the underlying ideas, as much as the languages in which they were realized, had germinated and matured over several years, often longer. The continuing absence of close counterparts abroad, the almost intimate connections and healthy rivalry that result from a situation in which artists inhabit the same milieu and frequently find themselves showing together, whether in Britain or abroad, has contributed to the cross-fertilization of ideas, and even, at times, to passing affinities in form and imagery. The past half-decade has witnessed a deepening and strengthening of their individual voices and a growing self-assurance which permits exchanges to occur and so keeps at bay those qualities of eccentricity and idiosyncrasy that have beguiled too many British artists to their detriment.

While this latest group has secured a solid place in the international art scene, they remain, by default not design, a national grouping. Unlike their immediate forebears, such as Long and Flanagan, they were not part of a wider phenomenon from their earliest years.[61] Rather, as with many recent painters from Germany, Italy, and the United States, they have addressed themselves to and grown out of a set of debates which were not particular to a specific context but to a certain moment in time. Thus they have not developed in isolation. The works of Beuys, of several Minimalist, Arte Povera, and Postminimalist artists have been as crucial in forging their aesthetics as has any local product. But although they *inherited* a set of debates that by the 1970s was truly international, they *matured* in a situation marked by certain local pressures. It is out of this dialectic that each has forged an individual vision.

Notes:

1.
Richard Wentworth, in *The Sculpture Show* (London: Arts Council of Great Britain, Hayward Gallery and Serpentine Gallery, 1983): 143.

2.
The other three artists were Edward Allington, Margaret Organ, and Peter Randall-Page; Cragg was not included because he had shown at the Arnolfini Gallery the previous year.

3.
Several "generations" have appeared following the international acclaim that Moore and Hepworth received in the late 1940s. In the 1950s the "Geometry of Fear" sculptors, in the 1960s Caro and the New Generation, and in the 1970s those grouped by Anne Seymour in the exhibition at the Hayward Gallery entitled "The New Art" (including Michael Craig-Martin, Barry Flanagan, Gilbert & George, and Richard Long, among others).

4.
These seven were, for example, grouped together as the youngest generation in an exhibition of British sculpture, "Entre el Objeto y la Imagen: Escultura británica contemporánea," Palacio de Velázquez, Madrid (organized by the Ministerio de Cultura and The British Council), Jan. 28-Apr. 20, 1986.

5.
Quoted in Anthony Reynolds, "Zeitgeist," *Artmonthly* 62 (Dec. 1982-Jan. 1983): 11 (final italics are mine).

6.
See Lynne Cooke, "Paragone Redefined: Painter-sculptors in the twentieth century," in *In Tandem: The Painter-Sculptor in the Twentieth Century* (London: Whitechapel Art Gallery, 1986).

7.
Quoted in *Objects & Sculpture* (London: Institute of Contemporary Arts, and Bristol: Arnolfini Gallery, 1981): 5.

8.
Ibid.: 20.

9.
Ibid.: 17.

10.
Ibid.: 37.

11.
In "Avantgarde Attitudes," the Power Lecture delivered at the University of Sydney in 1969, Greenberg had argued that "rightness of form" was the final determinant and that the "quality of art depends on inspired felt relations or propositions as on nothing else. The superior work of art exhibits in other words, rightness of form." See Hilary Gresty, "Introduction" to *1965 to 1972 — when attitudes became form* (Cambridge: Kettle's Yard Gallery, 1984): 8.

12.
See Robert Pincus-Witten, *Post-Minimalism* (New York: Out of London Press, 1977).

13.
The art historian Albert Elsen subsequently argued that Tucker was in danger of becoming "the Charles Blanc or Adolf Hildebrand of his era, spokesman for an academic abstract art" (Albert Elsen, "A Review of William Tucker's Early Modern Sculpture: Rodin, Degas, Matisse, Brancusi, Picasso, Gonzalez," *Art Journal* 35, 2 [Winter 1975-76]: 138).

14.
Quoted in *Entre el Objeto* (note 4): 233.

15.
The best discussion and defense is that written by Richard Morphet, "Carl Andre's Bricks," *The Burlington Magazine* 118, 884 (Nov. 1976): 762-67.

16.
"A Silver Jubilee Exhibition of Contemporary British Sculpture," Greater London Council, Battersea Park, London, 1977, included almost 50 sculptors, among whom Nicholas Pope and Tony Cragg were the youngest. Catalogue essays were written by William Packer, Bryan Robertson, and Barry Martin.

17.
Ben Jones, "A New Wave in Sculpture: a survey of recent work by ten young sculptors," *Artscribe* 8 (Sept. 1977): 14-17.

18.
Long's statements continue to express this kind of Georgian attitude, as seen in *Five, six, pick up sticks . . .* (1980) whose title is derived from a children's nursery rhyme: "I use the world as I find it/Mountains and galleries are both/ in their own ways extreme, neutral,/uncluttered; good places to work." See also, for example, the essay by Gabrielle Jepson in *Richard Long* (Cambridge, Massachusetts: Fogg Art Museum, Harvard University, 1980).

19.
David Nash, "David Nash," *Aspects* 10 (Spring 1980): unpag.
20.
A number of other factors helped consolidate this trend, including the institution of residencies for sculptors to work *in situ* in forests, of which the best known is Grizedale, begun in 1977, and the development of parks outside cities as semipermanent sites for sculpture. For a full discussion, see Peter Davies and Tony Knipe, eds., *A Sense of Place: Sculpture in Landscape* (Sunderland, England: Sunderland Arts Centre, 1984).
21.
Andrew Causey, "Space and Time in British Land Art," *Studio International* 193, 986 (Mar.-Apr. 1977): 126.
22.
Dave King, "Recent Developments in Wood Sculpture," *Aspects* 14 (Spring 1981): unpag.
23.
"Carl Andre on his sculpture," *Art Monthly* 16 (May 1978): 5-11, and 17 (June 1978): 5-11.
24.
Compare, for example, Andre's comment: "But if my work had any significance, I was introducing into Modernism concerns which had escaped it, like industrial materials" (quoted in "Carl Andre on his sculpture II," *Art Monthly* 17 [June 1978]: 8) with Caro's assertion that in his welded steel sculpture: "There isn't any reference to industrial use" (quoted in John Glaves-Smith, "The Man of Bronze and his descendents," *Art Monthly* 22 (Dec. 1978-Jan. 1979): 14.
25.
Quoted in *Entre el Objeto* (note 4): 233.
26.
Hesse's work was shown at the Mayor Gallery in London in 1974 and a retrospective was held at the Whitechapel in 1979, but numerous articles and Lucy Lippard's monograph published in 1976 ensured that her work, aesthetic, and persona were widely known. Margaret Organ's work in "Objects & Sculpture" (see note 7), for example, seems to owe much to Hesse.
27.
Richard Deacon, *Stuff Box Object 1971/2* (Cardiff: Chapter Art Centre, 1984).
28.
Tony Cragg, unpublished interview for video accompanying "Entre el Objeto" (note 4).
29.
This notion of stuff as a neutral and not identifiable material partly stems from Caro, who had regarded his material in this light from the early 1960s. In the early 1970s Tucker made several works from scrap timber, perceived as neutral matter – the "Shuttlers" – which Richard Deacon admires.
30.
Dutch elm disease, which destroyed a great many trees, contributed to making timber in large quantities relatively inexpensive. A number of sculptors, including older figures such as Phillip King, began using it in this form.
31.
Nash claims that Tucker selected him because: "He wanted some 'eccentric' pieces in the show to try and balance the bias of his own conditions' of sculpture. My piece looked like a scarecrow off an allotment in that company" (*Sixty Seasons: David Nash* [Glasgow: Third Eye Centre, 1983]: 42).
32.
Nicholas Pope, "Nicholas Pope," *Aspects* 11 (Summer 1980): unpag.
33.
King (note 22); indicated the kind of associations it conveyed at this time: " . . . it provides a workable, sympathetic and reasonably durable medium for sculpture. It's a natural material, ecologically sound and generally involving the simplest and most direct processes and activities in working it" (unpag.). Peter Randall-Page, who exhibited in "Objects & Sculpture" but has closer affinities with Pope, not least on account of their return to "first principles" in carving and their admiration for Brancusi, argued that stone "can confront us with a sense of our existence in a way that something which is second hand or man-made cannot" (quoted in *Objects & Sculpture* [note 7]: 29).
34.
See, for example, Causey (note 21): 122.
35.
See John Beardsley, *Earthworks and Beyond* (New York: Abbeville Press, 1984): 50.
36.
This critical approach finds a number of parallels in the work of certain historians investigating landscape, the genre and its traditions, such as Raymond Williams, *The Country and the City* (New York: Oxford University Press, 1973); and John Barrell, *The Dark Side of Landscape* (New York: Cambridge University Press, 1980). Barrell discusses, in passing, the enormous appeal in 1977 to save Stubbs's paintings *The Haymakers* and *The Reapers* for the nation, and the variety of interpretations from all sides of the political spectrum that were advanced in the cause of securing these works for the Tate Gallery collection. Although it is a coincidence, the contrast between this situation, with virtually unanimous support for the works in question, and that surrounding the "bricks affair" of some months previously, well characterizes the British art world in the later 1970s.
37.
The B.P. Lecture, Southampton Art Gallery, 1985, quoted in *Entre el Objeto* (note 4): 233.
38.
Ibid.: 236.
39.
For a more extended discussion, see Lynne Cooke, "Alison Wilding: Bearings and Alloys," in *Alison Wilding* (London: Serpentine Gallery, 1985).
40.
For a fuller discussion of Kapoor's early work, see Lynne Cooke, "Mnemic Migrations," in *Anish Kapoor* (Kunstnernes Hus Oslo, 1986).
41.
See note 7.
42.
Michael Craig-Martin, unpublished interview for video accompanying "Entre el Objeto" (note 4).
43.
Michael Craig-Martin (Zagreb, Yugoslavia: Studio Gallery, 1981): unpag.
44.
Michael Craig-Martin, "Taking Things as Pictures," *Artscribe* 14 (Oct. 1978): 14-15.
45.
Johns had been the subject of a major retrospective which opened at the Whitney Museum of American Art, New York, in October 1977; it toured Europe, on view in Cologne in February-March 1978 and at the Hayward Gallery, London, in June and July.
46.
Quoted in Norbert Lynton, "Introduction" to *Tony Cragg*, Fifth Triennale India, The British Council, 1982: 2.
47.
Fenella Crichton, "When Form Engenders Attitude," in *The Sculpture Show* (note 1): 57.
48.
Speculating on the title/object, Wentworth wrote: "Toying with an idea/political puppet/'forces' used in political games/Games which become serious. Games in which rules are broken/*playing* one's hand/'Theatre' of

operations" (see Richard Francis, "Richard Wentworth's Etymology," in *The British Show* [London: The British Council, 1985]: 116).

49.
For a fuller discussion of Wentworth's work, see Lynne Cooke, "Making Good," in *Richard Wentworth* (London: Lisson Gallery, 1984).

50.
Although he uses photography as his medium, Webb's work is far closer to that of Woodrow and Wentworth than it is to most of the photographically based work of the 1970s in Britain where the medium was used to investigate and comment on itself.

51.
Lynne Cooke, "Interview with Bill Woodrow," *Artics* 2 (Dec.-Jan.-Feb. 1986): 44.

52.
Richard Deacon, unpublished interview for video accompanying "Entre el Objeto" (note 4).

53.
Quoted in *Entre el Objeto* (note 4): 235.

54.
John Roberts, "Objects and Sculpture," *Artscribe* 30 (Aug. 1981): 50-51.

55.
John Roberts, "Car Doors and Indians," *ZG* 6 (Apr. 1982): unpag.

56.
Michael Newman, "Tony Cragg," in *The British Show* (note 48): 38.

57.
Germano Celant, "Tony Cragg and Industrial Platonism," *Artforum* 20, 3 (Nov. 1981): 45.

58.
Nicholas Serota, "Introduction" to *Transformations: New Sculpture From Britain* (London: The British Council [for the XVII Bienal de São Paulo], 1983): 8.

59.
See Robert Klein, "The Theory of Figurative Expression in Italian Treatises on the *Impresa*," in *Form and Meaning, Writings on the Renaissance and Modern Art* (New York: Viking Press, 1979): 3-24.

60.
To misquote slightly Francis Ponge: "Things are *already as close to images* as they are to things, and reciprocally, images are *already as close to things* as they are to images" (*La Fabrique du pré* [Geneva: Skira, 1971]: 23).

61.
Several attempts have been made to identify international connections in thematic shows of the ilk of "Space Invaders" (Mackenzie Art Gallery, University of Regina, Canada, 1985), which combined a few British sculptors in a mixed anthology whose theme was "the fusion of popular and high culture in art objects." But this is such a broad and ubiquitous notion that dozens of shows could be constructed around it. Subgroups have also been made from this wave of British sculptors, as seen in "The Poetic Object" (The Douglas Hyde Gallery, Trinity College, Dublin, 1985), which linked Deacon, Houshiary, and Kapoor.

By Mary Jane Jacob

Tony Cragg:
"First Order Experiences"

Objects are used as materials, materials form an image, images are made up of many images: Tony Cragg's art deals with the stuff that populates our world to an ever increasing extent.[1] Cragg focuses physically and conceptually on the things in our environment. He employs the scraps and residue of our culture, having first used raw materials (wood, metals, papers), then manufactured items (particularly those made of plastic — the quintessential material of our age), and now both (from hardboard and masonite to discarded objects). Working with familiar things from our own environment, he seeks to make us perceive them in a new way, pointing out the differences between the informational and perceptual levels on which we function. In doing so, Cragg also seeks to close this gap and to provide insight and understanding of our world. Working from his own experiences, Cragg has said that his "initial interest in making images and objects was, and still remains, the creation of objects that don't exist in the natural or in the functional world, which can reflect and transmit information and feelings about the world and . . . [his] own existence."[2]

In his personal philosophy and view of the world, Cragg maintains a strong scientific orientation. His father, a pilot and engineer, designed aircraft parts and Cragg himself was trained as a scientist and worked from 1968 to 1969 as a research associate in a biochemistry laboratory, carrying out experiments on natural rubber. Drawing and manipulating the objects in his lab, Cragg soon turned to making art, which he saw as an expansion of his interest in science: to Cragg, both science and art deal with ideas, the former taking an abstract form, the latter a tangible one.

Primary among the uses of scientific principles that Cragg applied to art is his method of composing whole images out of discrete elements, his art becoming a product of accretion and a study of the relationship of the part to the whole. This idea has its roots in the particle nature of matter, a theory which Cragg felt he could better express by artistic rather than scientific means. "What science lacks are perceivable images. Atoms, maths, programmes and other scientific elements . . . they are completely abstract, devoid of sensuality and eroticism. . . . I am looking for associations, images and symbols which could enrich and enlarge my vocabulary of responses to the

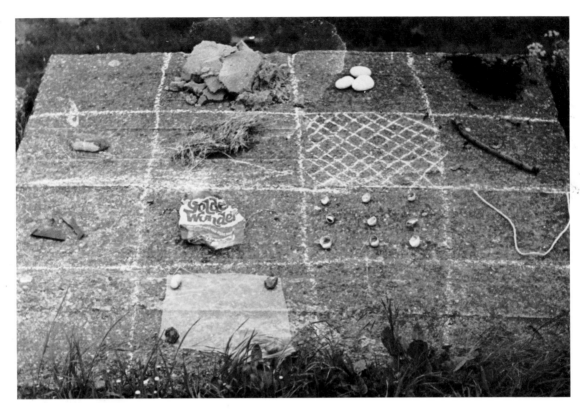

Pl. 1. Tony Cragg, *Combination of Found Beach Objects*, 1970, no longer extant

world I see and even function as thinking models."[3] In Cragg's search for meaningful visible images, he appropriated elements from nature and the man-made world. Using these like atoms, like parts from which to form a whole, he has created a visual vocabulary that, like the language of science, can be used to create models for thought from which we can learn to view the world differently.

Leaving his position in the laboratory, in 1969 Cragg entered the Gloucestershire College of Art and Design; he studied there for one year before transferring to the Wimbledon School of Art in London which he attended until 1973. His early efforts as a student show the influence of the time-based art of the period, namely performance and temporary installations. Like the leading forces of the St. Martin's School (Barry Flanagan, Gilbert & George, Richard Long, Bruce McLean) who had graduated in the years immediately preceding, Cragg soon joined the ranks of those artists who found a new and independent direction in rejecting the welding techniques of Anthony Caro, as well as the carving and modeling tradition of Henry Moore.

In the summer of 1970, at the invitation of his Wimbledon tutor, Roger Ackling, Cragg went to stay at the Ackling family's resort hotel on the Isle of Wight off the southern coast of England. This was

not an idyllic, remote landscape, but one touched by man, as evidenced by the discarded items left by visitors. Time to work and the natural and manufactured resources found along the shore afforded Cragg the opportunity to execute quickly a number of experimental pieces that proved to be crucial to the development of his ideas and working method. The most important of these was a temporary site-specific installation entitled *Combination of Found Beach Objects* (pl. 1). Cragg's choice of materials demonstrated the direction that would become his hallmark: not only natural materials, such as stones and shells, interested him, but also those of man — string, cellophane bags, and other litter. As in his laboratory experiments, he collected these items, classified and ordered them, and placed examples of the types in each of the 16 boxes he drew onto several large, flat concrete blocks on the beach; the arrangements presented various permutations of these generic types. This procedure of finding, sorting, and organizing into an objective and structured form would become his signature modus operandi.

Recognizing the promise of his student, in September 1970 Ackling introduced Cragg to Richard Long, whose work immediately became a point of reference for Cragg. The following summer, returning to the Isle of Wight, Cragg again used the beach, this time to

create temporary earthworks in which he arranged stones into rows on rocks, or formed arrows on the sand pointing out to sea, or made numerals in computer-style typeface out of seaweed on the beach. In these cases the materials were natural, but the images were of man-made forms.

During the next three years at Wimbledon, he experimented with works documented only in photographs without any intention of preserving the physical objects. For Cragg, art has always been a proposition, like a scientific premise, to be tested and in these years he formulated numerous propositions, but did not give them a final form. He cut paper into irregular shapes and fitted them together like a puzzle into rectangles whose shape extended over several elements in space (pl. 2); or fitted together wood blocks to form the outline of a rectangle supported by a shelf or stool (1972); piled up bricks to the point of near collapse (1973); arranged stones into circles (pl. 3) or curves on top of his body (1972-73); and undertook other performancelike pieces such as holding up seven cartons in a horizontal line against a post (1972), or drawing the outline of his body successively in two alternating gestures (1973).[4]

Cragg's work changed while he was at the Royal College of Art from 1973 to 1977. Abandoning a way of making art that was formally tied to mainstream Conceptual and Minimal Art (which he felt by this time had become no more than an art game), Cragg sought to reinfuse the intellectual experience of art with emotional content through his choice of objects, materials, and images. From 1973 to 1976 he experimented with various new materials, many of which were industrial cast-offs that he collected. Stacked, piled, cut into parts, and laid out to approximate their original shape or placed in simple rows, these compositions were quickly executed propositions (see pl. 4). They achieved a sense of finality only when in 1975 a large number of these works were brought together in the form of the Minimalist icon – the cube – to make Cragg's first *Stack* (see pl. 7), a work whose substance and feeling, despite its geometry, was alien to Minimalism.

Other works of 1975 demonstrate the beginning of Cragg's union of graphic images and objects as he stacked pieces of cardboard against the wall and drew a mountainous landscape across them; or drew loose lines, totally covering the surface of wood constructions to unite the parts and create a gestalt. He also placed wood boards at random on the floor and drew lines to indicate the shapes hidden by their overlapping (pl. 5), increasing the amount of available information and enabling the viewer to see what is not visible.

In 1975 Cragg also began a series called "Hybrids" in which he introduced manufactured goods, cutting them into sections and combining them with pieces of raw materials. Some of these "sandwiches," as they were called, were shown in the outdoor sculpture exhibition at Battersea Park, London, in 1977. His use of fragments to create a homogeneous, monolithic structure was compared to the processes of Richard Long.[5] Like Long, Cragg began to arrange broken fragments of the same material which, together with the interstices, formed a rectangle (see pl. 6). Other works consisted of minute fragments – crushed rubble – ground to an even consistency and spread out according to color in a generally circular shape (1976). He also erased portions of a graphite-covered paper to indicate vari-

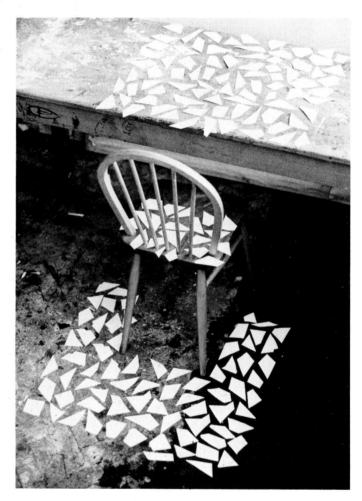

Pl. 2. Tony Cragg, *Untitled*, 1972, no longer extant

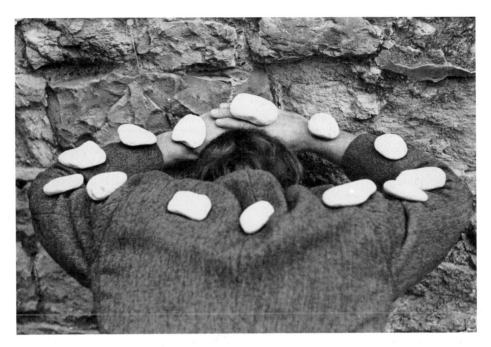

Pl. 3. Tony Cragg, *Untitled*, 1972, no longer extant

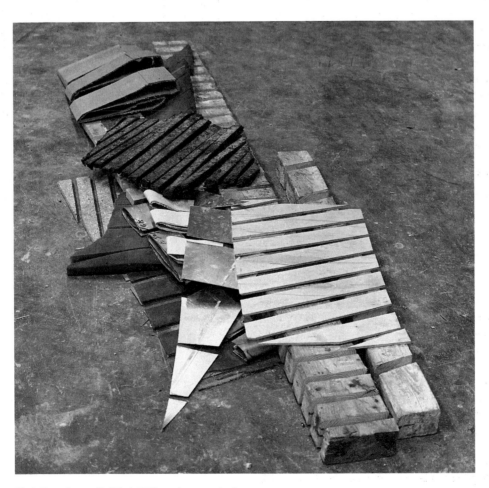

Pl. 4. Tony Cragg, *Untitled*, 1975, no longer extant

ous shapes associated with a found object; the shapes became fragments that comprise a drawing whose overall outline is that of the found object; the object is shown with the drawing in the final work.

In *Four Plates* of 1976 (pl. 8), Cragg applied this technique to an actual, recognizable object which served both as prototype and material for the final work of art. Using four identical plates, Cragg broke three, spreading farther apart the fragments of each successive plate. While challenging the identity of these arranged fragments as plates, they are still perceived as plates because the model (the unbroken plate) is supplied and because in each group of fragments the circular outline is retained despite the expanding diameter.

The epistemological construct of reference object and fragments arranged within a related shape, begun with *Four Plates*, continued to operate in Cragg's work for the next two years. It appeared most significantly in 1978 with *New Stones – Newton's Tones* (pl. 9), which for Cragg was a breakthrough, furthering this use of object. In distinction from his earlier works largely assembled from scraps of wood and other construction materials and, like the use of a dinner plate, here Cragg used broken bits of everyday utilitarian items, predominantly those made of plastic. With this work Cragg found a means to endow banal objects with expressive power. Having graduated and moved to Wuppertal, West Germany, by this time Cragg had begun to collect refuse material that washed up along the river of this industrial city. Out of necessity and convenience (and not motivated by an ecological ideology of recycling), he continues to collect materials in this manner and does so locally when making an on-site piece. These items, removed from and, in most cases, incapable of performing their original functions, were used for their intrinsic formal properties of color, shape, and volume. Yet, as Cragg has observed, they also serve a role because of the associations they carry with them: "A precondition for working with man-made materials is that they are equally worthy of carrying significant meanings as natural materials . . . and as such belong to a huge category of materials/objects which are integral to the physical, intellectual and emotional lives of men."[6]

To Cragg, the modern landscape is a man-made one; everything is by man, and we are constantly confronted with plastic and other artificial imitations of nature. The landscape of today is not a natural one but a built and planted one; planned, it can be constantly changed and renewed. In *New Stones – Newton's Tones*, Cragg replaced the romantic and rustic view of nature expressed by Richard Long with a more investigative and urban one; he abandoned the natural landscape as celebrated in 19th-century art in favor of the man-made landscape of the 20th century. Yet, by formally confining a multiplicity of elements within a strictly defined form on the floor, Cragg created a rectangular shape comparable to that of Long's lines.[7] However, as indicated by the title, "New Stones," Cragg replaced Long's rocks or twigs with industrially produced objects. Because the objects are plastic, their color is not dictated by nature, but by marketing. Cragg arranged these varied, synthetic hues according to the spectrum of "Newton's Tones."[8]

Using objects of the world, Cragg seeks to build a "poetic mythology" for man-made things. Using objects that are part of our life, he seeks to provide insight into our life. These things are physically and metaphysically tied to us, yet we are increasingly less aware of the role they play. Separated from the methods of production, we are not aware of how they come about; manipulated by the market, their very nature is always changing; relayed through media there is "always a choice of second-hand images."[9] Cragg believes that: "Reality can hardly keep up with its marketing image. The need to know both objectively and subjectively more about the subtle fragile relationships between us, objects, images and essential natural processes and condition is becoming critical. It is very important to have first order experiences – seeing, touching, smelling, hearing – with objects/images and to let that experience register."[10] Being directly presented with actual objects in a new context, scale, or color affords us the opportunity to reconsider the physical world and expand our knowledge of it, while addressing its metaphysical import on our lives.

Two major works made the year following *New Stones – Newton's Tones* were *Red Skin* (pl. 10) and *Aeroplane* (Galerie Bernd Klüser, Munich), both of which, like *Four Plates* or Cragg's earlier drawing works, are comprised of a reference object from which a group of fragments take their form. A system of relations is set up between parts to whole: the object-clue (the red Indian or airplane) on the wall to the pattern on the floor, the objects on the floor to the image they make up, and the reference object and floor images to the title. *Yellow Fragment* (1980, Collection of Dr. Franklin, London) was Cragg's first such wall work. As the floor had served as a base for an essentially sculptural art, now the work took on a more two-dimensional quality as the wall played the role of the ground in a painting. On the wall the image created – here, a yellow moon – became more emblematic. Cragg continues to use the moon shape over and over in his work; it is an appropriate image for him. First of all, it can be used to indicate how scale changes perception: in *Yellow Fragment*, for example, the element on which the larger composite image is based is a curved part of an unidentified object; its crescent shape when enlarged suggested the moon. Secondly, the moon, while a distant body in space, has been the subject of much commercialism; by using plastic production items from which to construct the moon, Cragg emphasized its commodity status.

With *Five Objects – Five Colors* (pl. 11), executed in a corridor in Ghent, the use of a prototype was now virtually gone from Cragg's work. Cragg applied the form of a frying pan, bottle, sock, piece of paper, and another bottle to groupings of discarded objects colored orange, yellow, red, blue, and green, respectively. The year 1980 also saw the introduction of the artist's own image into works made of plastic fragments. Initiated by a representation of Cragg reaching from atop a chair, self-portraits (in the form of generalized silhouettes) have continued to be incorporated into his work.

A major one-person exhibition at the Whitechapel Art Gallery in 1981 allowed Cragg to show for the first time in London new works made in the innovative style which he had been developing since his first one-person exhibition at Lisson Gallery in 1979 in which *New Stones* appeared. Six works were created for the Whitechapel, all constructed of materials gathered in London's East End. More overtly than ever before, they were commentaries on Cragg's views of the political, social, and economic situations in England, perhaps given impetus by his being acutely aware of the worsening conditions in his homeland when he returned from Germany to do this show. The

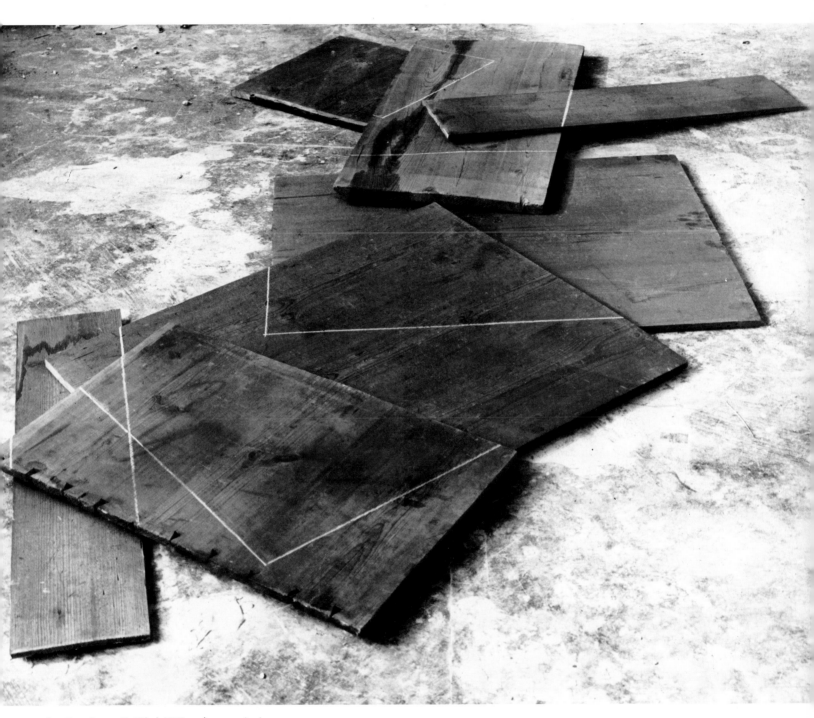

Pl. 5. Tony Cragg, *Untitled*, 1975, no longer extant

highlight of the show was *Britain Seen from the North* (pl. 12), whose form – rotated 90 degrees – shows the south looming large and distant. It is Cragg's visualization of how a nation views itself. It can also be interpreted as a commentary on the way northerners (particularly the Welsh and Scottish) view the authoritarian control of the government whose seat is in southern England. The other works made use of plastic fragments assembled into biting, satirical images: *White Crown* (1981, Collection of Lia Rumma, Naples), an emblematic and ironic image of royalty made of junk; *Postcard Union Jack, London* (pl. 13), the flag in its characteristic red, white, and blue; *Soldier* (1981, Collection of Lia Rumma, Naples), an aggressive figure in riot gear, on a massive scale; and *Polaris* (1981, Lisson Gallery, London), a submarine made of wood, a substance that, paradoxically, floats. These are all references to the nationalism, street violence, and militarism of England.[11] Unique in this group is *Everybody's Friday Night* (pl. 14). Made from wood sheets by cutting out images of televisions, music, and sunglasses and other accessories, it is a reflection on working-class pleasures. With this influential exhibition, Cragg took his place as a leader of a new generation of sculptors and as a pivotal figure in the creation of a new school of British sculpture, a new sensibility, characterized by the use of man-made materials and a restoration of content to sculpture.

For an installation commissioned by Le Nouveau Musée later in 1981, Cragg limited his working parameters to items found in the factory in Villeurbanne given over to his exhibition. Cut-out forms (like in *Everybody's Friday Night*) were again used to create *Factory Fantasies* (1981, Fonds Régional d'Art Contemporain, Rhône-Alpes, Lyons, France), a wooden locker cut to the breaking point to extract objects evoking eroticism in the workplace. However, new approaches were also devised in order to deal with the materials found, many of which were whole, retaining their complete identity, and, being mainly wood, were not brightly colored. Cragg arranged these items into the shapes of an axehead, horn, and canoe. For another work strips of wood were assembled and partially painted over, leaving visible in the unaltered portions of the wood the form of a tree, creating an illusion between figure and ground.[12]

Cragg's work since 1982 has expanded in other directions while still including earlier formal devices, mainly the fragmented image (see pls. 15, 18). These "new" types have their roots in Cragg's experimental work of the 1970s. In his use of larger, whole objects arranged in specific forms (see pl. 16), a major direction for Cragg is the creation of more three-dimensional, free-standing sculptures. These are often also physically linked, instead of demanding that the viewer make conceptual leaps across interstices to apprehend the entire image (see pl. 17). Cragg creates an even stronger bond between these elements by unifying the surface through an overall pattern of drawing (first employed on small stacks of wood in the mid-1970s); coating all objects with ground plastic (a mixture not unlike the crushed rubble he used in 1976, see pl. 19); completely wrapping all elements with plastic-coated wire (perhaps relating to Cragg's 1972 experiments with dropping bits of string to create a kind of netting to bring these forms together); or linking discrete parts together with an intertwining plastic pipe. In a recent new image – that of the landscape and simple gabled houses (see pl. 20) –

Cragg uses certain construction goods metaphorically, for example, fake wood veneers, to represent a man-made landscape.

Cragg's view of art as a proposition, not an answer, is seen in his continued sense of exploration and his ability to work in many ways simultaneously. His use of things from the real world is a catalyst to new ways of thinking. Reference to an urban landscape or man-made environment is inherent in each, and leads to reflection on man's impact on nature. Cragg picks up the remnants of our culture which are usually packaged and relayed to us via the media, and re-presents them, allowing us to reconsider them as "first order experiences" so that we may better understand our relationship to the objects, images, and materials of our world.

Notes

1.
Unless otherwise stated, this material is based on the author's interview with the artist in Wuppertal, Nov. 1985.
2.
Tony Cragg, "Pre-conditions," in *Tony Cragg* (Hanover: Kestner-Gesellschaft, 1985): 39.
3.
Tony Cragg and Demosthène Davvetas, "Tony Cragg: Interview with Demosthène Davvetas," in *Tony Cragg* (Brussels: Société des Expositions du Palais des Beaux-Arts de Bruxelles, 1985): 31.
4.
A videotape, no longer extant, was also made of this action.
5.
Ben Jones, "A New Wave in Sculpture: A survey of recent work by ten younger sculptors," *Artscribe* 8 (Sept. 1977): 16.
6.
Cragg and Davvetas (note 3): 39-40.
7.
In this regard Michael Newman points out that Richard Long's *Driftwood Line*, also made of materials found washed up on shore, was shown one year before at the Whitechapel Art Gallery (Michael Newman, "New Sculpture in Britain," *Art in America* 70, 8 [Sept. 1982]: 102).
8.
This is the first of a series of spectrum pieces which also included *New Stones* (pl. 15); *Spectrum* (1983, Lisson Gallery, London); and *Spectrum* (1984, Galerie Bernd Klüser, Munich).
9.
Tony Cragg, [Statement], in *Documenta 7* (Kassel, West Germany, 1982): 340.
10.
Ibid.
11.
Although specific social criticisms are not frequently found in Cragg's work, they did serve as the motivation for two works of 1982: *Mercedes* (Collection of the artist) and *M* (Collection of Bernd Klüser, Munich), whose forms are the logos of the Mercedes Benz Company and McDonald's respectively, and both of which are made of bottles and bricks which, for Cragg, are the "weapons of the proletariat."
12.
Cragg has employed the latter technique extensively to date. The reference to the form of a recognizable object revealed through drawing and painting across multiple boards finds a relation to the work of Michael Craig-Martin (see fig. 23).

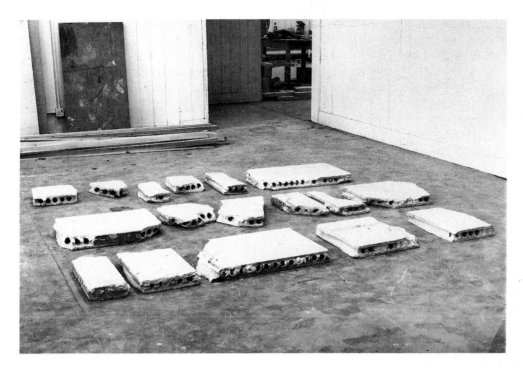

Pl. 6. Tony Cragg, *Untitled*, 1975, no longer extant

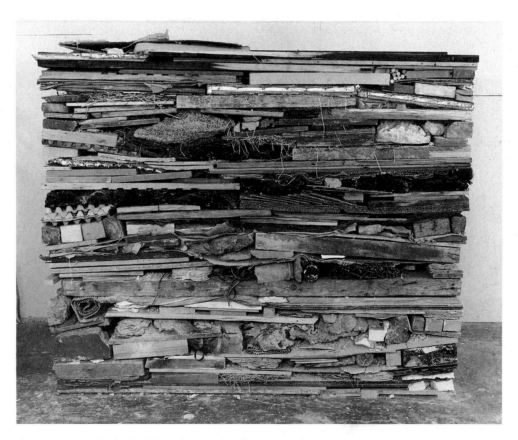

Pl. 7. Tony Cragg, *Stack*, 1975/76, no longer extant (see cat. no. 1)

Pl. 8. Tony Cragg, *Four Plates*, 1976, Private Collection, Belgium

Pl. 9. Tony Cragg, *New Stones – Newton's Tones*, 1978, Arts Council of Great Britain, London

Pl. 10. Tony Cragg, *Red Skin*, 1979, Stedelijk Van Abbemuseum, Eindhoven

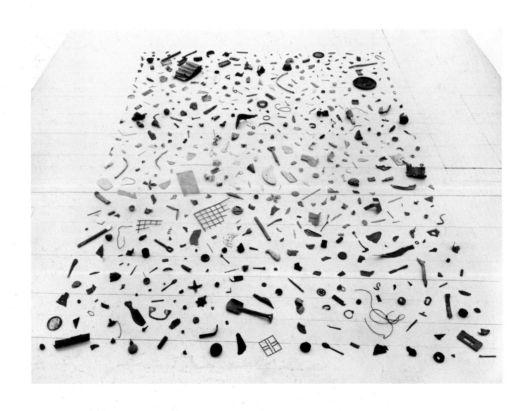

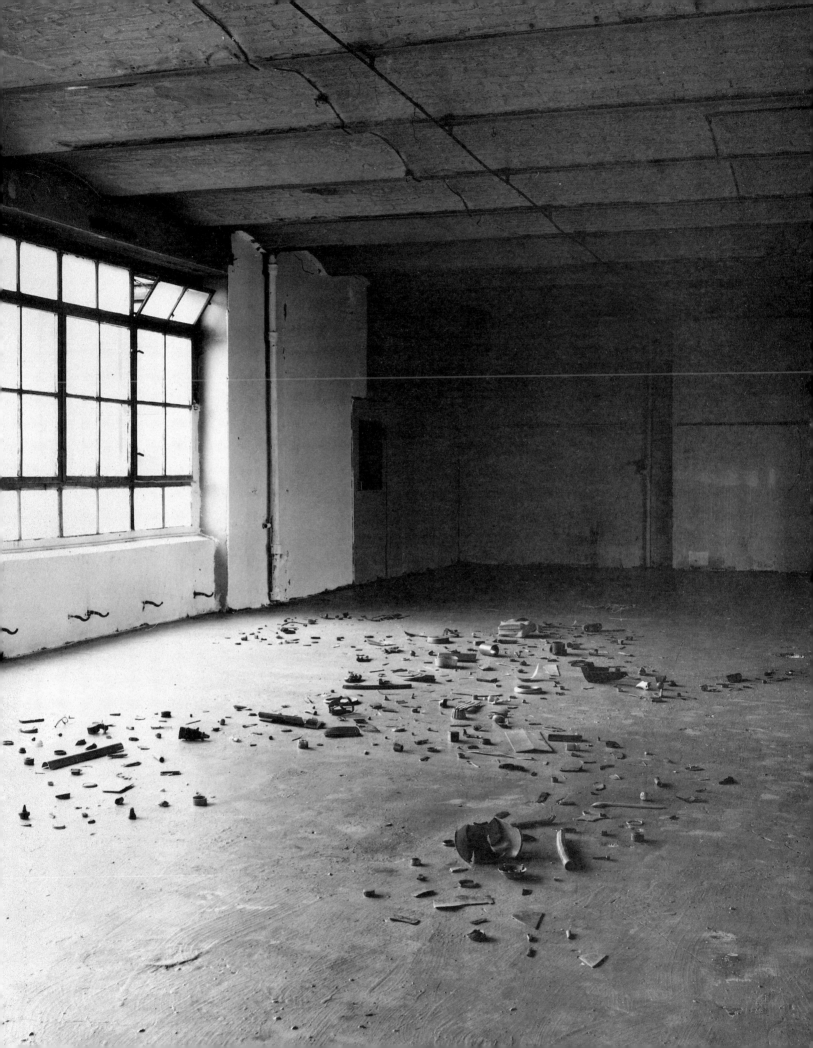

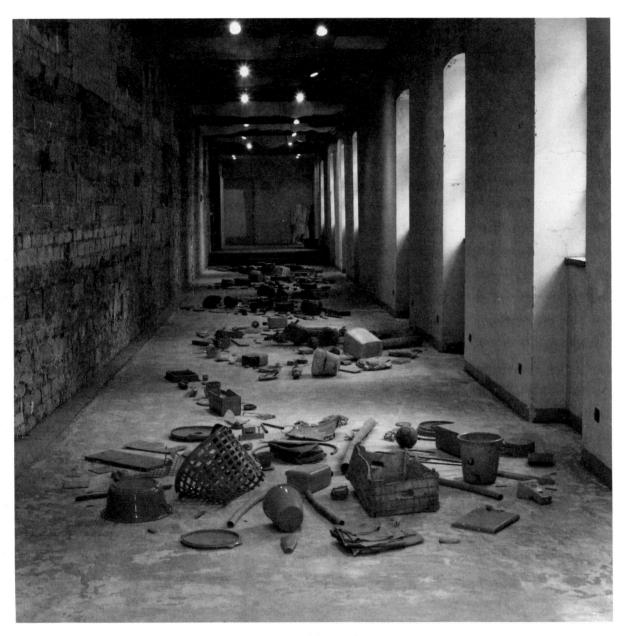

Pl. 11. Tony Cragg, *Five Objects – Five Colors*, 1980, Musée National d'Art Moderne, Centre Georges Pompidou, Paris

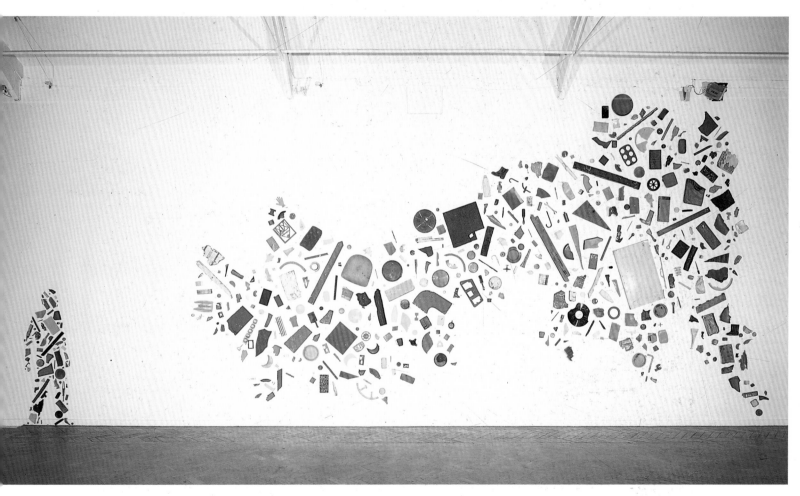

Pl. 12. Tony Cragg, *Britain Seen from the North*, 1981, Trustees of the Tate Gallery, London

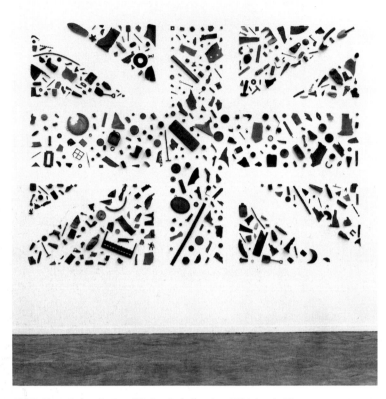

Pl. 13. Tony Cragg, *Postcard Union Jack, London*, 1981, Leeds City Art Gallery, England (cat. no. 2)

Pl. 14. Tony Cragg, *Everybody's Friday Night*, 1981, Private Collection, Belgium

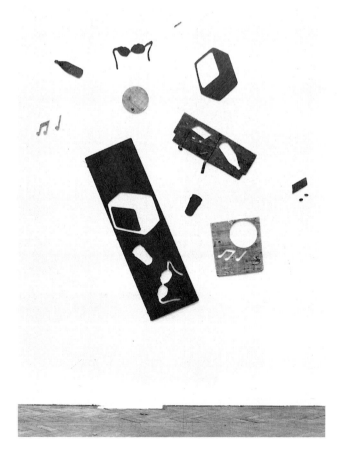

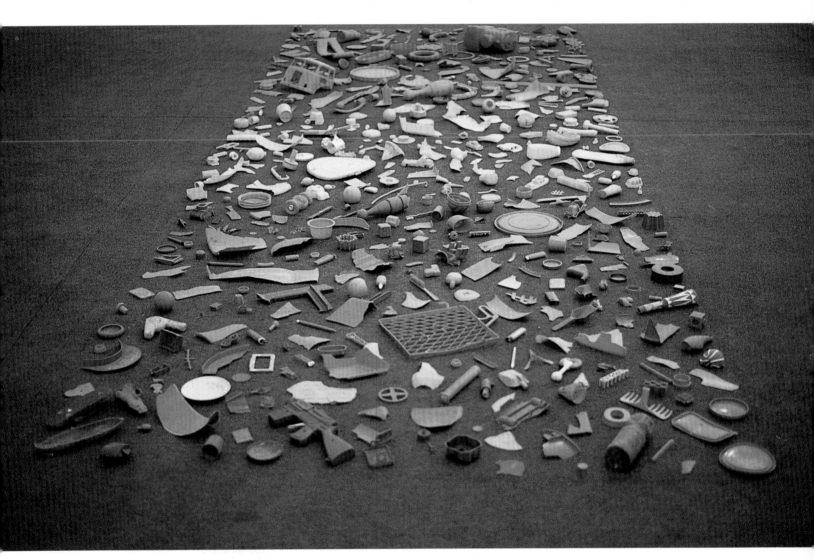

Pl. 15. Tony Cragg, *New Stones*, 1982, Courtesy Marian Goodman Gallery, New York (cat. no. 4)

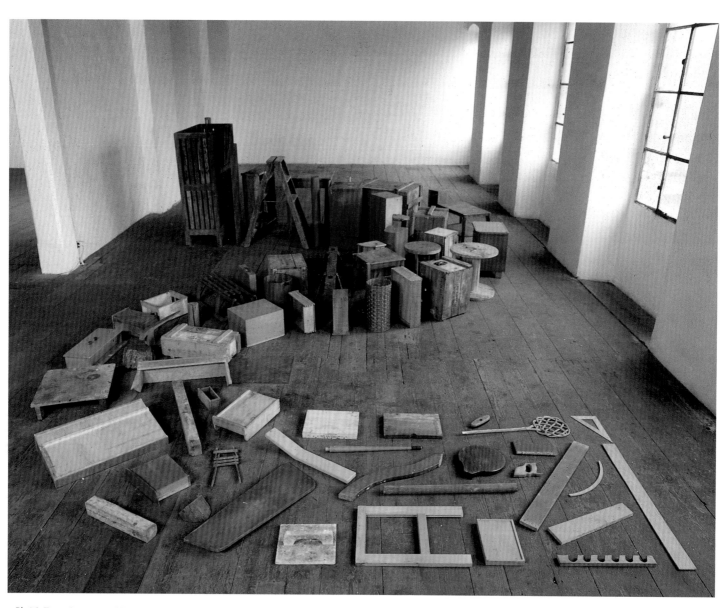

Pl. 16. Tony Cragg, *Middle Way*, 1984, Private Collection, Turin

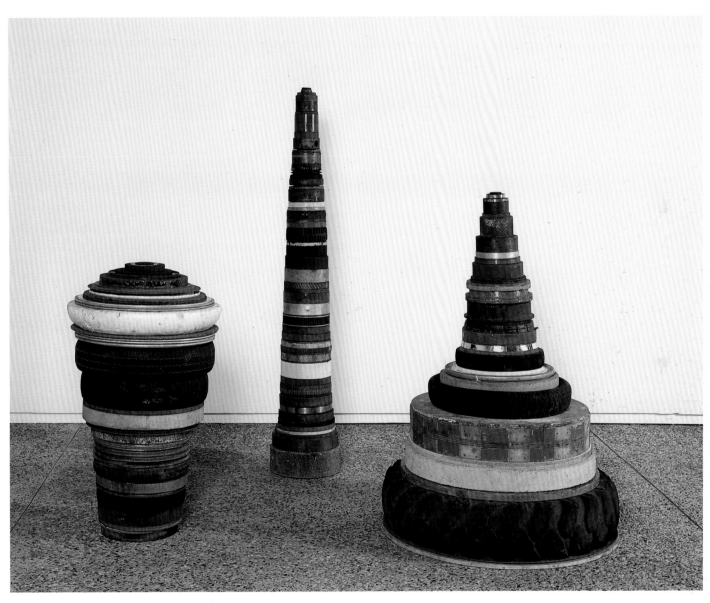

Pl. 17. Tony Cragg, *Circles*, 1985, Fonds Régional d'Art Contemporain, Ile de France (cat. no. 5)

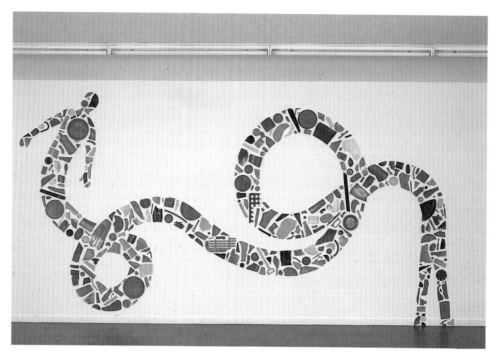

Pl. 18. Tony Cragg, *New Figuration*, 1985, Courtesy Art & Project, Amsterdam (cat. no. 6)

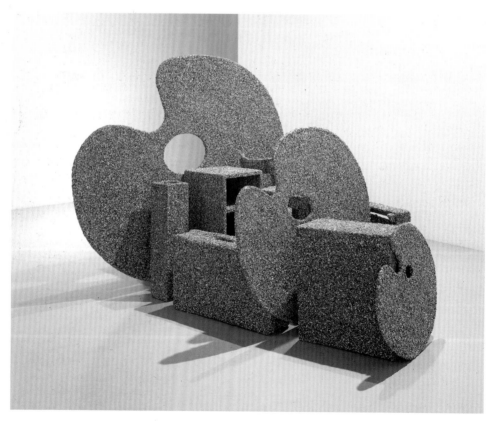

Pl. 19. Tony Cragg, *Shell*, 1986, Collection of Elaine and Werner Dannheisser, New York (cat. no. 7)

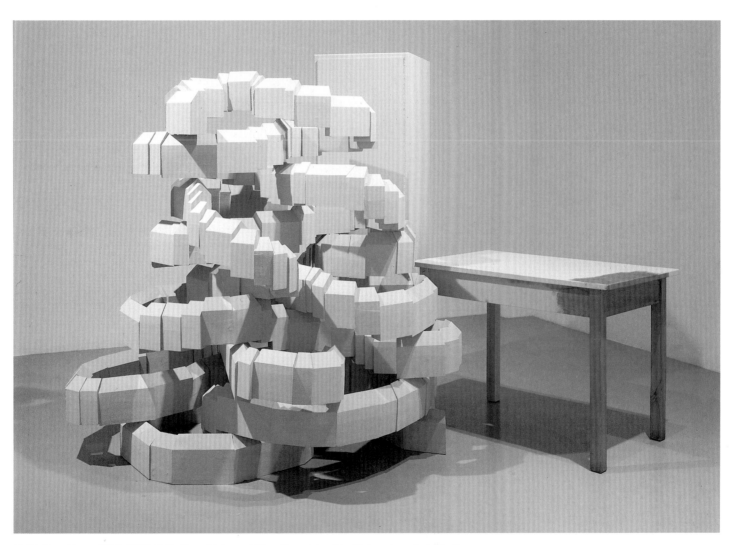

Pl. 20. Tony Cragg, *Città*, 1986, Collection of John and Mary Pappajohn, Des Moines, Iowa (cat. no. 8)

By Mary Jane Jacob

Richard Deacon:
The Skin of Sculpture

Early on as a student, Richard Deacon was immersed in the philosophies of Conceptual Art and the actions of Performance Art. Now a builder (in the true construction sense of the word) of sculptural form rich in metaphoric content, Deacon in his present work might seem to be at odds with his educational background. In fact, his objects are an outgrowth and further development of his first artistic efforts. Paradoxically, from his performance activities, Deacon developed a commitment to the *making* of art and, looking to the parallel art of poetry, he sought a way to give depth of meaning to form. While seemingly abstract the sculptures Deacon creates are always referential, often taking on several identities at once. In arriving at this interpretive level of art, Deacon has focused on curvilinear sculpture whose form is hollow or without internal structure; the covering or outer framework – the skin – conveys the idea of the work. With these works Deacon has emerged out of the period of Conceptual Art of the 1970s to make his own contribution to the sculpture of the 1980s.[1]

Deacon's exposure to performance began around 1968 when he was a student at the Somerset College of Art in Taunton. While continuing in this direction during his St. Martin's years (1969-72), Deacon, using scrap studio materials, also made installations, often on an environmental scale and at times involving a performance component. The most significant of these projects was *Stuff Box Object* (pl. 21), based on the construction/deconstruction of a box which was executed in a performancelike process and recorded in photographs, texts, and a play. The work began within a dictated conceptual framework: Deacon and a friend exchanged studio locations complete with their contents. Most prominent among the materials Deacon received was a large, boxlike structure which he decided to use in a sequence of activities: he entered the box, carpeted it inside, placed materials around it, built it up by layers with wood and other elements, covered them with cement and plaster, and then disassembled it all. A diaristic account of *Stuff Box Object* became the subject of one of five documentary books that Deacon made at this time.[2] The attention given here to both the inside and outside of form, the use of simple building materials, and the un-

Pl. 21. Richard Deacon, *Stuff Box Object*, 1971, no longer extant

masked, common construction techniques employed would later come to typify Deacon's mature work.[3]

In 1974 when Richard Deacon entered the Environmental Media Department of the Royal College of Art, he had already moved toward making sculpture, and he continued to pursue this direction despite the department's video, performance, and other time-based orientations. The interdisciplinary approach of the Royal College fostered freedom in how to approach making sculpture, and the prevalent collaborative mode of working there presented Deacon with a more stimulating, intellectually active dialogue than that offered in traditional departments. Joining fellow students in a group they called "Manydeed," he still engaged in actions, but they usually involved making; for instance, one person worked with materials while two others narrated.

Increasingly Deacon found the objects he made for his performances to be more interesting than the actions in which he employed them. As he began to make objects unrelated to action, he based them, nevertheless, on an activity that served as a model for him: house building. Using construction and home-decorating materials, he first made angled structures out of formica, plaster, veneer, wallpaper, and wood that looked "built" in a pseudo-architectural way (see pl. 22). Wanting to endow these sculptures with the sense of process that had been the subject of his performance-related objects, Deacon used somewhat crude methods of fabrication that disclosed the history of the object's creation.

At the same time while at the Royal College, Deacon wrote an essay on the relationship between language and perception. A kind of theoretical treatise, it expressed, in part, the philosophy behind his architectonic sculptures of 1974-75 and became the basis for the concepts behind his mature work. In this essay Deacon discussed how appearance is simultaneously revealed and obscured so that we perceive things in two ways: "as both open and closed, as proposing and denying interpretation."[4] He further explained this duality by using the analogy of poetry which, like house building, he viewed as a model activity. While poems are made of ordinary words which objectively have sound, meaning, and implication, it is not the words that are poetic, but "the placing together of words in the context of the poem is such that a peculiarity of meaning is both confirmed and denied."[5] Drawing from this analogy Deacon sought to create works that were both open and closed and, while made of ordinary materials, could be constructed in such a way as to become sculptural statements.

The works that first proceeded from this new position, and which he exhibited in 1978 in his first show at the gallery associated with his newly acquired Acre Lane studio, were open-framework pieces composed of rectilinear timbers, curvilinear work formed of laminated masonite, and standing cone shapes of plaster or fiberglass (see pls. 23-25). Independent of an internal skeletal framework, these forms were defined by only an outer skin; they were pierced in some manner so that inside and outside could be read at

the same time, allowing the viewer visually to penetrate and experience the piece in two ways, as "both open and closed." These works pointed to a new type of form for sculpture, one that departed from the impenetrable physicality of Caro School sculpture. To make these forms Deacon chose to use materials basic to the building trades which, like words in a poem, are not in themselves artistic, but can be brought together to create a sculpture. Leaving exposed the points where materials were joined stressed the syntactical structure of the sculpture, allowing it to be read part-by-part and as a whole, just as one can read words, phrases, or a poem in its entirety.[6] Deacon also chose to place these sculptures directly on the floor, giving them a matter-of-fact stance consistent with the common materials and methods employed.

In 1978, soon after the Acre Lane exhibition, Deacon left London for a year-long stay in New York, accompanying his wife, the ceramicist Jacqueline Poncelet, who had received a fellowship to work in the United States. This opportunity proved fruitful for both of them as it marked a breakthrough for Deacon, crystallizing his aesthetic ideas and enabling him to take further this new way of fabricating form. While in America, Deacon found an ideal for his theories about language and perception in the work of Rainer Maria Rilke, which he had begun to read while at the Royal College. This time he focused on Rilke's The Sonnets for Orpheus. Deacon saw a relationship between the structure of these poems and his abstract, penetrable forms made of simple materials and, through Rilke's example, discovered a means of adding other levels of meaning to his art. Eloquently, the poet used ordinary words to construct writings of profound metaphorical import; objects retained their identity while becoming symbolic vehicles. Rilke also used extensively images evoking the senses: the head, Orpheus's head, the ear, heart, lyre, flowers, fruit, and so on. This emphasis on the sensuous had a lasting impact on Deacon, as these images can be found in his later work. While adopting references to the sense of hearing so prominent in The Sonnets (sound — the sound of words — being primary to Rilke as a poet), Deacon also developed metaphorical images related to sight which for him, as an artist, were essential. Working in this way allowed Deacon to develop abstract forms with content and to break conceptually with the purely formalist tradition most closely associated with Caro.

Deacon, deciding to make sculpture that could function formally and metaphorically, undertook two bodies of work in America: a group of clay pots and a series of drawings titled It's Orpheus When There's Singing, after Rilke's sonnets (see pl. 26). Neither of these were sculpture per se, but both series enabled Deacon to explore sculptural concerns. The conelike shape of his pots and the spiraling network of lines in his drawings led Deacon to understand the sculptural and metaphorical potential of a nonrectilinear vocabulary. In addition, curvilinear forms assume a unique figure/ground relationship; never totally stable nor unstable, they are in a constant state of neutral equilibrium. In defying a single point of focus, curved shapes take on different appearances and multiple identities when read from different points of view, and hence, like a poem, are open to various interpretations. The ceramics and drawings also allowed Deacon to become fully involved with the inside of form as well as its outside shape, either by opening up a point of access (such as the mouth of a

vessel) or by literally building form from inside out (as in his drawings made by starting at the center of the paper and joining multiple internal shapes to build the outer form).

Deacon's experience with ceramics and drawings was first given sculptural form in Untitled of 1980 (pls. 27-29). While this work takes on the vessel or basketlike shape of the clay pots, it primarily draws inspiration from Deacon's drawings. To achieve in sculpture the open, linear effect of his drawings, Deacon used thin strips of wood built up through lamination, the repetitive layering making evident the process of making and giving a rough edge to the otherwise elegant form. This method, not predicated on predetermined structural decisions, gave great flexibility in making shapes. The resulting form, dynamic yet allusive, looks radically different depending on the point of view: the teardrop-shaped opening extending from the center to the upper edge changes shape and scale, at one angle even disappearing within the radiating lines; the curve of each wood strip projecting from the outline of the teardrop makes the object shift from a circular shape to a tapered form; and the encircling wood strip connecting the spokelike elements is perceived from different vantage points as a circle or various ovoid forms.

The sculpture that followed (pls. 30, 31) again was a penetrable, hollow form, but this time covered, its shell pierced by two openings. It is a large cone with apertures at each end where it was sliced off to expose deep recesses. More closely tied to his ceramics, it drew its form from that of a vessel. Like the earlier untitled work of 1980, this sculpture takes on a different shape from every point of view, suggesting diverse references that seem to be specifically related to Rilke's imagery: a head, ear, horn, or listening device. It is fabricated out of flat sections of sheet steel attached with rivets and screws left visible on the surface. This creates a skin without an internal skeleton, whereas in the preceding sculpture, the linear elements were pushed to the outer edge to define the shape; in both instances the interior remains hollow. In speaking of this process, Deacon has said: "When I'm making sculpture I have a resistance to things which are built up from the inside out, because if I do that, then I hide the bit that I've been working on. Whereas if I try to make it as if it were a skin all the time, then I have a continuous acquaintance with what constitutes the work, the surface."[7] Therefore, in these two untitled works of 1980 and those that have followed, the sculpture's structure and surface are one.

Deacon has maintained the two sculptural directions — shapes externally defined by linear elements with the interior remaining open, and skinlike, hollow shells pierced by one or more openings — that were heralded in these two works of 1980. The manufacture remains evident as the manner of joining (gluing, riveting, screwing) is not only unmasked but emphasized, often by securing parts beyond structural necessity. The banality of the materials employed seems a foil to the sculptures' poetic connotations. After 1980 Deacon also began to add titles to enhance the metaphoric content of his forms. These titles frequently are clichés such as If the Shoe Fits (pl. 35) and Listening to Reason (pl. 41). These vernacular expressions are linguistically familiar in the same way that the wood and metal used are part of our common, everyday circumstances. Many of the titles, however, also make reference to the senses, using especially images of the eye and ear, recalling Rilke's dominant imagery.

Pl. 22. Richard Deacon, *Untitled*, 1975, Collection of the artist

Pl. 23. Richard Deacon, *Untitled*, 1977/78, no longer extant

The sculptures in the form of solidly built shapes with openings in one or more places include works like *If the Shoe Fits*, *Out of the House* (pl. 36), and *The Eye Has It* (pl. 38). Their clumsy, awkward look is the result of the unexpected combination of materials and the rough construction. The other group has a more lyrical aspect, as strips of wood or metal are used in a linear fashion to indicate the edge, the skin, of things. Completely open, these transparent forms include steel structures such as *For Those Who Have Eyes*, *The Heart's In the Right Place*, and *Two Can Play* (all 1983, Saatchi Collection, London), as well as wood pieces such as *For Those Who Have Ears No. 1* (1982, Saatchi Collection) and *No. 2* (1983, Tate Gallery, London), *Tall Tree in the Ear* (pl. 37), *Like a Bird* (1984, Collection of Mr. and Mrs. R. D. Nasher, Dallas), *Blind, Deaf, and Dumb* (1985, Collection of the Rijksmuseum Kröller-Müller, Otterlo, The Netherlands), and *Listening to Reason*. In these works the use of serpentine rhythmic lines creates a heightened sense of movement. These works are characterized by a symmetrical elegance, due not only to the delicate linearity, but also to the sense of refinement in the handling of laminated wood strips or steel bands in spite of the evident manner of construction.

Paralleling the creation of these two types of major works has been an ongoing sculptural series titled "Art for Other People" (see pls. 32-34). Deacon sees these diminutive works functioning like drawings — as a means for developing ideas. Taken as a group they set up a vocabulary of form. For example, the basic outline of an ear in *Art for Other People No. 9* (pl. 33) is found in several larger-scale works (see pls. 37, 41). Since for Deacon all products of human manufacture (poetry, sculpture, or other objects) serve as means of communication between us and the world, "Art for Other People" can be compared to letters, since they convey ideas on a more personal and intimate level than is possible with Deacon's full-scale works. Small and accessible, this series has a kind of domesticity, and hence a comfortable familiarity, reaffirmed by the found, household materials from which they are made, and the common objects with which they seem to have some family resemblance.

Characterizing all categories of large- and small-scale works is the articulateness of Deacon's forms; they have the capacity to refer to things beyond themselves, to serve as metaphors. Endowing ostensibly abstract shapes with content, Deacon gives clues to manufactured objects, and organic and anatomical forms, doing so by means of both the shape and title. For example, from one end *If the Shoe Fits* appears like a great tongue of a shoe projecting outward. However, the ringlike shape and opening also give the "tongue" a spoutlike look and the work takes on the connotation of a pitcher. From the opposite end the shape and corrugation of the steel suggests a pleated collar and cloak, its folds neatly cascading; a hat or a tuba come to mind as well. In *Out of the House*, Deacon lined a steel, shell-like structure with linoleum. Seemingly erect, upright on the ground, its sinuous form is enlivened by appendages that look like vines or the tentacles of a sea creature. The supple pliability of cloth

Pl. 24. Richard Deacon, Installation at The Gallery, Brixton, London, 1978

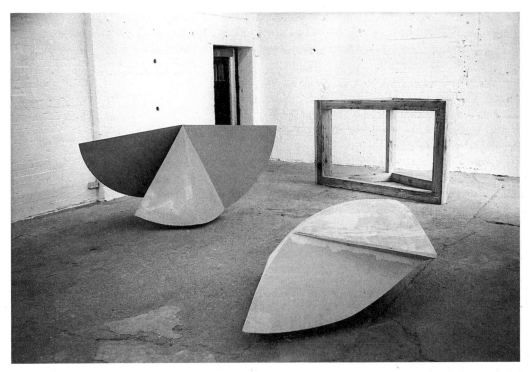

Pl. 25. Richard Deacon, Installation at The Gallery, Brixton, London, 1978

contributes to the organic, sagging, skinlike sense of *On the Face of It* (1984, Collection of the artist). We see here only the surface, the skin, the face of the form; unrevealed to us is the structure, the inside. *The Eye Has It* also includes cloth in combination with other materials (stainless and galvanized steel, brass, and wood) in a two-part sculpture that resembles a vagina and sperm, or a socket and eye whose delicate nerve ending is made of malleable cloth.

In exploring the use of metaphor in sculpture, Deacon has returned again and again for inspiration to Rilke, as seen in the many works associated with sight and sound. In "Art for Other People," sound is referred to by the symbol of the ear (see pl. 33) and by sound-related objects, like musical instruments (see pl. 34). The ear shape is the basis for *Tall Tree in the Ear*; its title comes directly from the first sonnet in Rilke's *Orpheus* cycle: "A tree ascended there. Oh pure transcendence!/ Oh Orpheus sings! Oh tall tree in the ear!" Tree and ear become one in Deacon's sculpture as the ear grows to treelike proportions. By encasing the form in blue cloth (blue, the color of transcendence), Deacon links the tree/ear to the sky. The blue accentuates the height of the form, while the crumpling of the fabric dematerializes its solidity, further fusing the tree/ear with the sky. The ear is seen five times in the interwoven forms of *Listening to Reason,* the sound caught in the hollow of the shapes travels from ear to ear as the sinuous lines create an interplay of a five-way conversation. Deacon's use of the metaphor of sight is particularly well expressed in *Turning a Blind Eye No. 2* (pls. 39, 40). The laminated wood is pressed into an eye shape which, from the side, seems in the process of opening or closing. The eyelash of hanging black cloth attached to the upper half of open eyelid is about to darken and obscure sight, depriving us of understanding and enlightenment, and separating us from the world.

Richard Deacon's work spans but a few short years so far, his first major sculptures emerging in 1980. Yet his contribution to the current scene has been significant. Not unlike others of his generation, most notably Cragg and Woodrow, he has chosen to link his art to the everyday environment. While his materials are not found, they are, nonetheless, easily purchased, manufactured construction goods — wood, masonite, steel, linoleum, canvas — which we can identify with our immediate surroundings as readily as we do a plastic bottle or twin-tub. The tactile quality of the works and the familiarity of materials are emphasized by the simple methods of joining taken from the building trades which become an evident part of the overall texture and look of the object. Applying his theories about perception, fortified by the example of Rilke, Deacon creates sculpture that ascends to take on other levels of meaning through metaphor.

Notes

1.
Most of the information in this essay is based on the author's interview with the artist in London, Mar. 1985.

2.
These five books originally took the form of photographs accompanied by text displayed on the wall. A small, unillustrated edition was also printed of each. For *Stuff Box Object*, the work and notes for which were executed in 1970-71, Deacon made two copies of the small edition of thirty with photographs. The only book of this series to be printed in an illustrated edition, *Stuff Box Object* was finally published by Chapter (Cardiff) Ltd. by courtesy of the Lisson Gallery, London, 1984.

3.
While at St. Martin's, exploring fabrication from a more craftsmanlike approach led Deacon to produce a series of four chair forms; originally intended to be fully finished, only one became functional, the others, minus seats and backs, remained purely aesthetic objects.

4.
Richard Deacon, "Notes on Work," unpublished thesis, Department of Environmental Media, Royal College of Art, London, 1975: 4.

5.
Ibid.: 4-5.

6.
Deacon has viewed syntactical structure as a part of his work from the beginning. In 1968/69 he made for a performance an object of sacks, balloons, a crate, and tubes linked by a 30-foot-long cord and carried by a group of people through the streets of Taunton. The *Stuff Box Object* of 1971-72 was made in distinct, progressive stages. In the performances of "Manydeed," processes of building and actual narration were joined, while in some of Deacon's mature works, alternative views or different aspects of a single piece can be considered to be the parts constructing the syntax of the sculptural sentence.

7.
Richard Deacon and Jon Thompson, "Richard Deacon in Conversation with Jon Thompson," in *Entre el Objeto y la Imagen: Escultura británica contemporánea* (Madrid: Ministerio de Cultura and The British Council, 1986): 233.

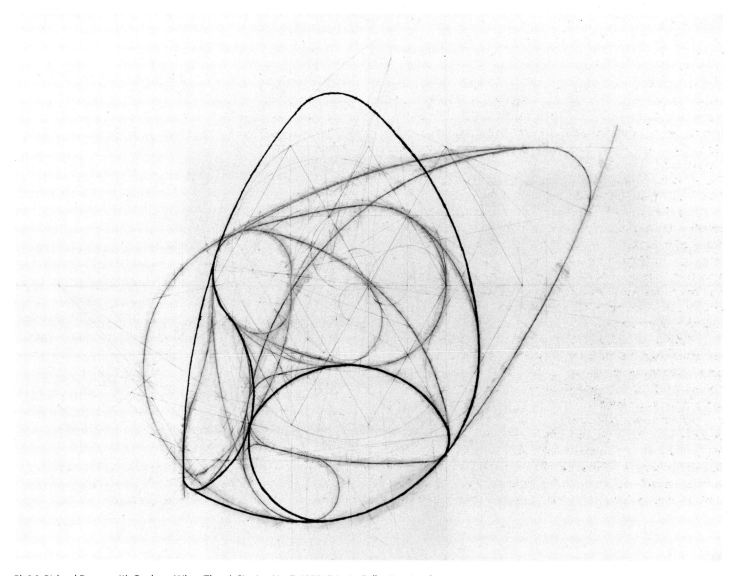

Pl. 26. Richard Deacon, *It's Orpheus When There's Singing No. 7*, 1979, Private Collection, London

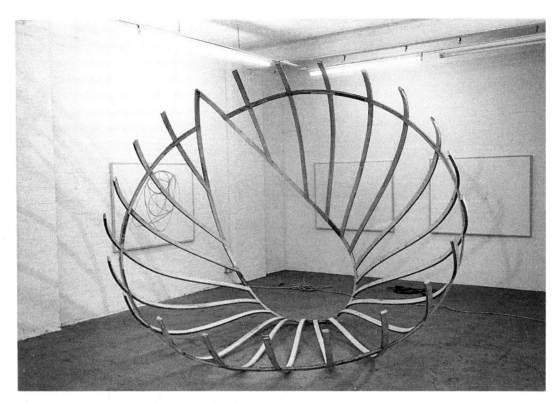

Pl. 27. Richard Deacon, *Untitled*, 1980, Saatchi Collection, London

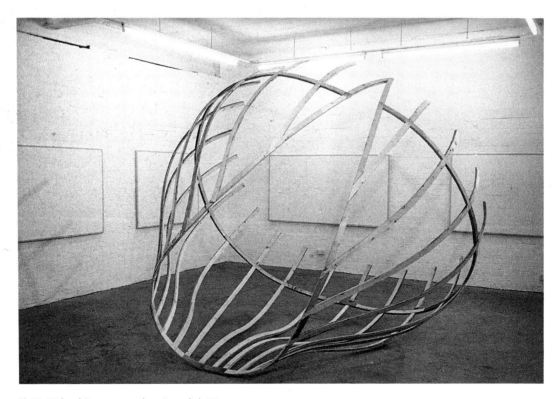

Pl. 29. Richard Deacon, another view of pl. 27

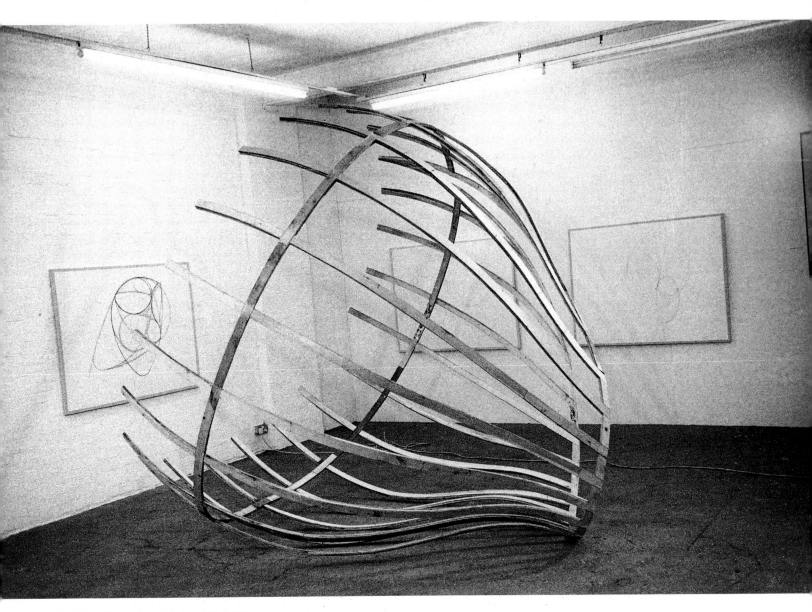

Pl. 28. Richard Deacon, another view of pl. 27

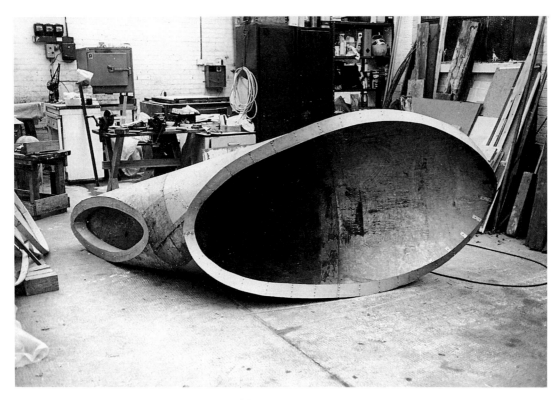

Pl. 30. Richard Deacon, *Untitled*, 1980, Collection of the artist

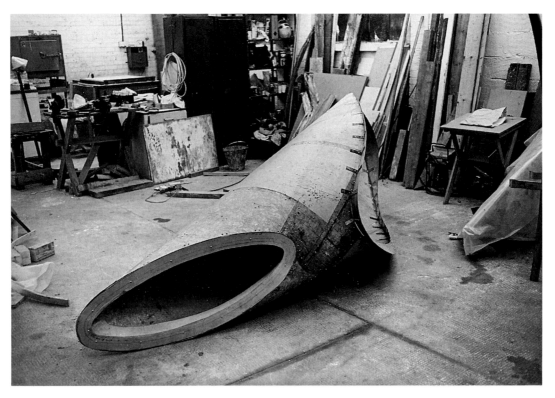

Pl. 31. Richard Deacon, another view of pl. 30

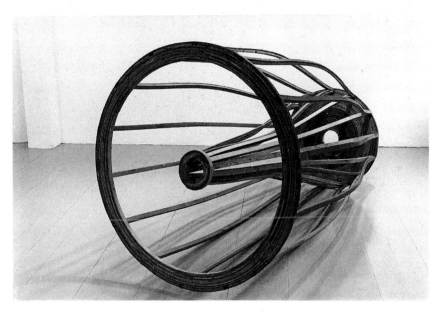

Pl. 32. Richard Deacon, *Art for Other People No. 5*, 1982, Saatchi Collection, London
(cat. no. 10)

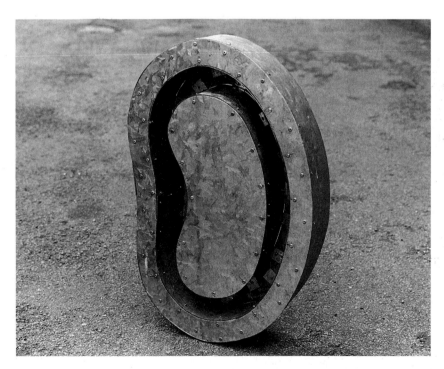

Pl. 33. Richard Deacon, *Art for Other People No. 9*, 1983, Saatchi Collection, London
(cat. no. 11)

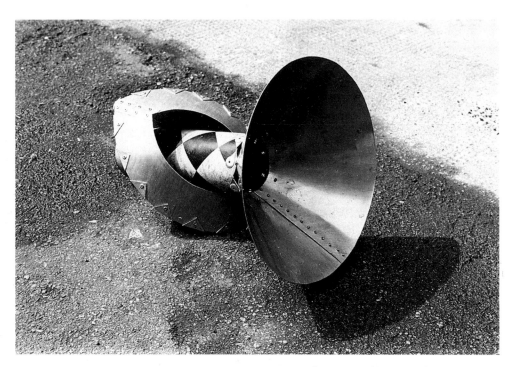

Pl. 34. Richard Deacon, *Art for Other People No. 11*, 1984, Private Collection, Basel (cat. no. 14)

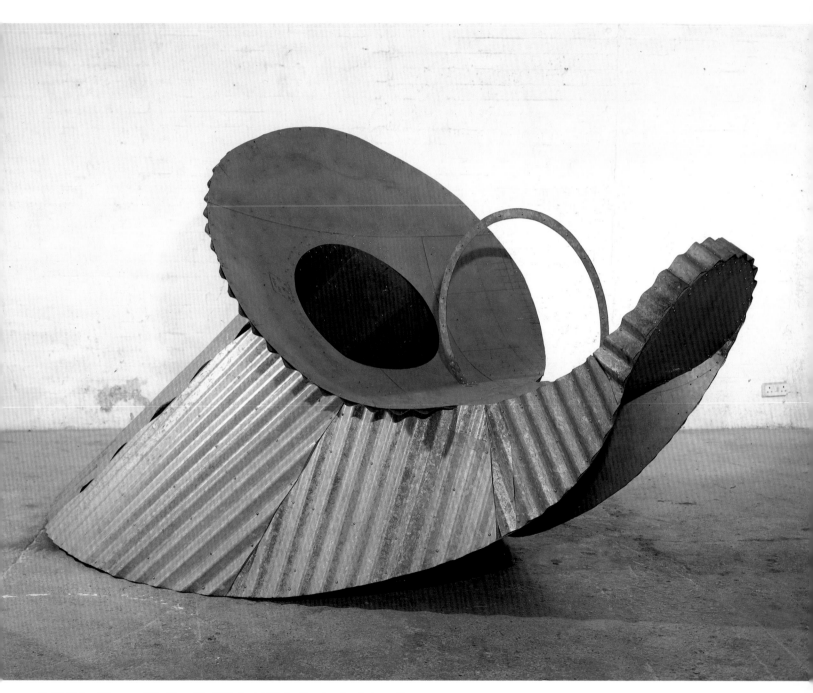

Pl. 35. Richard Deacon, *If the Shoe Fits*, 1981, Saatchi Collection, London (cat. no. 9)

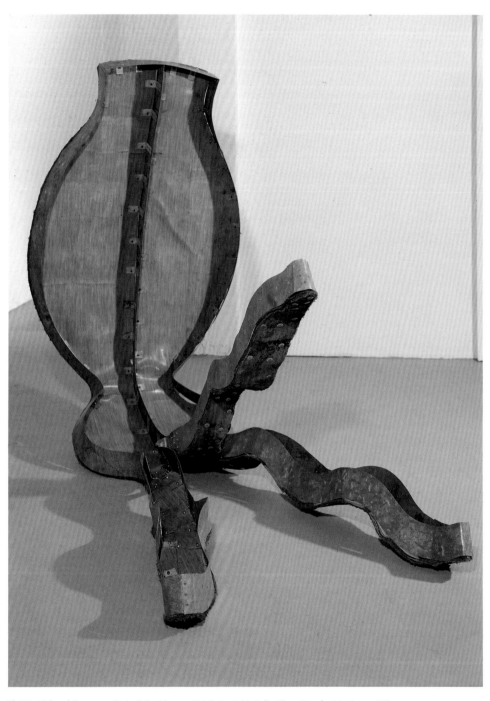

Pl. 36. Richard Deacon, *Out of the House*, 1983, Saatchi Collection, London (cat. no. 12)

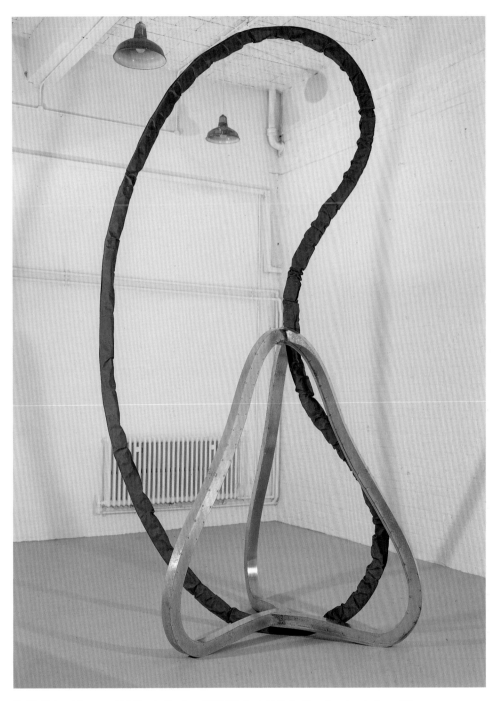

Pl. 37. Richard Deacon, *Tall Tree in the Ear*, 1983-84, Saatchi Collection, London (cat. no. 13)

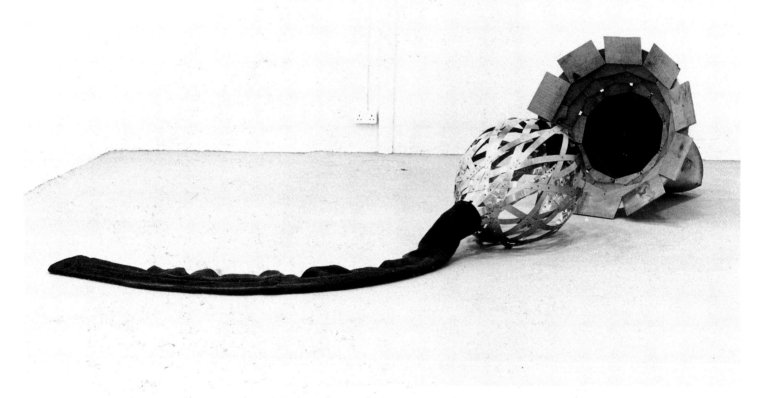

Pl. 38. Richard Deacon, *The Eye Has It*, 1984, Arts Council of Great Britain, London (cat. no. 15)

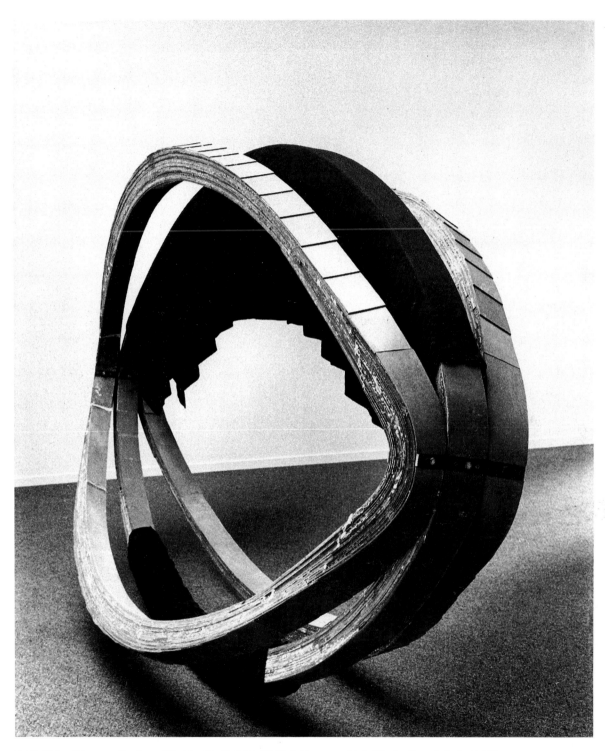

Pl. 39. Richard Deacon, *Turning a Blind Eye No. 2*, 1984-85, High Museum of Art, Atlanta, Georgia (cat. no. 16)

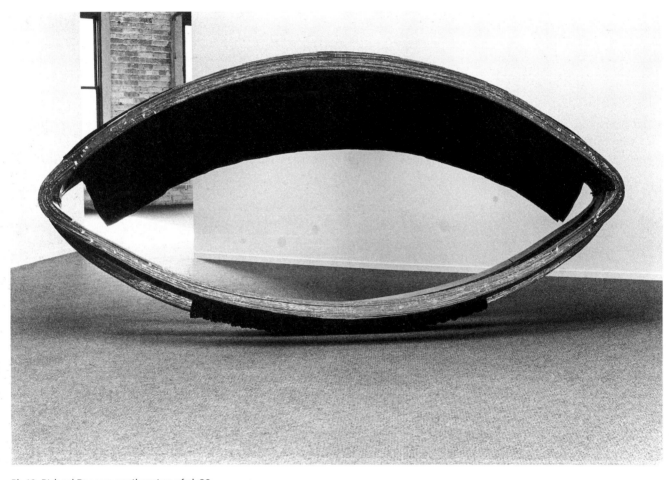

Pl. 40. Richard Deacon, another view of pl. 39

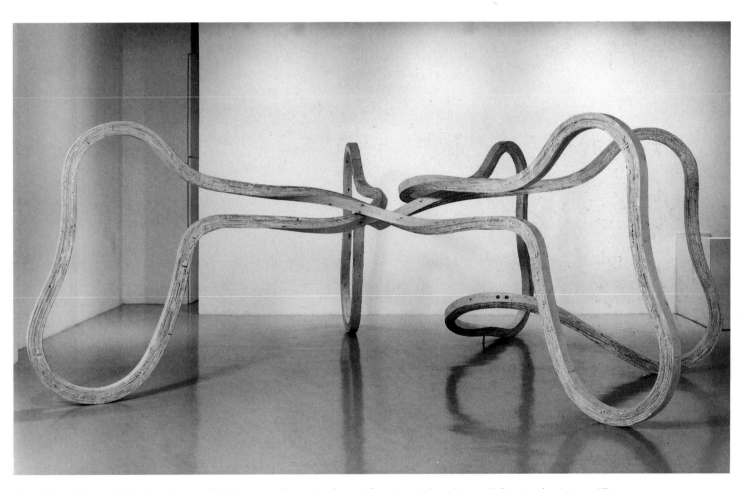

Pl. 41. Richard Deacon, *Listening to Reason*, 1986, Courtesy Marian Goodman Gallery, New York, and Lisson Gallery, London (cat. no. 17)

By Graham Beal

Barry Flanagan:
"Twice as Hard in a Negative Way"

From the very beginning of his career, Barry Flanagan set himself in opposition to what he perceived as traditional; not necessarily for the sake of flaunting rules, but as a crucial tactic in maintaining the creative process throughout the making of a sculpture. Even his early decision to sculpt rather than paint was inspired by the feeling that, in painting, the artist tended to be executing preconceived ideas.[1] Sculpture on the other hand, by the very physicality of the medium, entailed a more basic and thoroughgoing dialogue between the artist's intentions and the materials. Balancing this notion which, left by itself, could easily be a prescription for the most refined kind of formalistic sculpture (such as was, in fact, being evolved at St. Martin's School of Art, London, where Flanagan studied) was Flanagan's strong sense of his being a *conscious* participant in a ubiquitous activity. "Truly," he says, "sculpture is always going on. With proper physical circumstances and the visual invitation, one simply joins in and makes the work . . . there is a never-ending stream of materials and configurations to be seen, both natural and man-made, that have visual strength but no object or function apart from this. It is as if they existed for just this physical, visual purpose – to be seen."[2] In general terms this attitude led him to explore widely and to reject anything that smacked of reworking established attitudes, however recently arrived at. In particular, it led him to work with such hitherto "unsculptural" materials as sand, rope, and cloth, in opposition to the welded steel and plastics that were, at the time, the signature materials of British avant-garde sculpture. He was fortunate to be at St. Martin's, where such strong talents as Anthony Caro and Phillip King (working in metal and plastic, respectively) vigorously pursued their own distinctive work, and yet fostered genuine debate.

Flanagan felt that metal and plastic, no less than paint, inclined the artist to evolve ideas *away* from the materials and that in opting for such labor-intensive industrial materials, the artist forsook most of the spontaneity that derives from involvement with the "never-ending stream of materials and configurations" in the world at large where "sculpture is always going on." In an open letter to Anthony Caro, Flanagan provided a particularly lucid rationale for his way of working: "Rejection has always been a motivation for me . . . or is it that in these times positive human assertion, directed in the channels

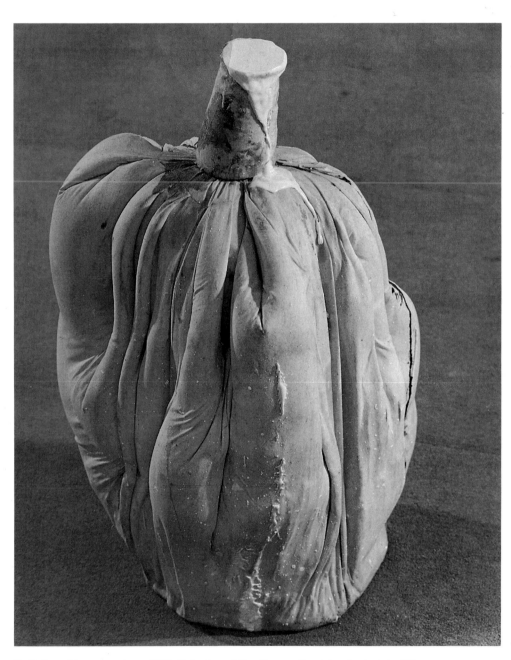

Pl. 42. Barry Flanagan, *pdreeo*, 1965, Collection of Alex Gregory-Hood, London (cat. no. 18)

that be, lead up to the clouds, perhaps a mushroom cloud. Is it that the only useful thing a sculptor can do, being a three dimensional thinker and therefore one hopes a responsible thinker, is to assert himself twice as hard in a negative way. . . . This is my dilemma."[3]

But it was not all rejection. On the one hand Flanagan's open-ended attitude to form in sculpture was augmented by a concern for poetry, music, and performance. On the other hand it is not difficult to see in the early sculpture the direct influence of certain attitudes and forms deriving from his teachers at St. Martin's. The conical shape that occurs frequently in Flanagan's sculptures of the 1960s was (and indeed remains) a favorite configuration of Phillip King's. More specifically, Flanagan's early work such as the rope and sand pieces further explored the "St. Martin's" question of the relationship of sculpture to floor and it was, in fact, King, who as Flanagan's third-year tutor, first suggested the use of a painted circle on the floor as a means for unifying his student's 1965 sculpture *aaing j gni aa* (pl. 43).[4]

Flanagan's description of himself at this time as a "heretic," then, is an apt one in that he used information shared by many to arrive at a set of conclusions closely related to those of the others, but different in one or more details. In radical times he was marginally more radical than the rest, but it was more than a difference of degree. His soft and floppy materials bespoke an altogether different sensibility which, for all its reductivism and apparent formal emphasis, was in genuine opposition to that of his teachers. Where they labored to make "pure" sculpture from tough substances, the attraction of which derived from their modernity, Flanagan attempted to elicit sculptural qualities from the pliable and evasive. Through deft manipulation he combined sticks, sand, hessian, felt, furniture, and mylar, creating scruffy-looking arrangements that were subject to change and even destruction. *ring n* of 1966 (no longer extant), for example, was made by pouring sand in a single stream onto the floor. The natural qualities of the sand caused it to form into a cone which Flanagan transformed into a ring simply by scooping out four handfuls, one at each point of the compass. In such a procedure, Flanagan acts as interventionist rather than prime mover; his actions are calculated to bring out its sculptural potential in a manner sympathetic to the sand's inherent qualities.

If this basic respect for materials places Flanagan in the Henry Moore tradition of "truth to material," it no less relates his work to that of Richard Long (with whom he also shares a strong sense of the transient nature of substance). As does Long's, Flanagan's sculpture combines intellectual vigor ("three dimensional thinker") with formal elegance and, above all, great lightness of touch. That is the constant in the otherwise ever-changing face of Flanagan's sculpture. In this sense the materials are only significant in relation to the sculptor's actions. As Flanagan himself wrote: "Within the area of sculpture there are carried its own solutions, we invest it with problems, ideas and excitements. One merely causes things to reveal themselves to the sculptural awareness. It is the awareness that develops not the agents of the sculptural phenomena."[5]

By 1967, the year after he graduated from St. Martin's, Flanagan was already being widely exhibited, his work of this period culminating in a tripartite piece, *four casb 2'67, ring l 1'67, rope (gr 2sp 60) 6'67* (pl. 44). In the statement just quoted, Flanagan con-

tinued, the separate parts "are seen in the same space; it is fortuitous or interesting that they negate their specific identities and work in such a way." In *four casb* . . . , Flanagan created an elegant environmental sculpture with a limited range of materials but, depending on how the basic components are deployed and on what kind of sand is used at a given time to fill the tall canvas bags, they are capable of infinite variation. The tongue-twisted titles, typical of this period, reflect Flanagan's concurrent interest in Concrete Poetry, a movement that emphasized the visual properties of words.[6] Flanagan has categorically denied that there are any "implications" within this work, but however unfair to the artist, it takes no great stretch of the imagination to read landscape forms — trees, rivulet, and pond — into the sandbags, rope, and linoleum circle.[7] Blessed with the hindsight of Flanagan's later drawings and sculpture, much of which testifies to his strong feeling for landscape, the "evocative" reading becomes particularly attractive.

Certainly the next group of works were uncompromisingly nonreferential. *Heap, Stack, Bundle, Pile* (see pl. 46), *Line* (see pl. 45), and *Rack* were arrangements of his familiar materials that fulfilled their titles. In fact, for all but *Heap*, the title came first. As Flanagan tells it, having recognized that he had made a "heap," he thought of related words and went on to make the sculptures that would "illustrate" them. By limiting himself to a few materials and a few words, he set up a situation in which verbal and visual elements were mutually enhancing, and the viewer's attention constantly returned to the basic physical facts of each sculpture.

At about this time in the late 1960s, Flanagan began to experiment with aspects of the exhibiting environment. Light, a particularly important element, was manipulated in a variety of ways. At the same time his other materials, more disheveled than ever, included cloth, bits of flax, broken and burned sticks (see pl. 48). Together they evoke a bleak world, shattered and disemboweled, an effect that Flanagan's accustomed deftness does little to mitigate. Even when less amorphous elements are used, the end result is emotionally similar, as is the case with *'60s dish* of 1970 (pl. 47), which presents a cello on a settee that is jammed hard against an old square mirror. As the sides of the settee and mirror effectively coincide, the overall composition has something like geometric rigor: the vertical square of the mirror is balanced by a horizontal one made by the top edges of the settee and its reflection. In the midst of all this fortuitous structure sits a cello, inaccessible and dumbly staring at its reflection. It is tempting to think of paintings by René Magritte in which domestic objects and mirrors are used to such disquieting effect. The comparison is most useful in highlighting the unambiguous motive of Flanagan's sculpture in which the purposes of the settee, mirror, and instrument are all thwarted, locked together in an act of self-negation. Any lightness of touch in *'60s dish* is confined to the economical placement of the components; altogether absent, though, are those otherwise ubiquitous elements: irony and wit.

In 1973 Flanagan turned from his established management and maneuvering of disparate elements within a more or less given space to working with a single object: he took up carving (see pls. 49-51). But he brought to carving the sense of paradox, verging on ambivalence, that characterizes his earlier work. In *The Road to Altissimo* (pl. 49), one side of the sculpture is flat, as cut by the masons,

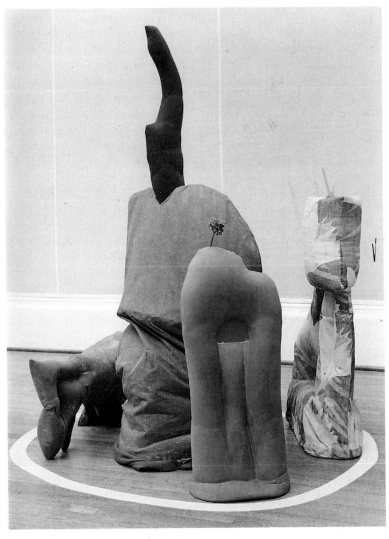

Pl. 43. Barry Flanagan, *aaing i gni aa*, 1965, Trustees of the Tate Gallery, London

adorned by only a few drawn marks that suggest what further carving *might* be done. In other works, *Lamb/fish* (pl. 52) for example, Flanagan scratched out an animal shape suggested by the accidental marks caused by splintering stone from the quarry bed. In both cases the act of drawing – the apparent opposite of sculpting – is a prominent feature, a tactic taken to an extreme in *Tantric Figures* (pl. 51), where deeply incised lines cut into the rectangular block of the stone set up an extraordinary tension, as if the figures, crammed into confined space, struggle for release.

Flanagan is, in fact, a natural draftsman who has put out a constant stream of drawings and prints. Until the carvings of the mid-1970s, drawing tended to be a separate activity, but his vital linear sense can be detected in his use of rope and his general preference for attenuation seen in the sculpture of the late 1960s. But even if Flanagan makes no preparatory drawings per se, there is a direct relationship between the two activities, which have been described by one writer as "a very relaxed naturalism. . . . Lines take their course . . . and tend to waver and curl at the ends so that the shapes become slightly lumpy. . . . There is no distinction between outline and incident."[8]

The influence of Constantin Brancusi and Joan Miró is most apparent in carvings of the mid-1970s. *The Memory of the Flight of Owls* (1975, Collection of M.-F. and M. Gijsegem, Ghent) and *Ubu of Arabia* (pl. 53) are achieved by precariously balancing chunks and slabs of rock on top of one another to create unlikely beings. To call them carvings is to stretch a point, as the various stone elements seem, like so much else in Flanagan's work, found rather than made. In both works blobby, organic forms sit on more geometric components which in turn sit on the floor. Flanagan combines St. Martin's sculpture/floor relationship with Brancusi's determination that the base should be an integral part of the sculpture. Miró's influence can be discerned here particularly in the wittily perceptive use of frag-

ments to suggest human or animal anatomy, but the Spanish artist seems to have had long-standing significance for Flanagan who, in 1964, "hired a tuxedo to present himself to Joan Miró at his Tate Gallery retrospective."[9]

Sensitivity to intrinsic qualities of the artist's chosen material is, of course, a central theme in much British sculpture of the 20th century and, as stated earlier, was championed by Henry Moore as "truth to material." Flanagan's teachers had turned their backs on Moore's achievements but Flanagan, in reaction to them, often harks back to the work of the "grand old man" of British sculpture. One of his earliest pieces, the 1965 *pdreeo* (pl. 42), was, Flanagan felt, something "Henry Moore might like."[10] And for over 20 years, Flanagan has made extensive use of Hornton stone, a material practically synonymous with Henry Moore's pioneering years. As we have seen, Flanagan's use of a wide range of unlikely materials was informed with a great respect for their intrinsic qualities and an instinctive sense of biomorphic connotations. In his perverse-seeming use of cloth, rope, poured sand, and plaster, Flanagan may be said to have taken a surprising new direction. Henry Moore expressed the notion that "A sculptor is a person obsessed with the form and shape of things . . . the shape of anything and everything."[11] Moore was thinking of rocks, trees, flowers, and bones; Flanagan was thinking of "*everything*."

In his most recent carvings, Flanagan avails himself of the time-honored (by Modernist standards, questionable) practice of using Italian craftsmen to translate quirky, hand-formed lumps into objects of considerable bulk. Taking the clay, Flanagan rolls it around in the palm of his hand, pinching, squeezing, folding to create organic forms that are then scaled-up and executed by the craftsmen (see pls. 55, 56). Flanagan trusts these men (whose forebears assisted Michelangelo) to make the decisions about such things as how to render (or not) palm- and finger-prints, details of wrinkles, and surface quality. In this way accidental discovery is combined with technical deliberation and the whole process informed with great sensitivity to chosen materials. What seems at first glance to be mere perversity, play, and indolence is transformed into a process of discovery and refinement.

The sly wit that pervades so much of Flanagan's work broadens into a more tangible form of humor in the hare sculptures. The hare has a highly respectable literary career, ranging from Aesop's *Fables* to Lewis Carroll's *Alice in Wonderland*; fey and erratic according to legend, a traditional byword for lunacy, the hare in Flanagan's hands is usually presented either dancing and tumbling or, as the crowning feature of many bronze sculptures, stretched out in headlong flight. In *Leaping Hare on Crescent and Bell* (pl. 59), he has combined three very different forms: the floppy but volatile animal, the geometric, nearly two-dimensional moon shape, and the volumetric bell. The contrast is more than one of form. The bell is a cliché of bronze-casting, a rigid, official, utilitarian thing at the opposite end of the emotional and artistic spectrum to the mad-cap hare. In between them is the crescent moon, a shape also charged with meaning: the attribute of the goddess Diana, the symbol of one of the world's great religions, and an allusion to lunacy. Beneath the obvious humor,

Flanagan's shifts of meaning and sleights of hand are as subtle as ever. Craftsmanship and tradition (the bell) are set against artistic freedom (the hare). And as employed by Flanagan, the traditional bell is useless, all but reduced to the function of a base out of which flows the bright crescent that carries the hare into the kind of rhapsodic flight hitherto reserved for the extraordinary cow of nursery-rhyme fame.

Viewed from one aspect, Flanagan's work may be seen as a virtual compendium of Modernist attitudes: elements of Dada, Surrealism, Minimalism, Concrete Poetry, Arte Povera, and Conceptualism abound. He is a supremely intelligent artist: analytical, utterly serious, and yet breathtakingly sly. His early work particularly defied the limits of the medium and viewer. From another point of view, he is a successor in a line of sculptors who treasured the natural world and lovingly gave it refined form in stone, marble, wood, and bronze. Since the mid-1970s it has become increasingly clear that Flanagan, having cleared the way with his earlier iconoclasm, is prepared to be counted in a tradition that encompasses Brancusi, Miró, and Moore.

Notes

1.
"There always seemed to be a *way* of painting. With sculpture, you seemed to be working directly, with materials and with the physical world, inventing your own organizations" (in Gene Baro, "Sculpture made visible: Barry Flanagan in discussion with Gene Baro," *Studio International* 178, 915 [Oct. 1969]: 122).
2.
Ibid.
3.
Barry Flanagan, "A Letter and some submissions," *Silâns* 6 (Jan. 1965): unpag. This is often cited as "Silence"; *Silâns*, the actual title, is the phonetic spelling of the word "silence."
4.
Tim Hilton," 'Less a slave of other people's thinking . . . ,' "in *Barry Flanagan* (The British Council, exh. cat. for Biennale di Venezia, 1982): 8.
5.
Barry Flanagan, [Statement], *Studio International* 174, 892 (Sept. 1967): 98.
6.
In the catalogue of the Midland group exhibition of Concrete Poetry, held in February-March 1966, Flanagan wrote, "poetry is the most economical manifestation of one's 'chemistry' — always working towards poem." The title is an acronym and translates as "Four ca(nvas) s(and) b(ags) 2(nd version) (19)67, ring l(inoleum) 1(st version) (19)67 and rope gr(een) 2 sp(aces) 60(feet long) 6(th version) (19)67."
7.
Flanagan, *Studio International* (note 5).
8.
Michael Compton, "A Developing Practice," in *Barry Flanagan* (note 4): 22.
9.
Barry Flanagan, "Chronology," in *Barry Flanagan* (note 4): 79.
10.
Hilton (note 4): 8.
11.
Philip James and Henry Moore, *Henry Moore on Sculpture*, rev. ed. (New York: Viking Press, 1971): 60.

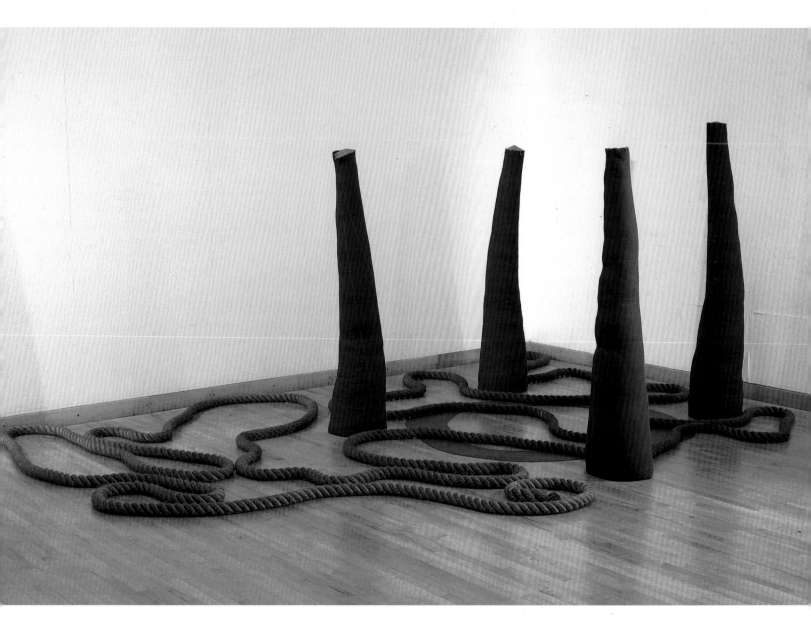

Pl. 44. Barry Flanagan, *four casb 2'67, ring l 1'67, rope (gr 2sp 60) 6'67*, 1967, Trustees of the Tate Gallery, London (see cat. no. 19)

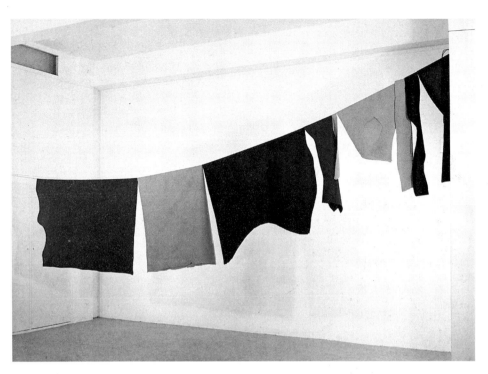

Pl. 45. Barry Flanagan, *Line 1 '67/'68*, 1967/68,
present location unknown

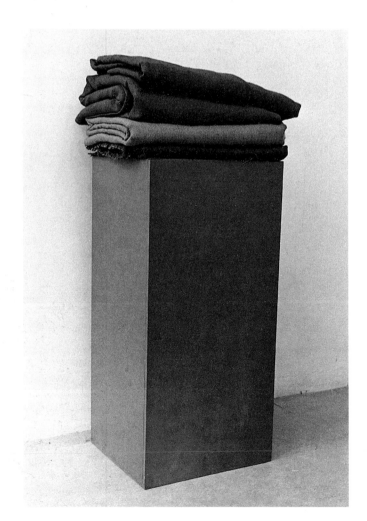

Pl. 46. Barry Flanagan, *Pile 3*, 1968, Arts Council of Great Britain,
London (cat. no. 20)

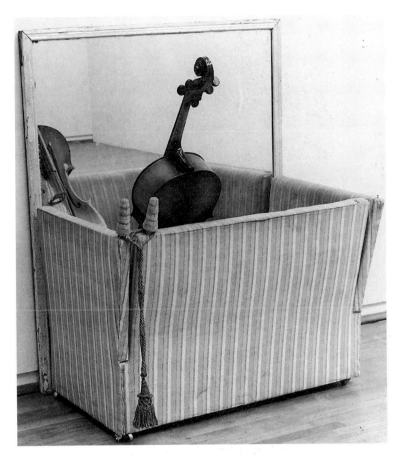

Pl. 47. Barry Flanagan, *'60s dish*, 1970, Trustees of the Tate Gallery, London

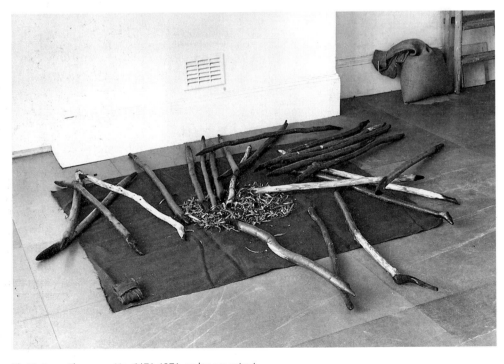

Pl. 48. Barry Flanagan, *No. 6 '71*, 1971, no longer extant

Pl. 49. Barry Flanagan, *The Road to Altissimo*, 1973, Private Collection, Great Britain

Pl. 50. Barry Flanagan, *The House at Seano*, 1974, Collection of Nikos Stangos and David Plante, London (cat. no. 21)

Pl. 51. Barry Flanagan, *Tantric Figures*, 1973, Collection of E.J. Power, London

Pl. 54. Barry Flanagan, *a nose in repose*, 1977-79, Trustees of the Tate Gallery, London

Pl. 52. Barry Flanagan, *Lamb/fish*, 1975, Collection of Pieter Sanders, Schiedam, The Netherlands

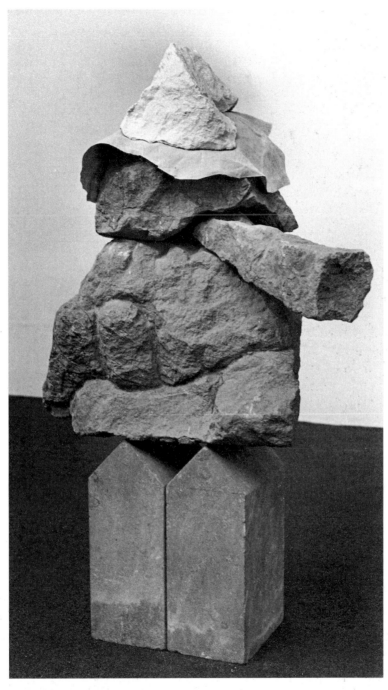

Pl. 53. Barry Flanagan, *Ubu of Arabia*, 1976, Collection of Agnes and Frits Becht, Naarden, The Netherlands (cat. no. 22)

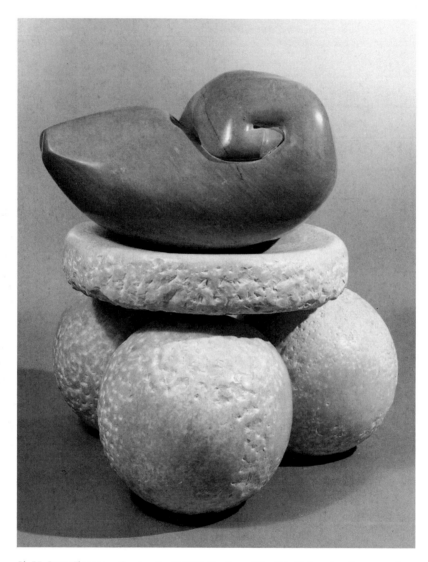

Pl. 55. Barry Flanagan, *Carving No. 2*, 1981, Trustees of the Tate Gallery, London

Pl. 56. Barry Flanagan, *Carving No. 11*, 1981, Private Collection, Akron, Ohio (cat. no. 24)

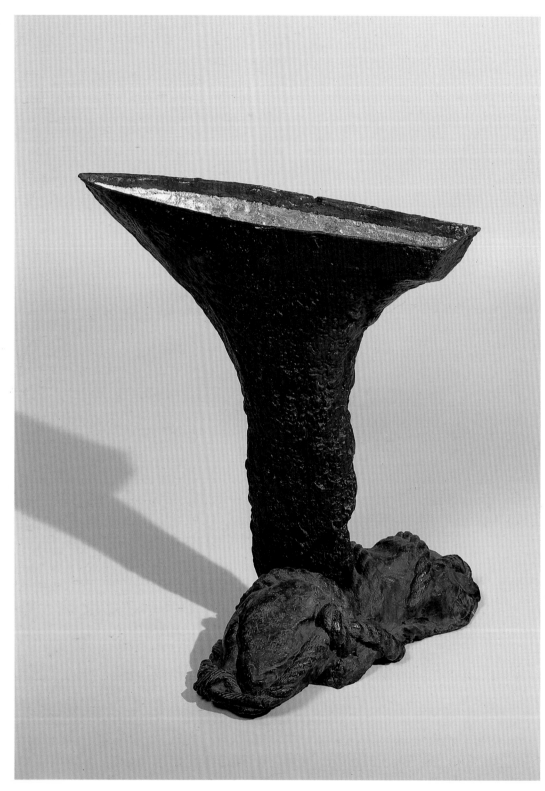

Pl. 57. Barry Flanagan, *Vessel (in Memoriam)*, 1980, The Museum of Modern Art, New York (cat. no. 23)

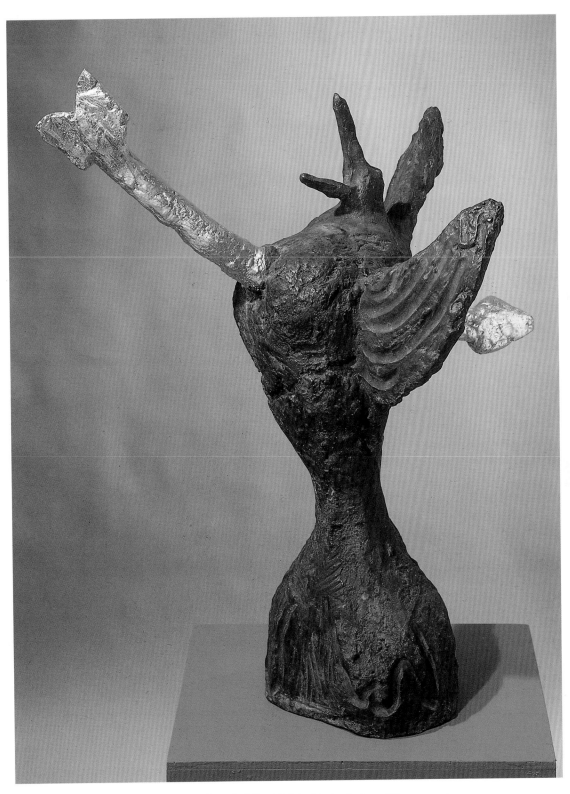

Pl. 58. Barry Flanagan, *Soprano*, 1981, Arts Council of Great Britain, London (cat. no. 25)

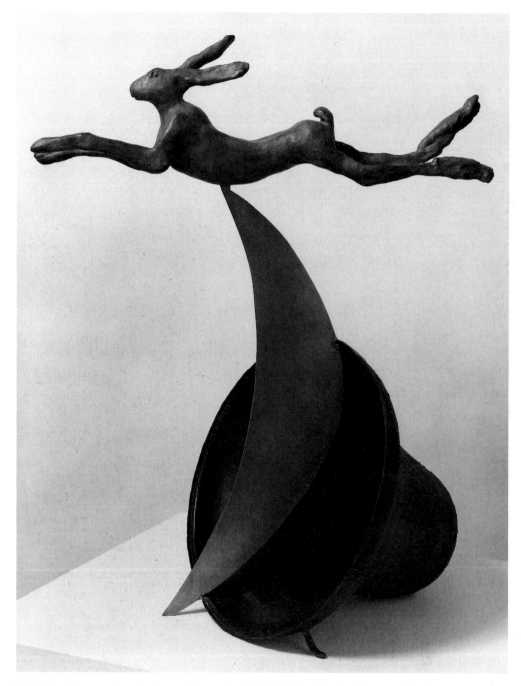

Pl. 59. Barry Flanagan, *Leaping Hare on Crescent and Bell*, 1983, San Francisco Museum of Modern Art, Madeleine Haas Russell Fund Purchase (cat. no. 26)

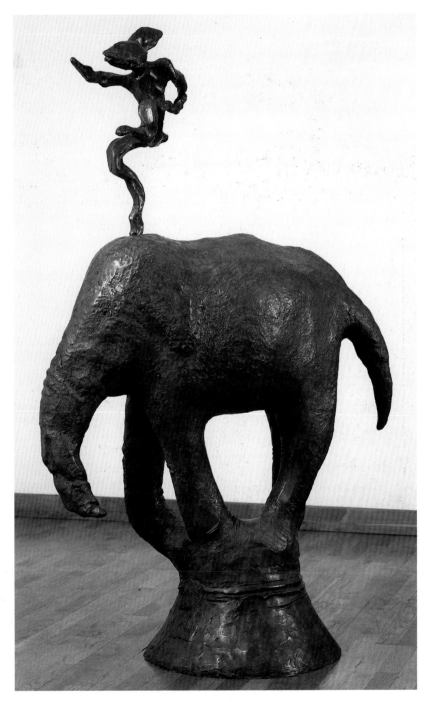

Pl. 60. Barry Flanagan, *Baby Elephant*, 1984, The Art Institute of Chicago, Twentieth Century Discretionary Fund and the Barbara N. and Solomon B. Smith Fund (cat. no. 27)

By Graham Beal

Richard Long:
"the simplicity of walking,
the simplicity of stones"

The most immediate and striking feature of Richard Long's work is, indeed, its simplicity.[1] On seeing a straight line trodden into a field, three concentric circles drawn on a map, or driftwood arranged in a spiral on a gallery floor, the first impression is one of conceptual elegance and material economy. But this is only the surface of things. As each aspect of Long's work is examined and brought into relationship with others, the effect is one of unusual density; a wealth of references and associations are yielded up that seem out of all proportion to the original minimalistic gesture. Indeed, apart from implying the genuinely radical individuality of a work by Long, "original" is, in fact, a dangerous adjective to apply to his art. What is ultimately as impressive as any formal elegance is the consistent overlap from one area to the other. The sculptures in the galleries derive from the walks; the routes of his walks are invariably determined by geometric shapes akin to those of the sculptures; the photographs make accessible sculpture made on walks in remote places; and so on. There is a seamlessness about Long's activities that beggars tired notions of breaking down barriers between art and life and that makes much art of its kind — the found object/assemblage school — seem baroque and bombastic by comparison. Certainly it makes writing about his work curiously difficult. As Anne Seymour wrote, "Wherever you begin, before you have got very far, you find yourself discussing something else. . . . There is a lightness of touch and magic quality which defy crude investigation."[2]

Richard Long attended the West of England College of Art in Bristol for a while but was, according to his own account, suddenly asked not to return after the vacation. He still, he says, does not know why.[3] In 1966 he enrolled at St. Martin's in the now-famous vocational course, pioneered by Anthony Caro, Kenneth Martin, and Phillip King, of which Barry Flanagan, a fellow student, has remarked, "There was almost constant debate, profusely illustrated by the goods."[4] What Long found most valuable to him, however, was neither "debate" nor "goods," but the freedom to do what he wanted.

A SCULPTURE IN BRISTOL
1965

Pl. 61 (detail)

He was, he says, already walking and cycling as part of his art; St. Martin's was open-minded enough to give him credit for it.

Whatever the actual dynamics for Long at St. Martin's, his first recorded works were carried out while there. One of them, *A Line Made by Walking England 1967* (pl. 63), is exactly what the title says it is. The artist walked up and down the same line on a grassy area until the trodden grass was clearly discernible. He then recorded the result by photographing it head-on. Here, in an apparently dead-pan image very early on in his career, can be sensed some of the "magic" of the artist. The line works both perspectively and formally; it indicates the space of the field and asserts the two-dimensionality of the picture plane. What initially seemed like a mere statement that avoided formal issues is a careful and telling composition, and one that, moreover, involves the viewer immediately. The camera's viewpoint is Long's as he walked, and it takes no great effort for viewers to re-create the walk in their own imagination, vicariously sharing the effort and the achievement. Thus is the artist's presence evoked, even though he is no longer there. Long's act comes to symbolize all the paths that have been made by men throughout history, and his photograph of his sculpture becomes a metaphor for the transcience of human life in the face of geological time — all this from a simple photograph of a simple activity.

But paths made specifically to walk on can be a positive barrier to experiencing nature in that they help the walker to negotiate the landscape by avoiding its most difficult and inconvenient features. The geometric forms, frequently concentric circles or squares that Long draws on a map (see pls. 64, 69, 75) and then walks to the best of his ability, usurp the helpful and protective role of footpaths. By imposing arbitrary artistic will on a map, Long thrusts himself into a more direct relationship to nature than the one experienced by the average backpacker. Now that such awkward things as steep inclines and running streams have to be negotiated directly, according to artistic plan, Long's abstract imposition on the map (itself an abstraction of nature) quickly becomes an imposition on himself. He is the one who suffers the full effects of drawing lines on the landscape and when he has finished a walking sculpture, the landscape has not, in any sense whatsoever, been changed. The only change is in Long and in the viewer who responds to the record of the walk. By a nice paradox the geometric shapes that Long draws on the map act as foils to the topographical detail. Contour lines, rivers, houses, ruins, prehistoric mounds, and much else all become somehow more tangible, more real, when confronted by Long's lines, and the question of arbitrary form is rendered moot.

On walks that are predicated less in geometry, Long will take time to make sculptures from nearby materials. A circle of stones in Ireland (pl. 66), a line of stones in the Himalayas (pl. 67), a square of brushwood in Bolivia — he always avails himself of what is there, adding nothing, removing nothing, simply rearranging and (having photographed the result) leaving. As many of these sculptures are in remote places, they have the potential of lasting a long time, but that is not Long's concern; rather the opposite. They are primarily the physical manifestation of Long's response to time, space, and a particular landscape. There is, indeed, something of the philosopher Bishop George Berkeley in Long: without his photographic record of the sculptures, we would have no way of knowing that they existed.

Long's way of working inevitably caused him to be linked to the Earth or Land Art movement of the late 1960s and the 1970s. As such, "Earth Art" (American particularly) was simply an extension of gallery-spawned art, an opportunity to make even bigger objects in wide open spaces. Long finds the association uncomfortable. His work is about judicious intervention and involves rearrangement as much as fabrication. In short, while Long in many ways epitomizes the Earth artist, his work is based in an entirely different morality. With characteristic economy, Long has said:

> In the sixties there was a feeling that art need not be a production line of more objects to fill the world. My interest was in a more thoughtful view of art and nature, making art both visible and invisible, using ideas, walking, stones, tracks, water, time, etc. in a flexible way.... It was the antithesis of so-called American "Land Art," where an artist needed money to be an artist, to buy real estate to claim possession of the land, and to wield machinery. True capitalist art. To walk in the Himalayas . . . is to touch the earth lightly . . . and has more personal physical commitment, than an artist who plans a large earthwork which is then made by bulldozers. I admire the spirit of the American Indian more than its contemporary land artists. I prefer to be a custodian of nature, not an exploiter of it. My position is that of the Greens. I want to do away with nuclear weapons, not make art that can withstand them.[5]

Long has, if anything, moved from the land into the gallery and, in formal exhibition spaces, he brings to his simple arrangements of stones or sticks his profound experience of nature (see pls. 73, 74, 76-78, 81). To liken his quiet but eloquent arrangements of lovingly selected particles of nature to the contemporaneous materialist Minimalists is seriously to miss the point. Although sharing a number of characteristics, they are hardly even dialects of the same language. Minimalism is reductivist and aims, through strict self-limitation, at a kind of total control./Long's work is deeply circumstantial. Wherever he is working, he finds that "Mountains and galleries are both/in their own ways extreme, neutral, uncluttered;/ good places to work./A good work is the right thing in the right/ place at the right time. A crossing place."[6] Economical though Long's works are, he is no formalist. His lines of stones or mud circles are about the power of nature and, placed in pristine, not-so-neutral gallery spaces, they become correspondingly eloquent; the specificity of their source — be it granite from Vermont or mud from the Avon (pl. 79) — serves only to increase awareness of the overwhelming variety of natural form in the world. Long's gallery pieces not only have the power to transport the viewer to distant places, they also act as a stimulus to a greater awareness of the viewer's surroundings, closer to home. As one writer put it, "If against all odds we have persisted in the romantic views of Long as an artist, perhaps it will become clear that Long is a realist working with the sublime . . . a bucket of mud thrown at a gallery wall may bring this home."[7]

In keeping with the artist's global orientation, Long attaches little or no significance to his nationality. Even so, while by no means limited to British culture, the walk through the landscape does seem to have had particular significance for it. In the 18th century, Samuel Johnson prided himself on having walked through five counties in

TURF CIRCLE
ENGLAND 1966

Pl. 62

one day; more to the point, walking was a *sine qua non* of William Wordsworth's poetry. Walter Scott's novels are as much about landscape as they are about historical characters. While in art, of course, the position of James M.W. Turner and William Constable needs no elaboration. The pictorial soul perhaps closest to Long's is that of John Sell Cotman, although their means are greatly different: Cotman, the 19th-century watercolorist, Long, the 20th-century conceptualist, but like Long, Cotman traveled quietly — a journeyman recording the reality of man in nature with a minimum of fuss, and brought to his landscapes a sense of order that verges on the geometric. The parallels may be fortuitous, but they are, nevertheless, strong. Against this "Englishness" must be set the wider context of Long's career. If Cotman was working at a time when contact with Europe was made difficult by war, Long has worked in a time when English art was scrambling to be as modern and internationalist as possible. But where many of Long's contemporaries were concerned with art issues and the status of their art in a scale measured from New York, Long himself took only what he wanted and walked away to pursue his own interests.

Several writers, notably Anne Seymour and David Reason, have convincingly argued that Long's spiritual parallels are to be found in the related oriental philosophy of Taoism and Zen Buddhism.[8] This tendency has also been remarked in the work of Barry Flanagan and David Nash, but it perhaps finds most thoroughgoing expression in Long's work. Patience, respect for nature, assertion through humility, concentration on the matter at hand — these are all features central to Long's work that would be recognized by any Zen master. When Long sets aside an hour to walk each of four concentric circles in a landscape, he is not indulging a conceptual whim, but is focusing his attention even more firmly on the physical fact of walking in a real landscape. In ritualizing the activity, Long accentuates its factuality.

Long's art, so refined-looking and, often, so physically removed, is almost shockingly matter-of-fact. Each of his sculptures, word pieces (see pls. 68, 72, 80), mud drawings, by themselves assert the physical facts of a particular spot in the world. Each one bears witness to Long's claim that his "work is real, not illusory or conceptual. It is about real stones, real time, real actions."[9] The wonder of it is that it does not stop there. So focused is the reality of each of Long's statements that they act as touchstones, releasing a wealth of associations and putting the viewer back in contact with nature.

Words have always been important in Long's work. Whether under his own photographs or arranged in a geometric composition. They are used with characteristic care: that is to say, sparely and sans-serif. As such, they heighten the meditative quality of his work and permit certain facts, crucial to the artist, often poetic to the viewer, to be incorporated. These words, too, are real; an integral part of Long's experience and, like all other components of his work, miraculously eloquent in their reticence; all others are, as Long cautioned in his own artist's statement of 1980, merely "words after the fact."

Notes

1.
See Richard Long, *Five six pick up sticks/Seven, eight, lay them straight* (London: Anthony d'Offay Gallery, Sept. 1980).
2.
Anne Seymour, "El Estanque de Bashō — una nueva perspectiva," in *Piedras Richard Long* (Madrid: Ministerio de Cultura, Dirección general de Bellas Artes y Archivos and The British Council, 1986).
3.
Conversation with the author, London, Oct. 1985.
4.
Barry Flanagan, *Barry Flanagan: Sculpture* (The British Council, exh. cat. for Biennale di Venezia, 1982): 79.
5.
Richard Long in Suzi Gablik, *Has Modernism Failed?* (New York: Thames and Hudson, Inc., 1984): 44.
6.
Long (note 1).
7.
Seymour (note 2).
8.
Ibid. and David Reason, "Richard Long," *The British Show* (The British Council, exh. cat. for The Art Gallery of New South Wales, 1985): 101-104.
9.
Long (note 1).

A LINE MADE BY WALKING
ENGLAND 1967

Pl. 63 (cat. no. 28)

UNTITLED
1970

Pl. 64 (cat. no. 29)

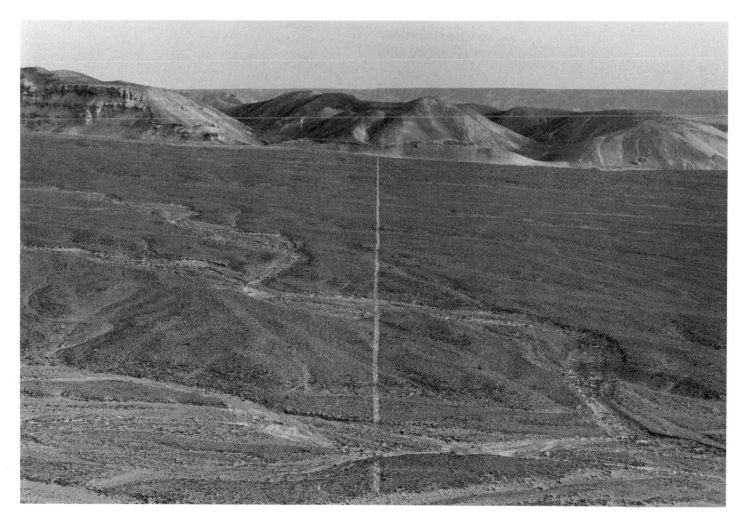

WALKING A LINE IN PERU
1972

Pl. 65

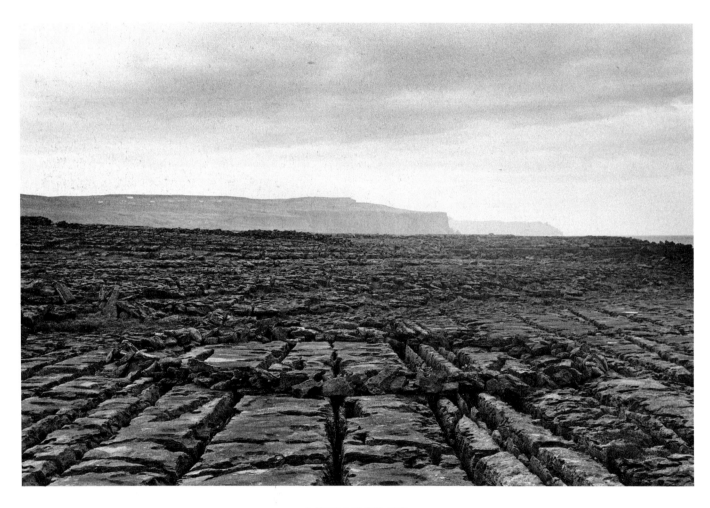

A CIRCLE IN IRELAND
1975

Pl. 66 (cat. no. 30)

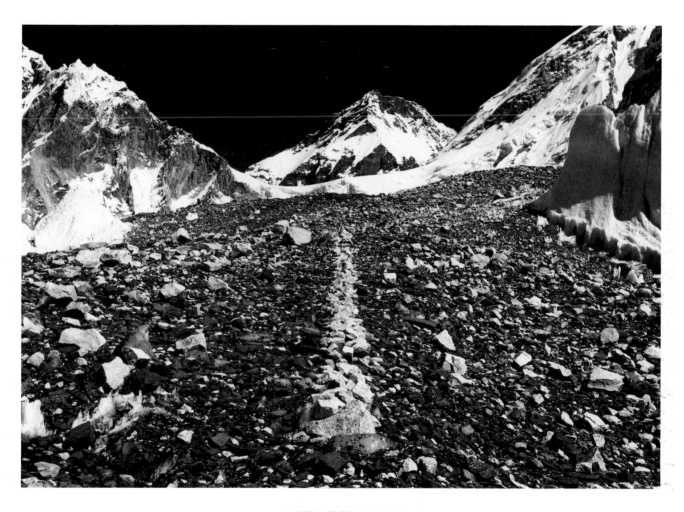

A LINE IN THE HIMALAYAS
1975

Pl. 67

GRANITE LINE

SCATTERED ALONG A STRAIGHT 9 MILE LINE
223 STONES PLACED ON DARTMOOR

ENGLAND 1980

GRANITE LINE
1980

Pl. 68

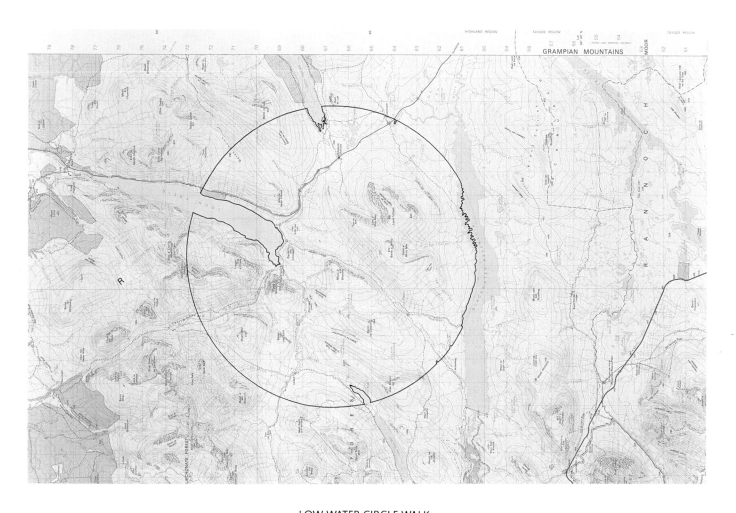

LOW WATER CIRCLE WALK
A 2 DAY CIRCULAR WALK AROUND AND INSIDE A CIRCLE IN THE HIGHLANDS
SCOTLAND SUMMER 1980

Pl. 69

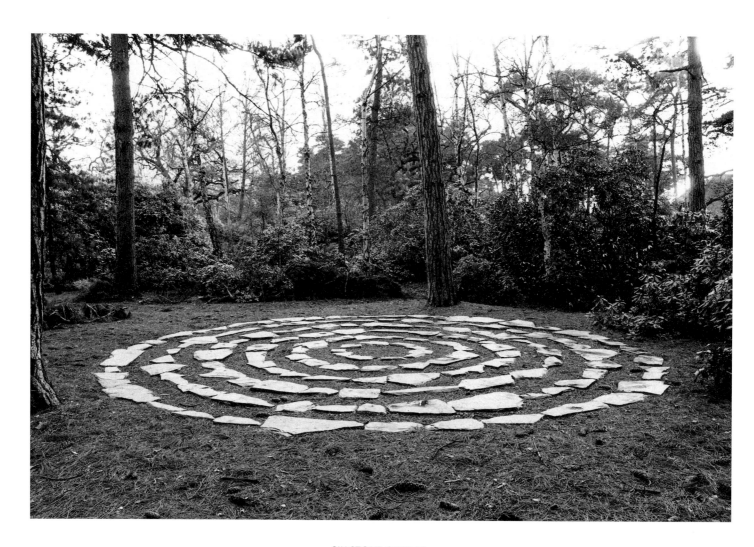

SIX STONE CIRCLES
LONDON 1981

Pl. 70

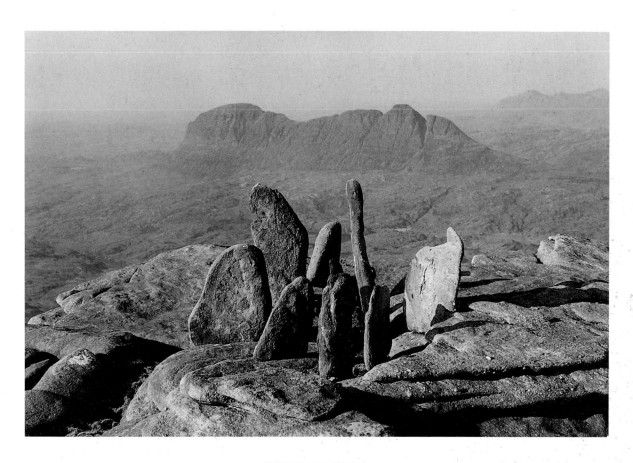

STONES AND SUILVEN
SCOTLAND 1981

Pl. 71

HEAVIER SLOWER SHORTER
LIGHTER FASTER LONGER

A FOUR DAY WALK IN ENGLAND
PICKING A STONE UP EACH DAY AND CARRYING IT.
A FOUR DAY WALK IN WALES
SETTING DOWN ONE OF THE STONES EACH DAY.

1982

Pl. 72

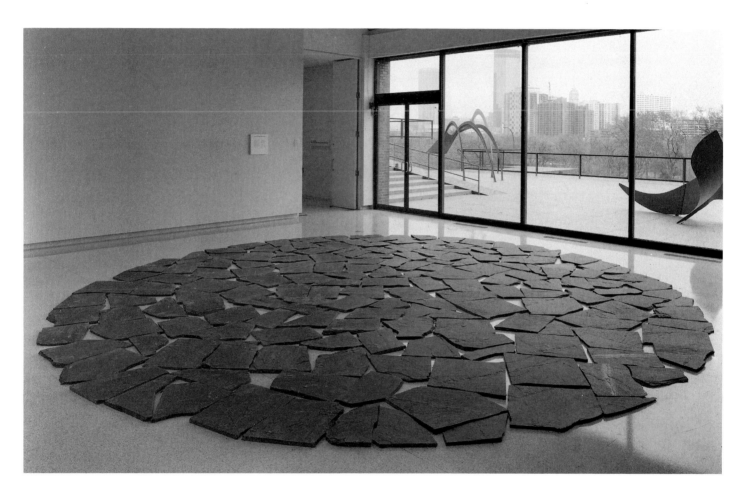

MINNEAPOLIS CIRCLE
1982

Pl. 73 (cat. no. 31)

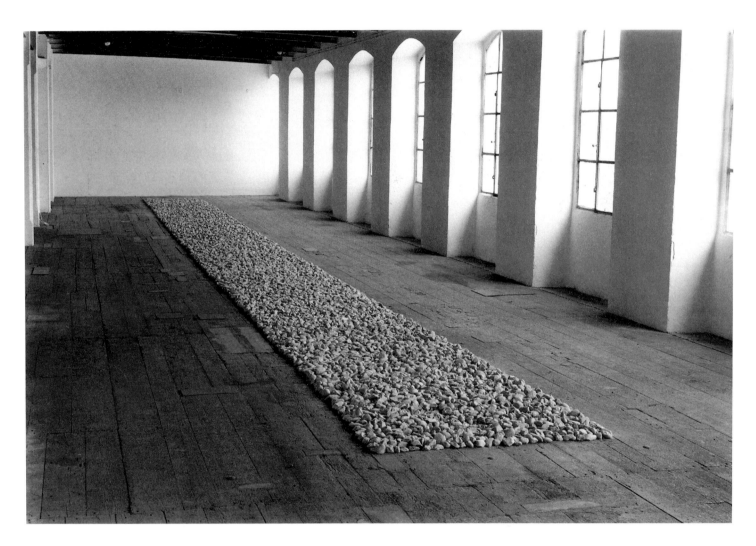

LINE OF LAKE STONES
TURIN 1983

Pl. 74

TWELVE HOURS TWELVE SUMMITS
1983

Pl. 75 (cat. no. 32)

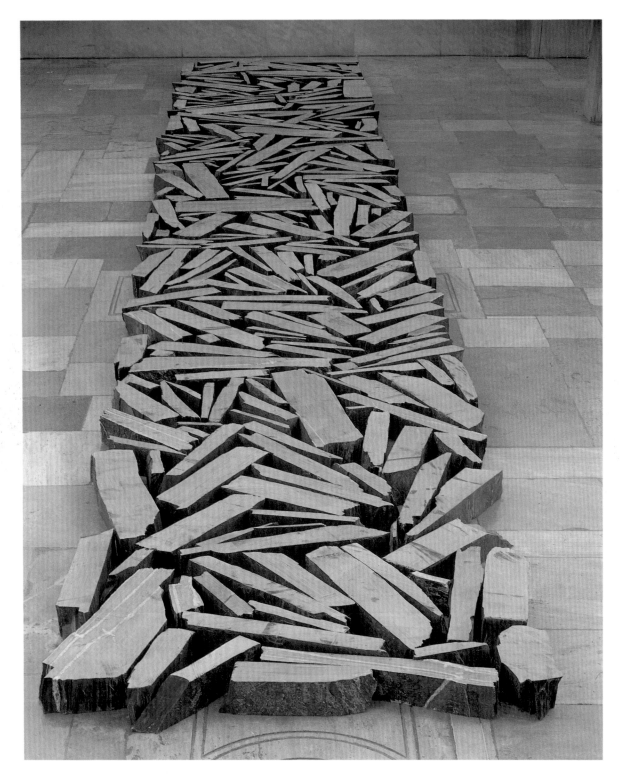

ATHENS LINE
1984

Pl. 76

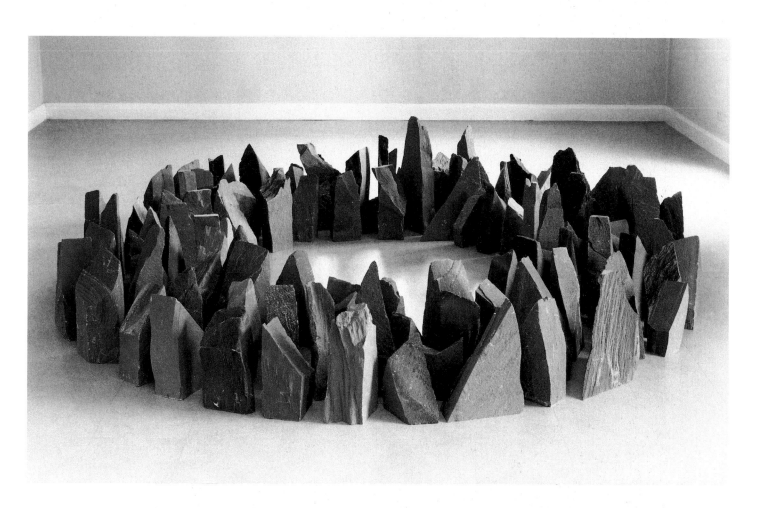

ELTERWATER RING
KENDAL 1985

Pl. 77

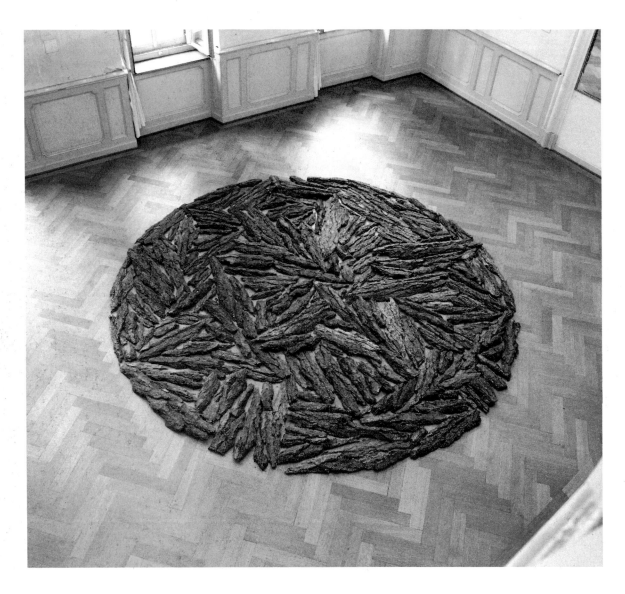

PINE TREE BARK CIRCLE
FÜRSTENAU SWITZERLAND 1985

Pl. 78

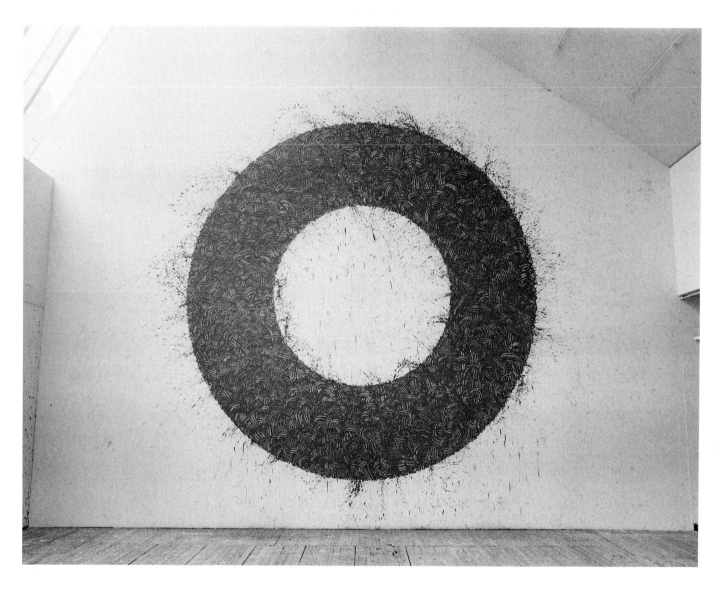

RIVER AVON MUD CIRCLE
MALMÖ 1985

Pl. 79

WIND STONES

LONG POINTED STONES

SCATTERED ALONG A 15 DAY WALK IN LAPPLAND
207 STONES TURNED TO POINT INTO THE WIND

1985

1985

Pl. 80 (cat. no. 33)

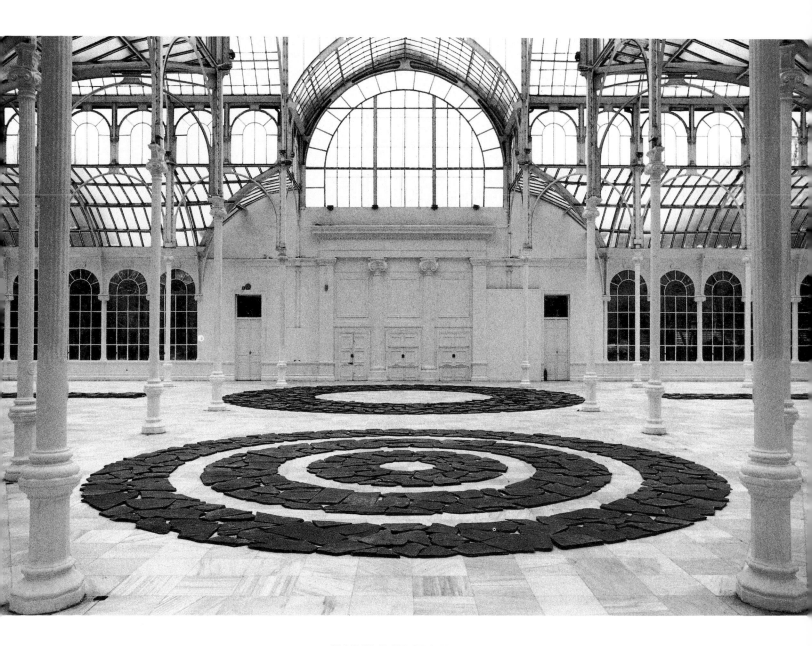

SEGOVIA SLATE CIRCLES
MADRID 1986

Pl. 81

133

By Graham Beal

David Nash:
"Respecting the Wood"

Immediately upon leaving art school, David Nash removed himself to the remote Welsh town of Blaenau Ffestiniog (see pls. 83, 84). Though English, his father's family had connections with that part of the world and Nash knew that it would be a place where a "starving artist" could both live economically and work undistracted by the noise of the art scene. In doing so, Nash asserted from the very beginning that, for him, his way of making art went hand-in-hand with his way of life — an attitude that has found particularly strong expression in the work created since 1977, all of which exploits, with great sensitivity, the anatomy of living trees.

Before 1977 Nash's work revolved around found timber — milled lumber, dead trees — and his first sculptures at Blaenau Ffestiniog were rickety-looking, painted towers. Basically they were an extension of interests held over from his days as a student of painting, and Nash described them as "putting colour into space. Wood was a convenient material to put colour onto. I loved putting big colour shapes high up into the air above me. I made a series of 30 ft. high towers of painted wood. I loved the engineering involved, the joints, the weight, the give to the wind."[1] *Chelsea Tower* (pl. 82), an example of this love of engineering, is a complex, cacaphonous structure with elements ranging from basic planks to curving, bio-morphic shapes seemingly suspended high in the air. The most obvious parallels are found in the sculptures of Alexander Calder and the paintings of Joan Miró. Much of Nash's subsequent sculpture has investigated anthropomorphic aspects of a tree's anatomy, and the spirit of Surrealism is never far away from his work. But before Nash was to arrive at the style and methods that characterize his output of the past 15 years, his work underwent radical simplification.

At college in the late 1960s, Nash had been aware of the American Minimalists. His response was mixed. He liked their philosophical vigor but "loathed . . . the objects' . . . simplicity for simplicity's sake; going to great lengths to create a simple object. . . . I admired the geometry of it but wanted something rougher."[2] To Nash, the Minimalists' industrial geometry was too much a thing unto itself — art that had become divorced from a larger context. Nash's own inclination towards geometric simplicity was inseparable from his concern for the natural world. In this sense, as Nash himself

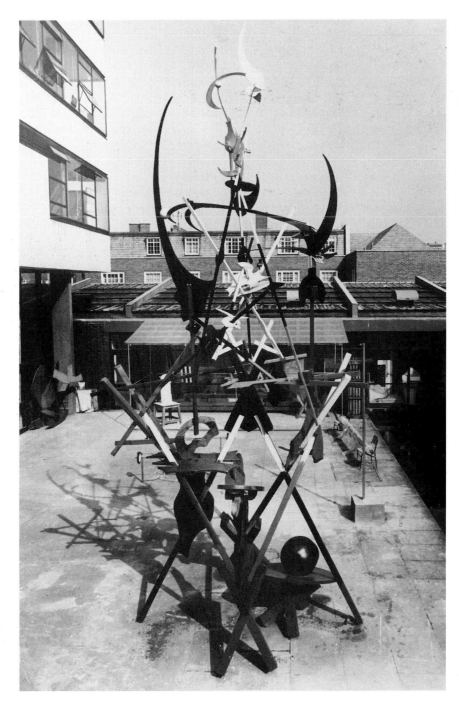

Pl. 82. David Nash, *Chelsea Tower*, 1969, no longer extant

likes to express it, he wished to return geometry to its original home as one of the seven liberal arts "under the protection of the goddess Natura."

A breakthrough for Nash came through his increased appreciation for Constantin Brancusi, whose life and work provided direct inspiration for his own. It was not a matter of imitation, but of learning from example: firstly of the simplicity of his life and its integration with work; secondly of the evolution of radical forms that despite their simplicity are always related to nature. Nash moved away from the polychromatic, engineered complexity of his towers and, relying more on natural hues and surface qualities, sought to elicit expressive form from simpler elements. In 1970, in a moment of daring that he understood only incompletely at the time, Nash hacked a large piece of ash tree into nine rough spheres. He enjoyed the exercise as an effort that combined straightforward work with straightforward shapes, but then put the balls aside where they soon became obscured by other pieces. When he came upon them later, they had changed: the wood had been green and as the balls had seasoned in the relative warmth of Nash's studio, they had split. They had, Nash says, "continued to work for me after I had stopped working," and the cracks seemed like mouths grinning at the artist in gleeful impertinence (pl. 86). From now on, Nash was to work exclusively with unseasoned wood, taking advantage of its unpredictable nature to counteract what he has always regarded as "the tyranny of finish." He quickly exploited the accident that resulted in *Nine Cracked Balls* in a series of works. On the one hand, in *Three Clams on a Rack* (pl. 87), the allusion of crack to mouth was given a humorous, descriptive emphasis. On the other, in *Cracking Box* (pl. 100), Nash presents us with a cube, the icon of Minimalism, that is literally being torn assunder by the tensions inherent in its fabrication (a fate shared by not a few industrially fabricated Minimalist boxes).

Much of the tension in Nash's work stems from the untouched nature of the wooden elements (see pl. 85). A tree branch (as is the case with any found object) when brought into a pristine gallery space, takes on added significance. Subjected to close scrutiny, natural and accidental features become formalized: bark becomes texture and color, configuration becomes volume and line, and Nash is fully aware of the effects of his displacements. "An object made indoors," he has said, "diminishes in scale and stature when placed outside. The reverse happens when an object made outside is brought inside, it seems to grow in stature and presence. It brings the outside in with it. The object outside has to contend with unlimited space, uneven ground and the weather. The sculpture I show inside is meant to be seen inside, it relates to the limited space, the peculiar scale, and the still air."[3] *Three Dandy Scuttlers (Chorus Line)* (pl. 88) was one of the last pieces Nash made from found wood and it epitomizes his works of the late 1970s. Very little seems to have been done to the elements that comprise it: three crudely sawn blocks sit on shaky tripods, but the overall effect is one of well-organized rhythm. Geometry and irregularity are evenly balanced and, finally, through the title, overlaid with the gentle humor that informs so much of Nash's anthropomorphism.

In 1977 Nash embarked on a project that can be construed as being both an extension of his respect for wood and a complete reversal of his old practice of using reject trees or timbers. On a piece of land in Maentwrog, not far from Blaenau Ffestiniog, Nash planted a circle of ash seedlings. Called *Fletched Over Ash Dome* (pls. 89-91), this slow-growing sculpture will, with the artist's periodic ministrations, reach maturity in the early years of the next century. As Nash himself wrote, "A circle of young ash trees fletched and woven into a thirty foot dome fletched three times at ten year intervals then left alone. A silver sculpture in winter, a green canopy space in summer, a volcano of growing energy."[4] When complete it will maintain itself, leaves will grow on the outer branches, presenting a natural mass of foliage, but on the inside no growth will occur because of lack of sun, and the shape of the dome will be perfectly clear. The sculpture should, the artist estimates, last about a hundred years, after which it will begin to decay.

Nash further explored the idea of trees as sculpture during a residency in the Grizedale National Forest, Cumbria, Wales, in 1978, where he implemented a less complicated larch circle planting (unlike the dome at Maentwrog, Nash cannot regularly tend to the larches) and made a series of sculptures that required much cutting, but little carving. *Willow Ladder* consists of two large boughs inverted (in fact, the ladder was planted and eventually took root) and joined in such a way that the smaller branches constitute rungs. Nash built another *in situ* piece at Grizedale in part to acknowledge a substance unseen but essential to his basic material: water. *Wooden Waterway* was created "after a long search [to] find a water source and two fallen trees lying down in a slope. Diverted the water along branch troughs [carved by Nash], through the roots of a fallen oak, down its trunk, off along a thin ash branch trough, through the roots of a fallen sycamore, down its trunk, off along more troughs to finally pour over a stone and disappear into the ground."[5] The work is perhaps stronger conceptually than visually, but Nash's exploration of the ecology of his medium has found an eloquent response from other users of Grizedale. He continues, "The *Wooden Waterway* has lasted years beyond expectation. Walkers who notice it . . . have been repairing it, realigning sections that have come adrift, cleaning out stones and leaves. For such a fragile, *ad hoc*, affair, it is remarkable how it has survived."

The other outdoor work of this period that Nash attaches special significance to is *Wooden Boulder* (pls. 92-95), a roughly spherical chunk of oak, four feet in diameter, cut by the artist and launched into a nearby stream. The artist's original thought was that the boulder would eventually make its way down to the sea, but the stream was too irregular, and after helping it on its way a couple of times, Nash has decided to leave it in a pool at the foot of a small waterfall where it rests, blackened by the action of the water, an inert counterpart to the growing tracery of the *Ash Dome*, a couple of miles away. Nash describes *Wooden Boulder* as his "antifountain."

At Grizedale, Nash had made available to him freshly felled trees and, since 1979, this has been his prime medium. Nash initially received criticism for this action from those who saw it as cruelly wasteful, but the artist's rebuttal of this sentimentalist view is firmly rooted in his deep understanding of the forces that make landscape. In Europe the landscape is bucolic, not arcadian; the result of thousands of years of use and modification — gradual but far-reaching — by human beings. Trees, particularly, are as much the result of husbandry as of nature, and even when not planted by human action,

136

Pl. 83. Exterior, Capel Rhiw, Blaenau Ffestiniog, Wales

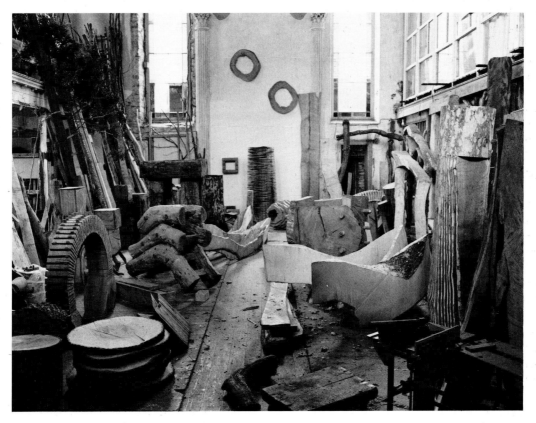

Pl. 84. Interior, Capel Rhiw, Blaenau Ffestiniog, Wales

they can only grow to maturity if protected from deer and sheep, which would otherwise eat the saplings. As Nash has said, "I've never cut a big tree down that still had a lot of life in it, but there is a point when it should be cut, because it's past its prime; it's actually dying. It's better to take that out, use it, and plant other trees."

In 1979 Nash began to work with "condemned" trees: those that were about to be cut down for various legitimate reasons, and, in doing so, he has evolved a way of working that neatly symbolizes his wholistic approach to his life, his work, and his art. Briefly put, having selected his tree and felled it, Nash stays with it, camping nearby, working all day every day until practically every element of the tree has been reconstituted as sculpture; even the smallest twigs are burned in an oven made with local materials, thereby creating charcoal for drawings that retrospectively describe the whole process (see pls. 96-99).

Explaining that he regards each tree as "a vein of materials in space," Nash relies upon the anatomy of each tree to suggest individual sculptures. Even so, he brings to every project a repertory of basic forms that he draws upon where necessary and which he gradually enlarges: boxes and columns, arches and tables, wedges and frames, all these and other basic configurations have found variable expression in different kinds of woods in very different parts of the world. In 1979 it indeed seemed that "Nash, more than any other Land Artist, has made a commitment to place. He has chosen his home and, as an affirmation of his faith that he will continue there, he has started a work that will need tending over the next thirty years. . . . In this, Nash is [Richard] Long in microcosm: the sensibility is the same but, whereas Long travels the world, making, marking, and recording, in distant places, Nash is more sedentary, and content to do the same thing where he has made his home."[6] Subsequently, Nash's work based on single trees has taken him from his eremitic existence in North Wales to places as far apart as The Netherlands, the midwestern United States, Japan, and Australia.

That Nash's work struck a chord in Japan should not be surprising. Much of Nash's attitude towards his work has striking parallels in Zen Buddhist philosophy. Such things as respect for nature, emphasis on simplicity, and quiet concentration, the conviction that only through strict limitations and self-discipline comes complete freedom, all these are notions common to both Zen and Nash. So is, more specifically, the fascination with positive and negative, inside and outside, and economy of means. Nash has never studied Zen in any formal sense, any more than has Richard Long or Barry Flanagan, but both of these artists have, at different times, been put forward as spirits intuitively attuned to the Japanese version of Bud-

dhism.[7] And, like Long and Flanagan, Nash exhibits a lightness of touch that somehow combines protracted meditation with sustained yet regulated effort. Most of all, in distinctly Zen fashion, what Nash does *not* do to the wood seems at least as significant as what he does.

Nash's work is, at root, a direct comment on the relationship of man to nature and a passionate plea for awareness of this and the responsibility that comes from such awareness. Each step he has taken has been based as much on the morality of ecology as on formal considerations: the decision to work out of London, to use discarded wood, to "replace" the trees he uses, to convert condemned trees into sculpture that maintains their identity, all of these affected the kind of work he could make. They are decisions that find socio-political echoes in such groups as the Green party in Germany and the more general back-to-nature movements of the United States and the United Kingdom. But Nash's decisions were all taken to facilitate his making sculpture and sculpture is the vehicle for his concerns. Through selective but incisive use of geometry, Nash collaborates with nature to create simple structures that clearly express his respect for wood and his concern for the earth that yields it.

Notes

1.
Alan McPherson, "Interview with David Nash," *Artscribe* 12 (June 1978): 30.
2.
Conversations with the author, Blaenau Ffestiniog, Nov. 1985. Where no other reference is given, this is the source for all quotations in this essay.
3.
McPherson (note 1): 33.
4.
David Nash, *Fletched Over Ash* (London: AIR Gallery, 1978).
5.
Peter Davies and Tony Knipe, eds., *A Sense of Place: Sculpture in Landscape* (Sunderland, England: Ceolfrith Press, 1984): 103.
6.
Hugh Adams, "The Woodman," *Art and Artists* 13, 12 (Apr. 1979): 46, 47.
7.
For Richard Long and Buddhism, see Anne Seymour, "El Estanque de Bashō — una nueva perspectiva," in *Piedras Richard Long* (Madrid: Ministerio de Cultura, Dirección general de Bellas Artes y Archivos and The British Council, 1986). Michael Compton recalled how Barry Flanagan's work of the 1960s was "considered at the time (more or less) to be Zen, Dada, biomorphic and to be testing the limits of the medium"; see his "A Developing Practice," *Barry Flanagan: Sculpture* (The British Council, exh. cat. for the Biennale di Venezia, 1982): 17.

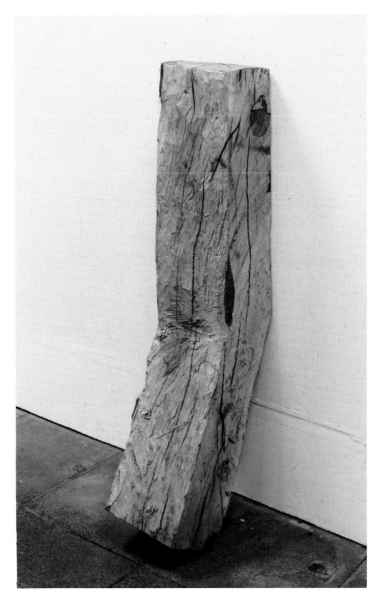

Pl. 85. David Nash, *Wall Leaner*, 1975, Sandie Barker Associates, London
(cat. no. 35)

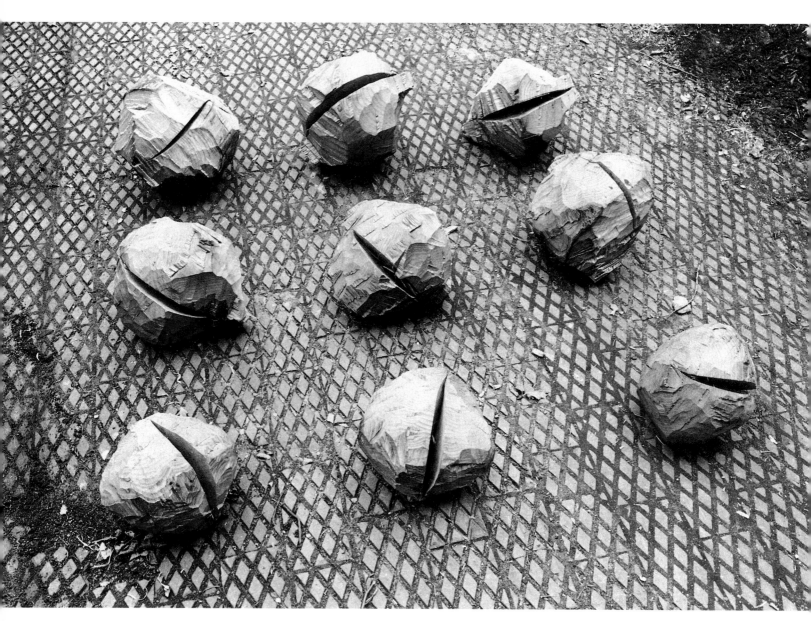

Pl. 86. David Nash, *Nine Cracked Balls*, 1970, Collection of the artist

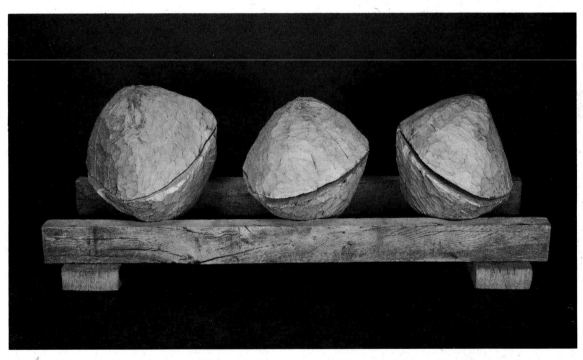

Pl. 87. David Nash, *Three Clams on a Rack*, 1976, Solomon R. Guggenheim Museum, New York, Gift of Mr. and Mrs. Jacob M. Kaplan (cat. no. 36)

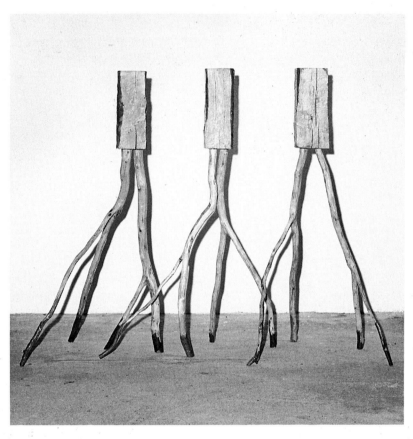

Pl. 88. David Nash, *Three Dandy Scuttlers (Chorus Line)*, 1976, Collection of Mr. and Mrs.
W. Riker Purcell, Richmond, Virginia (cat. no. 37)

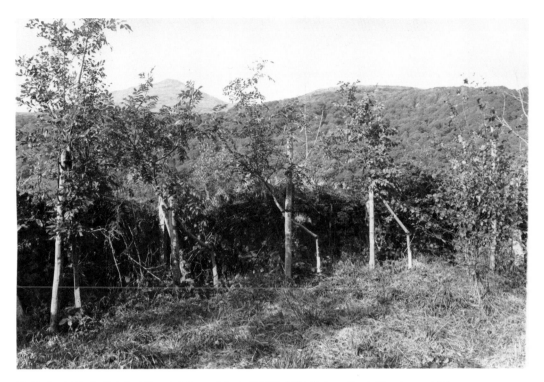

Pl. 89. David Nash, *Fletched Over Ash Dome* (planted 1977), 1983, Caén-y-Coed, Maentwrog, Wales

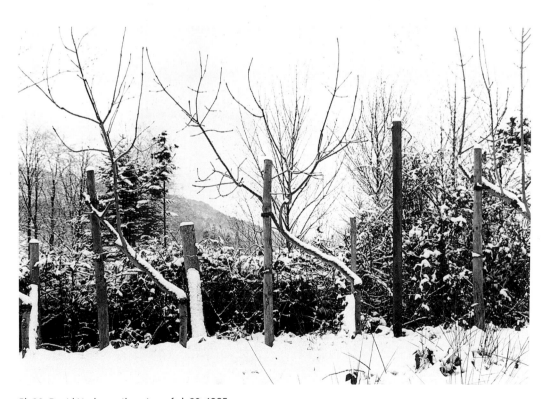

Pl. 90. David Nash, another view of pl. 89, 1985

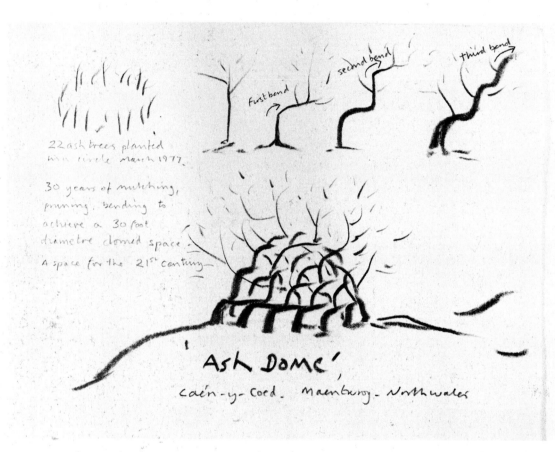

Pl. 91. David Nash, Drawing for *Fletched Over Ash Dome*, 1986, Collection of the artist

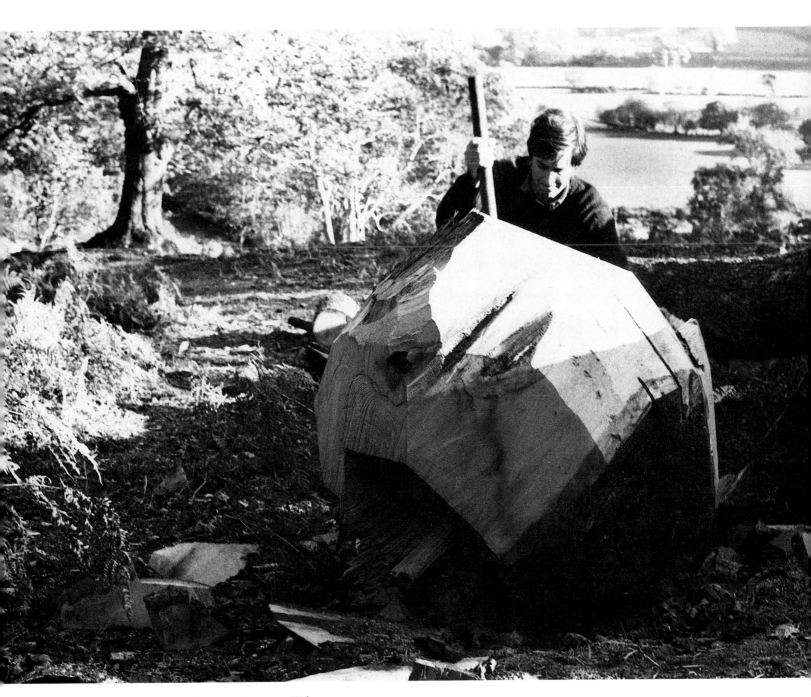

Pl. 92. David Nash, *Wooden Boulder*, 1978, Maentwrog, Wales

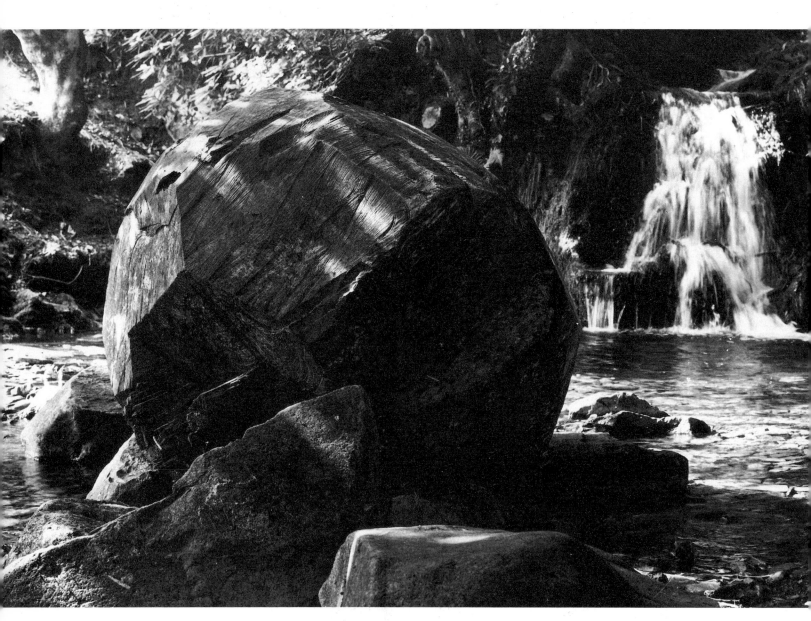

Pl. 93. David Nash, another view of pl. 92, 1980

Pl. 94. David Nash, another view of pl. 92, 1981

Pl. 95. David Nash, another view of pl. 92, 1982

Pl. 96. David Nash, *Wood Stove*, 1979, Maentwrog, Wales

Pl. 97. David Nash, *Sea Hearth*, 1981, Isle of Bute, Scotland

Pl. 98. David Nash, *Slate Stove*, 1981, Blaenau Ffestiniog, Wales

Pl. 99. David Nash, *Snow Stove*, 1982, Kotoku, Japan

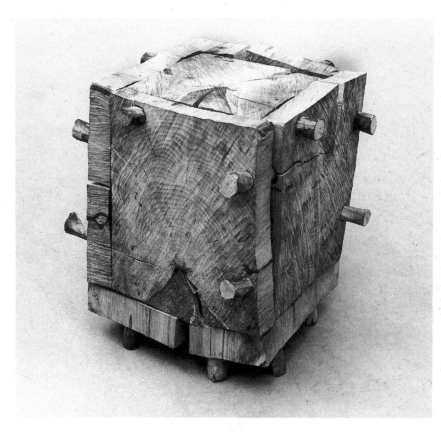

Pl. 100. David Nash, *Cracking Box*, 1979, Sheffield City Art Galleries, England (cat. no. 38)

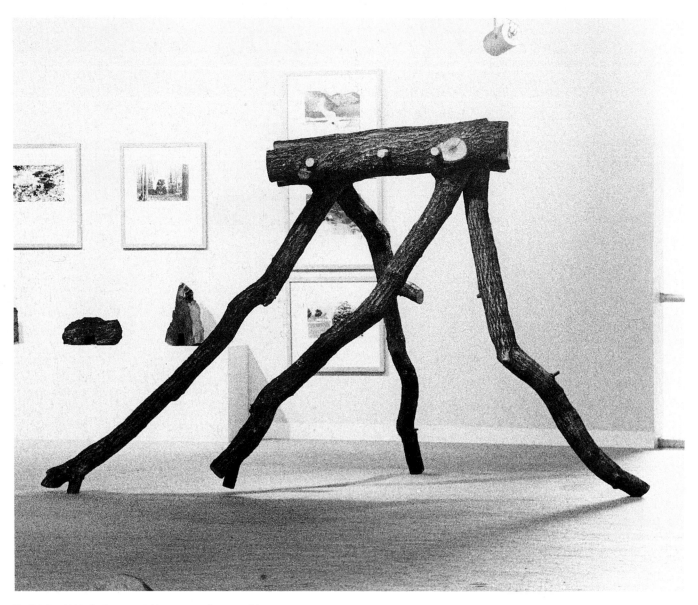

Pl. 101. David Nash, *Running Table*, 1980, Collection of the artist (cat. no. 39)

Pl. 102. David Nash, *Ash Branch Cube*, 1981, Collection of the artist (cat. no. 40)

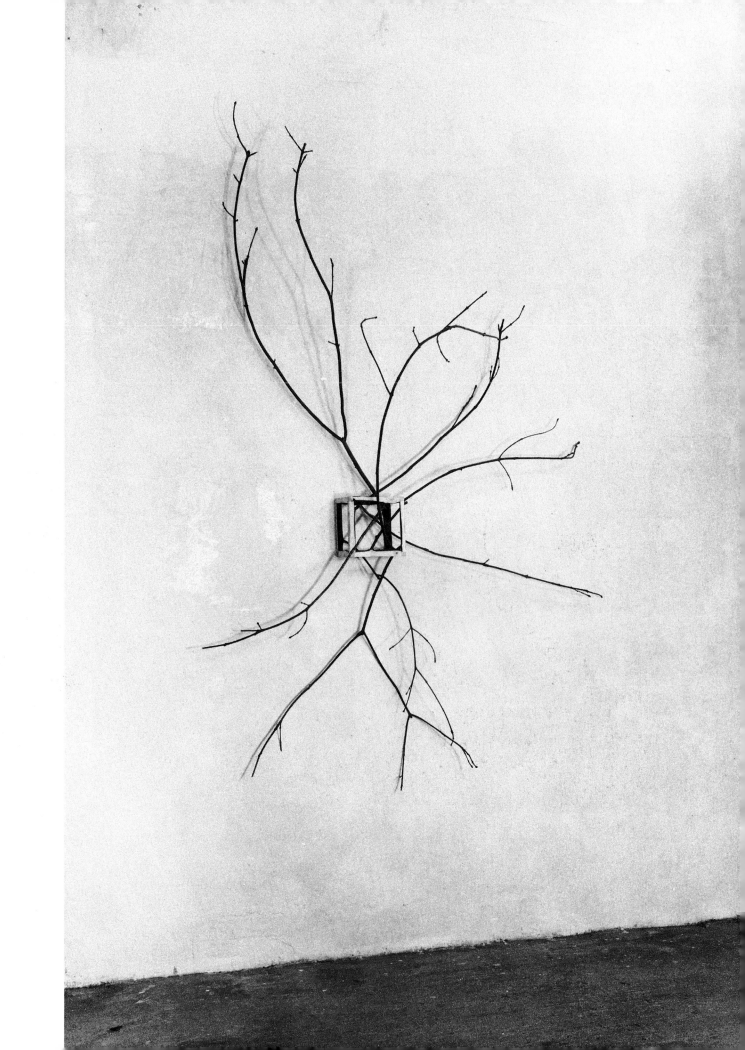

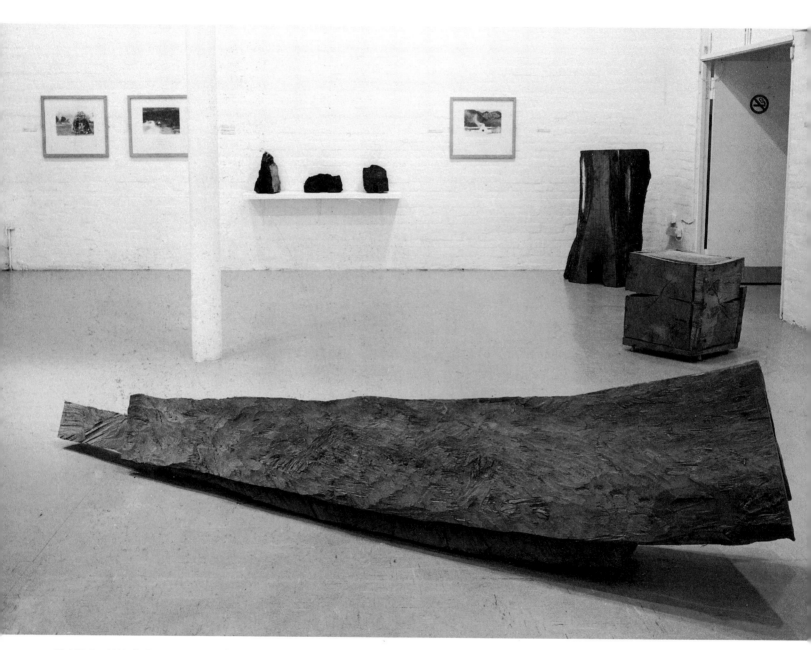

Pl. 103. David Nash, *Ram*, 1981, Scottish National Gallery of Modern Art, Edinburgh

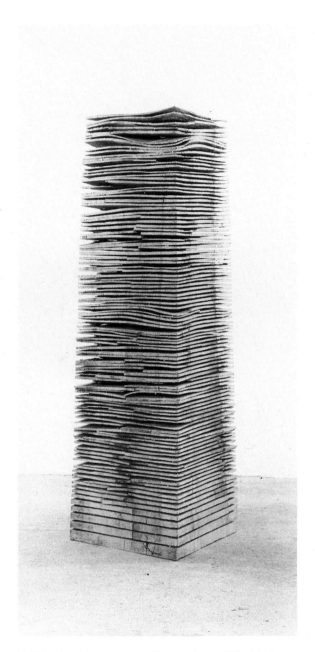

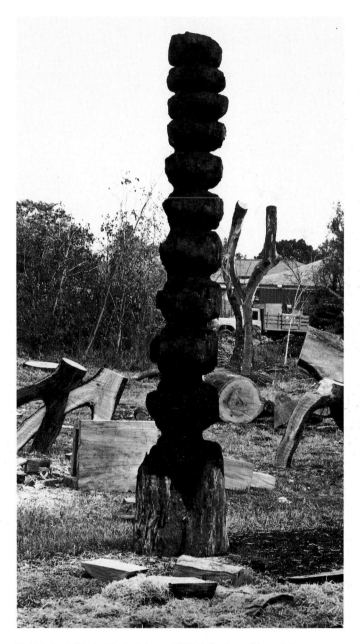

Pl. 104. David Nash, *Crack and Warp Column*, 1985, Private Collection (see cat. no. 43)

Pl. 105. David Nash, *Black Column*, 1983, Collection of the artist (cat. no. 41)

By Mary Jane Jacob

Bill Woodrow:
Objects Reincarnated

Bill Woodrow's art since 1981 results from a seemingly mystical transformation of material into images, as objects appear actually to become different objects. Woodrow endows with verity invented images literally cut from unrelated object-hosts. To engender this unnatural evolution, he uses imagination and metal cutters to alter items that seem to be wholly reincarnated, taking on a new, but equally recognizable, form. Increasingly incorporating into his art issues of content relevant to the everyday world from which he draws his materials and images (for both parent and child objects), Woodrow also imbues his work with aspects of his own political, societal, and humanistic concerns.

A dialogue between reality and invention began in the work Woodrow made as a student.[1] He chose to enroll in 1968 at St. Martin's School of Art (after one year of study in Winchester, where he had grown up), attracted by the dynamism of this new center of sculptural thought. Initially he undertook earth-related projects, which he had already been investigating the previous year; but finding the urban atmosphere of London to be inhibiting, logistically and intellectually, on his work with nature, he began to fabricate man-made equivalents. These re-creations or bits of "fake nature" took the form of rocks made of polystyrene (*Sleeping Sheep Rocks*, 1970, no longer extant) or a patch of natural materials to suggest a field. Looking to forms of "city nature," Woodrow also used available wildlife: pigeons. In Soho Square he did a temporary installation of pigeons gathered around a ring of feed. An urban outdoor work in the form of a circle (the shape of a classic Richard Long sculpture), the piece was eroded as the satisfied pigeons flew away. Woodrow also made papier-mâché pigeons which he placed indoors to be part of a naturalistic setting which he planted in the corridor of St. Martin's. Humor, which has become a key feature of Woodrow's work, was already evident in these confrontations between nature and the urban world.

Pointing to the technique of cutting, a method of transformation for which Woodrow would become well-known, was an installation that he made with fir trees during this period. Slicing a group of trees lengthwise, he made a row of splayed trees set trunk bottom to trunk bottom; in another sculpture he placed tree trunks in a contin-

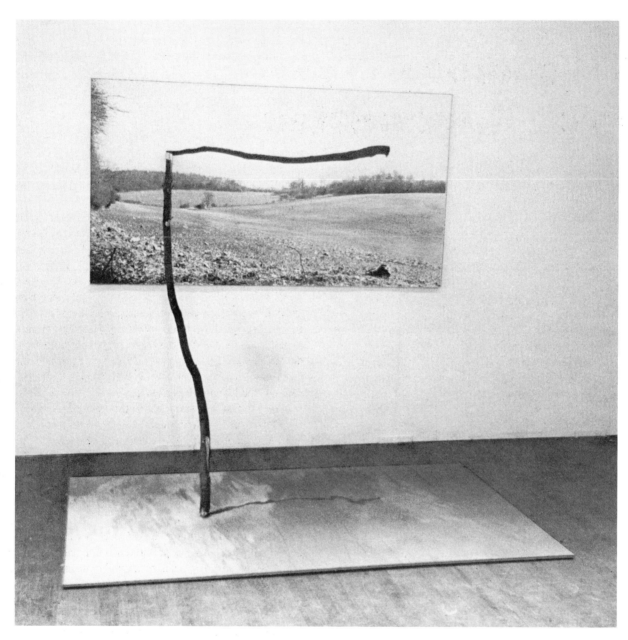

Pl. 106. Bill Woodrow, *Untitled*, 1971, Private Collection, London

uous line to create a 50-foot-long branch. Woodward's use of fragments of natural materials in arrangements on the floor was influenced by the work of Richard Long. However, it was the dissecting of an object – here a tree – to make of it something else (either a formal arrangement, such as rows, or the illusion of an actual thing, a single branch), that would prove for Woodrow to be a fruitful method of working.

Toward the end of his studies at St. Martin's, Woodrow produced a series of photo-sculptural works which became his first entry into the professional art world.[2] Made from branches found on journeys outside London, these works were Woodrow's way of bringing the countryside back to the city and into his studio. He used these natural elements to point out distinctions between urban and rural realities, and between representation and object. For example, he photographed a stick in two locations: first in its natural surroundings, then again its reflection in a pond in London. The two photographs – the country view on the wall and city pond on the floor – were linked by the stick iself: the real object joining its two representations (pl. 106).

Following the completion of his formal education in 1972, Woodrow began to teach full-time at Loughton College in Essex and for one year, beginning in 1974, part-time at St. Martin's. These increased demands as well as beginning a family left little time for making art and, for the next six years, Woodrow produced only a few works. However, in 1978 a dramatic change occurred when he decided to take a studio space in a former factory with other artists (including Richard Deacon) on Acre Lane in the Brixton area of London. This situation provided incentive and the opportunity to undertake a new body of work. Having previously worked in experimental, more conceptual art media, Woodrow felt he now wanted to get involved in making things manually, directly, and not through intervening technological processes. He began by stacking, sandwiching, and embedding found and construction materials. He used the streets and refuse piles as his sources, not because of an ideological stance, but out of cost-saving necessity. Whether found timber or broken wooden furniture, these items were thought of as material without inherent content. Some works were piles of wood with special attention given to defining the edges; others were pieces of wood inlaid with contrasting wood (see pl. 107), emphasizing the joins where Woodrow had cut the original form.

The notion of one material embedded into another took on a very different character in 1979 when Woodrow chose to make works using everyday functional items. The use of common objects, which he shares with Tony Cragg, among others, was a direction that marked the ultimate break with the abstraction of the Caro generation. The inherent identity of the objects has remained evident in Woodrow's work, signifying not only a radical move away from abstraction, but also from the avant-garde trends of Conceptual Art of the late 1960s in which he had been trained. Beginning with single objects and then linking several disparate items, Woodrow found a means of making new things and creating new identities.

Woodrow's development toward the use of object as material began with a fossilized series of actual objects set into plaster or concrete. The metaphor and image of fossils in these early works already lent to the objects encased a sense of past life, a notion that

they were once "alive" and functioning. At this time Woodrow was influenced by visits to the Natural History Museum which he frequented with his children; attracted to the fossils he saw there, his reaction was more visual than intellectual. Woodrow's first fossil-object, a record player, was buried in plaster which was partially chiseled away to reveal, or permit rediscovery of, the object. Then Woodrow broke up a cast of this work into smaller pieces and set them into a bed of plaster (an allusion to volcanic lava) around the pieces, altering further the image of the original object but still giving clues to its identity by exposing the shards from which it could be reconstructed. He also experimented with making fossilized impressions by branding the shape of hand tools into blocks of wood. Other fossils followed: hair dryers and plaster casts of them, a telephone and ten casts of it laid out in a diallike configuration, irons in concrete (pl. 108), brooms and carpet sweepers embedded in concrete to form monolithic *Standing Stones* (1979, Private Collection, London). Key among these is *The Long Aspirator* (pl. 109), a concrete-encased vacuum cleaner with only a few sections chipped away to indicate the object within. Its great extended form and long neck, as well as its title, evoke the image of a dinosaur or another extinct creature.

In 1979, following the fossil series, Woodrow again chose to use common, everyday household objects, but this time in a more direct manner. No longer partially hidden they retained their original identity, while their inner workings were exposed. These "breakdowns," as Woodrow called them, were disassemblies or demanufactures of appliances: a toaster, a television, a vacuum. In the first two instances, Woodrow took out all the parts and laid them carefully on the floor within given parameters derived from the remaining shell. In the latter and only extant work from this series, *Hoover Breakdown* (pl. 110), the entire vacuum, inside and out, is laid out in a shape on the floor, the smallest parts at the one end gradually giving way to the largest as the outline widens. At the narrower point stands a fully assembled Hoover upright – actually a wooden replica made by the artist. The disassembled real vacuum and its dummy version presented a startling view of actual and depicted reality.

Woodrow continued his experimentations with household appliances by combining them on a skewerlike steel rod. *Five Objects* (pl. 111) marked another step in Woodrow's use of discarded goods. Using two radio/record players, an electric tea kettle, and a toy iron, he cut a piece from the skin of each of the four objects in order to construct a fifth, hybrid appliance: an unspecific, nonfunctional mutant. Unlike *Hoover Breakdown*, in which the newly created object was made of new material distinct from the vacuum itself, here for the first time Woodrow made a new object with remarkable economy of means by using only materials extracted from the other real objects with which it was displayed. This process of disassembly continued. Influenced by and commenting on Brixton youths' local sport of smashing televisions, Woodrow made *Brixton Boys, Street Noise* (1980, Private Collection), in which he broke a television screen and laid out the remnants in a pile in front of the set.[3]

Other types of objects entered Woodrow's oeuvre as he continued to explore other possibilities. Wanting to see how long a bicycle frame would be if its elements were outstretched, he took apart eight frames and extended each into a single line; he also

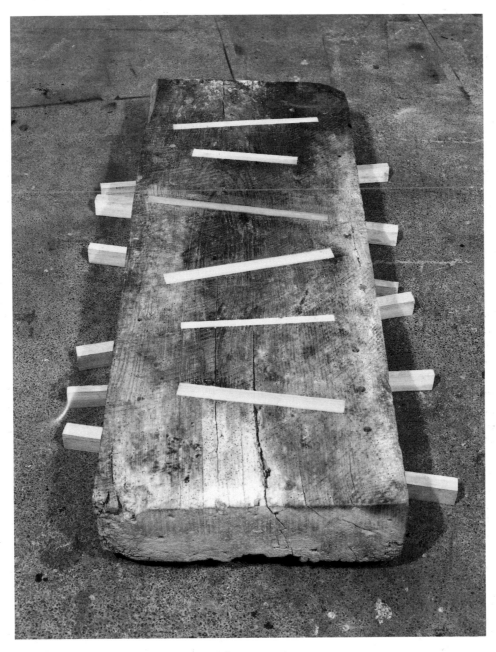

Pl. 107. Bill Woodrow, *Untitled*, 1978, Private Collection, London

presented these radiating out in a giant fan shape on the wall (pl. 112). Then, as with *Hoover Breakdown*, Woodrow decided to re-create a bicycle frame out of another material. He did so in the manner he had first developed in *Five Objects*: creating an object out of material acquired from a different, unrelated, yet equally familiar type of object that served as the material and host. The result was *Spin Dryer with Bicycle Frame Including Handlebars* (pl. 113). Woodrow had previously "skewered" spin dryers and washing machines but had never cut them. Now they appeared to be ideal materials for the new method he was developing: their flat, metal exteriors provided a neutral sheeting from which many different shapes could be cut; the shapes could then be assembled into different forms. This quickly grew into a series of four works, as the bicycle frame was joined by *Single-Tub with 9mm Machine Gun* (1981, Private Collection), *Twin-Tub with Chainsaw* (pl. 115), and *Twin-Tub with Guitar* (pl. 114), all of which were shown later that year in the landmark exhibition "Objects & Sculpture" at the Arnolfini Gallery, Bristol, and the Institute of Contemporary Arts, London (see fig. 16).

At first the works fabricated were tied closely to the parent object: the electric guitar was pressed against the front of the tub; in the other three versions, the newly created items were barely set apart, and all were connected by metal umbilical cords. But the expressive, as well as technical, potential of this process and material seemed great and Woodrow expanded on the idea. A twin-tub with one side covered in wood grain inspired the creation of a beaver (1981, Collection of the Contemporary Art Society, London), an animal whose place in the ecological system is hampered by contemporary culture which brings about such "advances" as plastic wood. *Twin-Tub with Satellite* (1982, Collection de Ville Chambéry, France) occupies space differently than the previous works; the fabricated satellite is suspended in mid-air and attached by a connecting metal strip to the tub, which in turn is fixed high up on the wall. In three works of 1981-82, Woodrow used twin-tubs in combination with other objects (a car door, ironing board, armchairs) to create an installation group, the center of which in each case was a newly formed object (a North American Indian headdress [1981, Tate Gallery, London], Bobo mask [pl. 116], or Bena Biombo mask [1982, Ray Hughes Gallery, Brisbane-Sydney, Australia]). Like the anonymous hybrid in *Five Objects*, each new form was made from parts of the other items; like the single twin-tub pieces, they showed their lineage by the strips or umbilical cords which still linked them to the source object. In addition to the increased complexity of materials, there is greater depth of content in these works. The twin-tub assemblages point beyond themselves to the relationship between Western culture (signified by the consumer items) and the cultures it calls "primitive" (represented by the masks or headdress). Western industrialized society's exploitation of "primitive" societies is further represented by the appropriation of tribal artifacts which, placed on a stand as if on display in a museum, are viewed out of the context of the culture that produced them.

Among the key ideas that Woodrow has dealt with in his work since 1981 is religion. His sense of religion as a doctrine of repression and his mistrust of clergy — individuals whom he feels carry out a form of coercion — has been addressed many times in his work. In a major early example, *A Passing Car, A Caring Word* (pl. 117), a car door is pressed against a blood-red mattress cover; from it is cut a huge crucifix, its image represented both in the opening cut into the cover, and the cut-out form which, like spilled blood, falls onto the mattress stuffing on the floor. The crucifix, or cross, a symbol of the sacrifice of Christ, lies on the fleecelike stuffing, Woodrow's reference to the flock of believers. From the car door is cut both a gun (the weapon used to murder the victim) and a microphone on a stand (representing the media). Broadcasting, a powerful means of addressing millions, brings news daily of human loss incurred in the name of religion — in Ireland, the Middle East, India, and other parts of the world. Religion and violence have always gone together and, as Woodrow points out, religious wars are as ubiquitous today as they have been for centuries, and, therefore, as banal as the objects from which *A Passing Car* is made.

In 1983, in part inspired by working on two exhibitions in Italy, Woodrow created several other works critical of religion. Drawing inspiration from Italian folklore, he created *Il Prete* (1983, Galleria Locus Solus, Genoa), making use of a bed warmer nicknamed for the clergy who, through their dictates, insert themselves into the middle of households just as the warmer is placed in the bed. A formally simple and beautiful example is *Table with Locust and Reliquary* (pl. 119), based on a medieval religious artifact cut from a car hood. Two years later when making new works for shows in the United States, Woodrow was struck by the grass-roots presence and power of American fundamentalism: *Fools' Coats* (1985, Private Collection, Boston) and *Collection* (1985, Barbara Gladstone Gallery, New York) were the results. *Promised Land* (1985, Collection of the Museum of Art, Carnegie Institute, Pittsburgh) which followed soon thereafter is in part related to this theme while it also incorporates overtones of Southern racism.

The Empty Spoon (pl. 118) deals with poverty, especially that of the Third World. The grocery cart of the rich and bountiful industrialized nations of the West is laden with goods, topped with gold ingots. This segment of society has a powerful position, using the resources of the earth in disproportion to its percentage of world population. The impoverished countries are represented by the empty spoon made from only a small part of the goods in the cart; the spoon falling to the floor remains connected to the goods in the cart, just as the countries it symbolizes are still dependent on the wealth of the industrialized nations. On the wall is the world: a planetary ball of interlaced appliance cords. It appears small in comparison to the consumer items, shrinking as it reaches the point of no longer being able to support the world's population.

In *Life on Earth* (pl. 120), a major large-scale installation, Woodrow used elements (a washing machine and armchairs) he had often employed for other purposes to express his concern about the threat of nuclear disaster. Depicting a family-room scene of showing home movies, the projector is placed on top of a washing machine from which it itself is fabricated. Film spills onto the floor toward the screen which is made out of part of the coverings from the five armchairs representing the absent family. While at once an underwater scene of a reef, the image on the screen also depicts a mush-

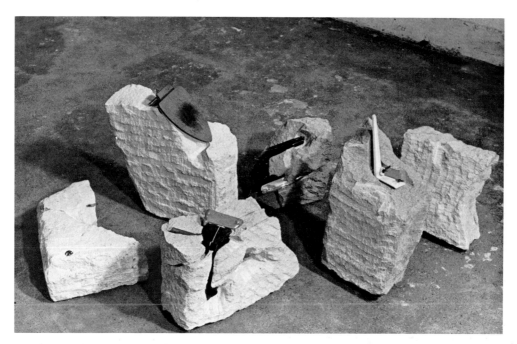

Pl. 108. Bill Woodrow, *Untitled*, 1978, Private Collection, London

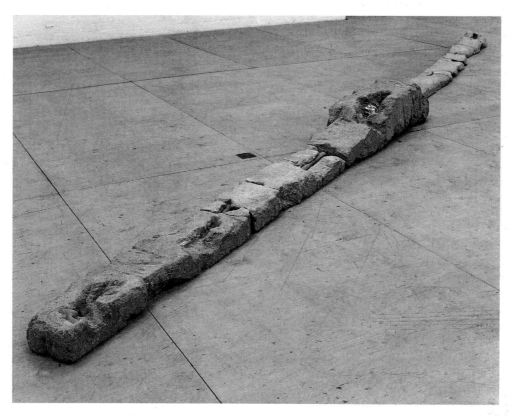

Pl. 109. Bill Woodrow, *The Long Aspirator*, 1979, Private Collection, London (cat. no. 44)

room cloud (its scale indicated by the tiny palm tree at the bottom center) with undersea creatures thrown up into the air; here is both the chaotic origin and cataclysmic demise of life on earth.

Animals have frequently been represented by Woodrow; he creates lifelike forms from "dead" objects and places them humorously in fantastic situations or uses them to make a commentary on issues such as ecology. In *Stone Wall* (pl. 121) an animal becomes the symbol for the politically and socially oppressive institution of apartheid in South Africa. The antelope, an indigenous African creature, is made from a carpet on the floor. Caught as it leaps the stone wall, it is unable to escape this man-made barrier; trapped, it becomes a trophy. The wall is built atop stacked furniture, all of which is dark-colored, except for a single white table, one of whose legs has been carved into a billy club. We see here the story of the native black culture of South Africa: the white minority maintains power by beating and otherwise keeping within a barricade those who seek to escape their authority.

In Woodrow's cuttings, whether single or groups of objects, he brings about an improbable juxtaposition of images through a technique that allows one image to emerge from another. This procedure has become his primary means of working. He often makes things that he himself would like to have. At times he has an object or thematic subject in mind and will look for another object that will allow him to execute it. He also collects materials which he feels would be useful and eventually, inspired by their form, he elects to make something in particular. In some cases he combines these approaches; beginning to make one thing, the object or objects employed lead Woodrow to create other things that further develop the narrative or character of the final work. Woodrow now exclusively uses everyday items, sometimes found or, if necessary, purchased, and he is interested in consumer items as material for making other consumer items. Both material and subject have an identity within the artist's environment and relate in some way to his life and experiences. Woodrow's use of known, everyday commodities familiar to us as well also makes his work engaging: once we have recognized the object and discovered the common items from which they are made, we proceed to the larger, more important themes with which Woodrow is concerned.

Incidents, car wrecks, hijackings, have all become part of Woodrow's oeuvre which has taken on a more narrative character in the 1980s as he deals with events of our time. Other works, such as the "Ship of Fools" series (see pl. 122), are about more general circumstances and the fate befalling humanity. Ironic, surreal, humorous, or satirical and critical, Bill Woodrow's art in the short span of six years has developed from simple to more adept techniques of fabrication. His method of cutting and his astute assembly of altered objects have enabled him to build an articulate vocabulary of images. Correspondingly, at the same time Woodrow's statements have grown more complex. Deceivingly simple and identifiable, Woodrow's images have the capacity to speak metaphorically and profoundly. Through familiar objects in newly created forms, Woodrow tells us about the imbalances of our culture, the lack of synchronization between man and nature in our Western industrialized society, and the need for a new harmony between us and our world as symbolized by the many consumer goods that comprise it.

Notes

1.
Most of the information in this essay is based on the author's interview with the artist in March 1986.
2.
These photoworks were exhibited in 1972 in a one-person exhibition at the Whitechapel Art Gallery, London, and in a group exhibition at the Museum of Modern Art, Oxford.
3.
In a related work (1979-80, Private Collection, London), shards of screens spelled out "T.V. BLIND," each letter lying in front of one of seven sets broken for the purpose.

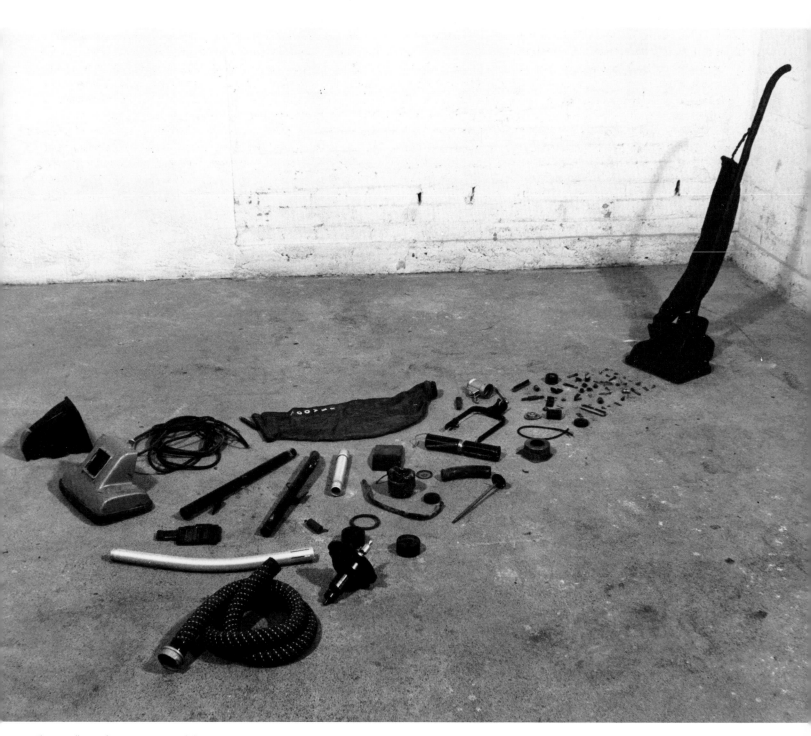

Pl. 110. Bill Woodrow, *Hoover Breakdown*, 1979, Private Collection, London (cat. no. 45)

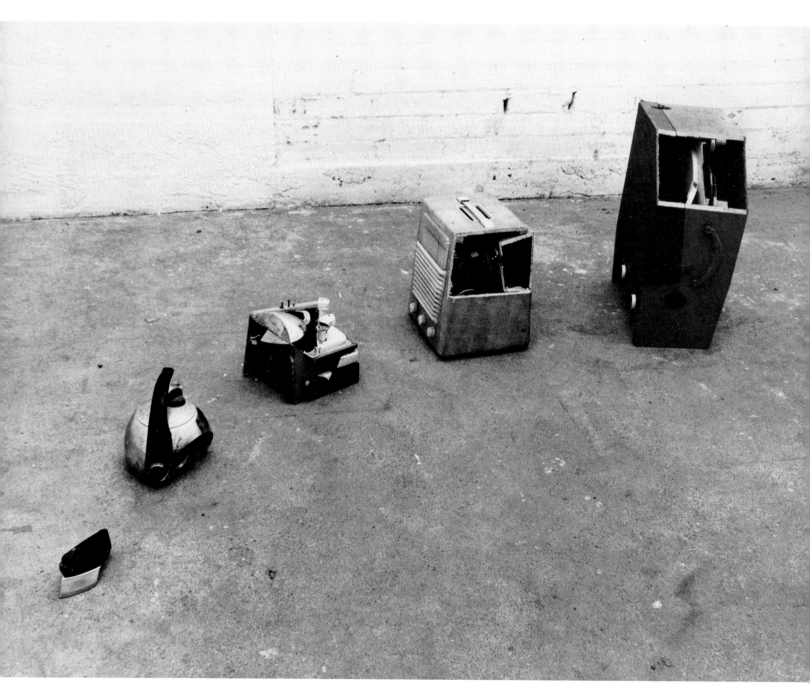

Pl. 111. Bill Woodrow, *Five Objects*, 1979, Private Collection, London

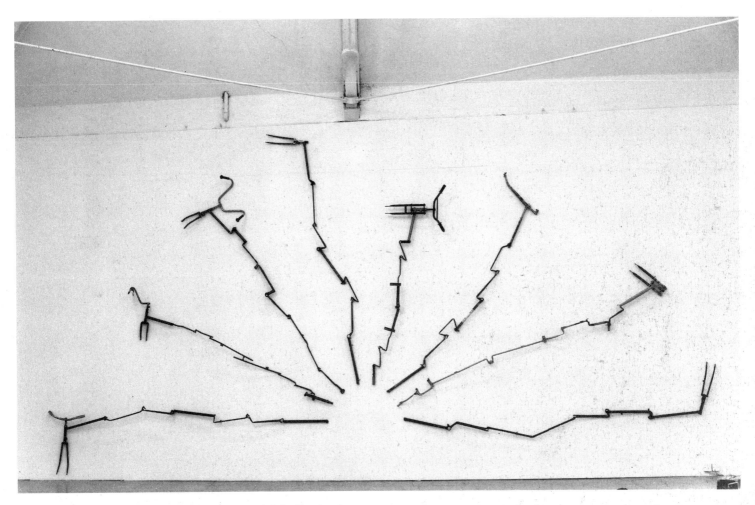

Pl. 112. Bill Woodrow, *Eight Bicycle Frames*, 1980, Private Collection, London

Pl. 113. Bill Woodrow, *Spin Dryer with Bicycle Frame Including Handlebars*, 1981, Private Collection, London

Pl. 114. Bill Woodrow, *Twin-Tub with Guitar*, 1981, Trustees of the Tate Gallery, London

Pl. 115. Bill Woodrow, *Twin-Tub with Chainsaw*, 1981, Private Collection, London (cat. no. 46)

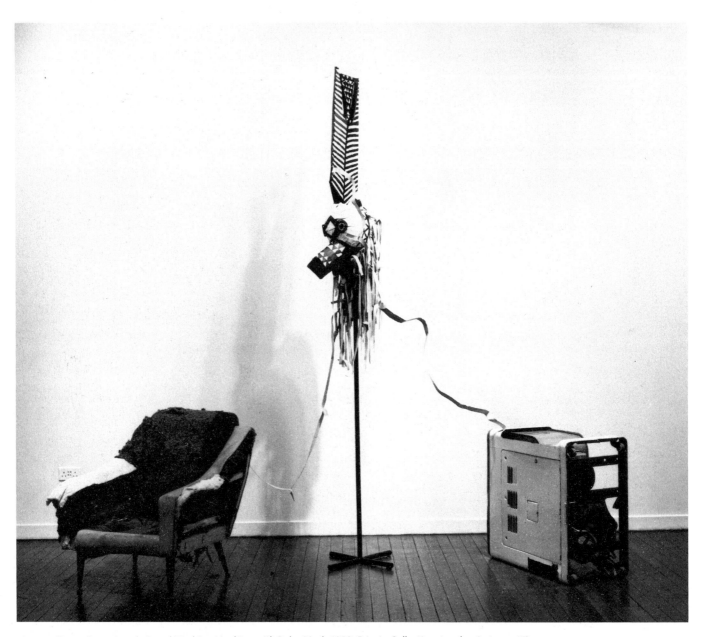

Pl. 116. Bill Woodrow, *Armchair and Washing Machine with Bobo Mask*, 1982, Private Collection, London (cat. no. 47)

Pl. 117. Bill Woodrow, *A Passing Car, A Caring Word*, 1982, Private Collection, London (cat. no. 48)

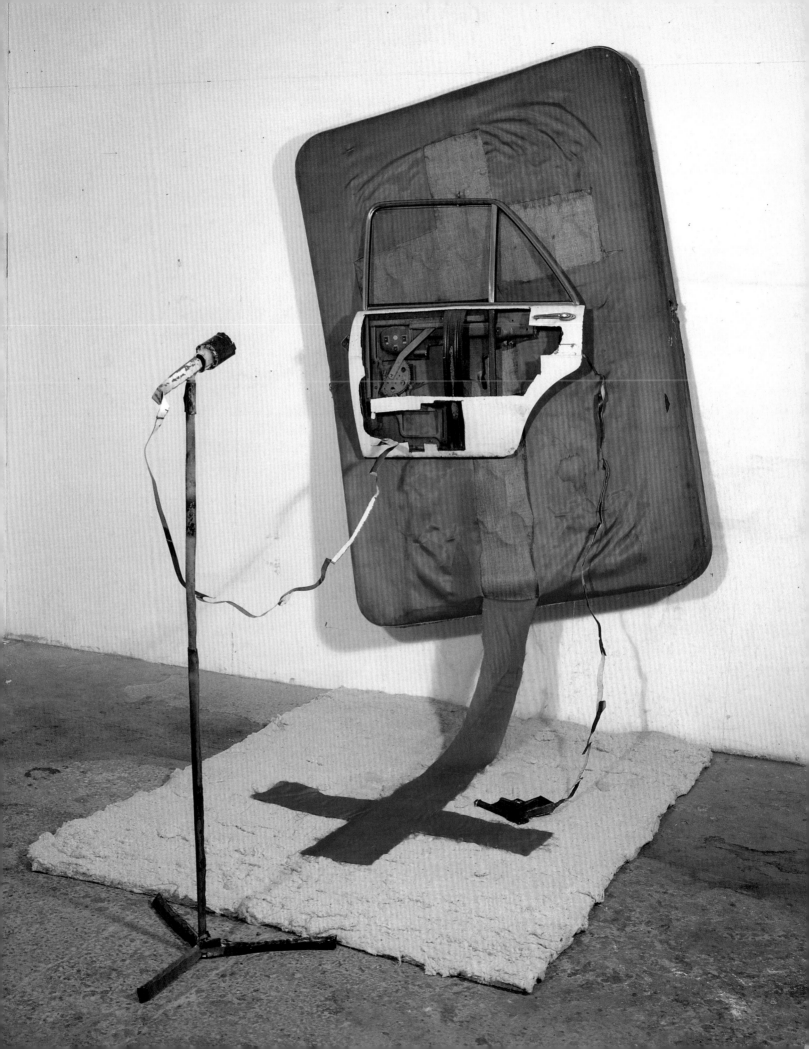

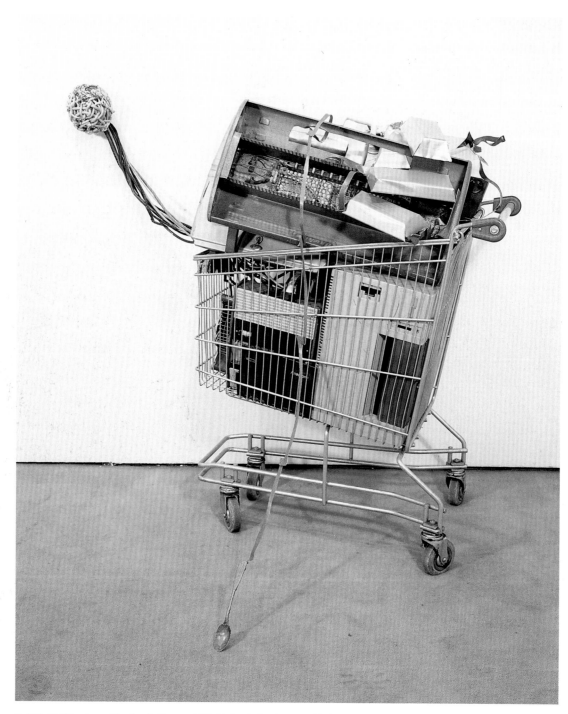

Pl. 118. Bill Woodrow, *The Empty Spoon*, 1983, Beijer Collection, Stockholm (cat. no. 49)

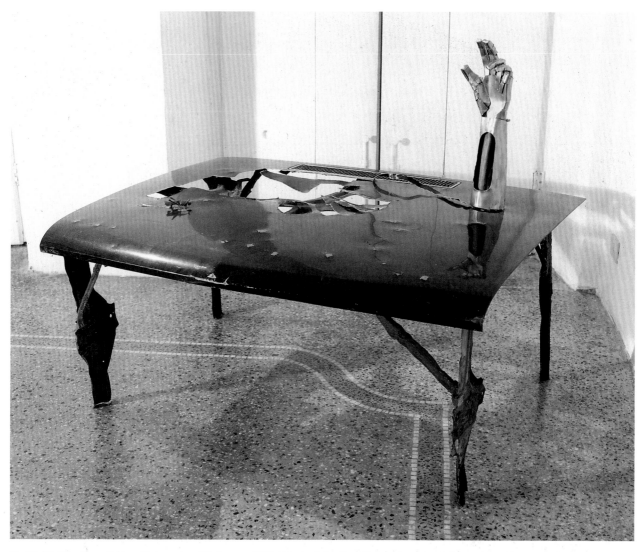

Pl. 119. Bill Woodrow, *Table with Locust and Reliquary*, 1983, Private Collection, Genoa, Courtesy Galleria Locus Solus, Genoa

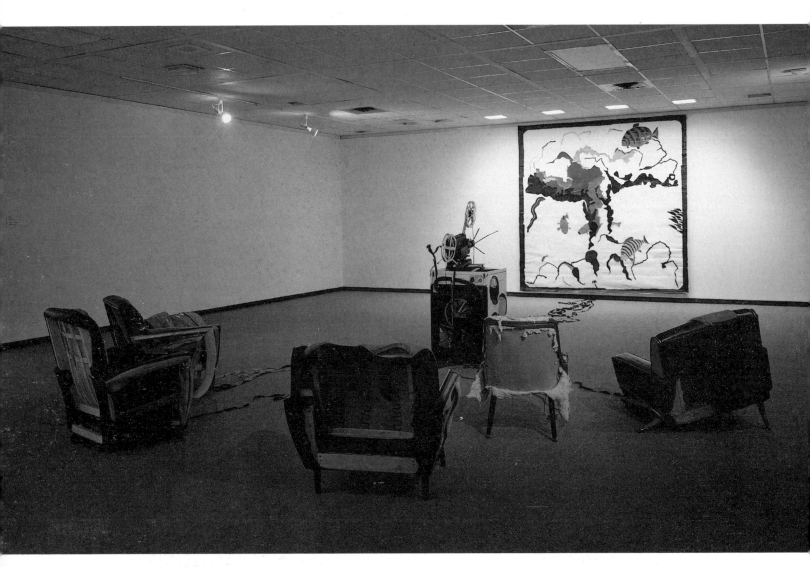

Pl. 120. Bill Woodrow, *Life on Earth*, 1984, National Gallery of Canada, Ottawa

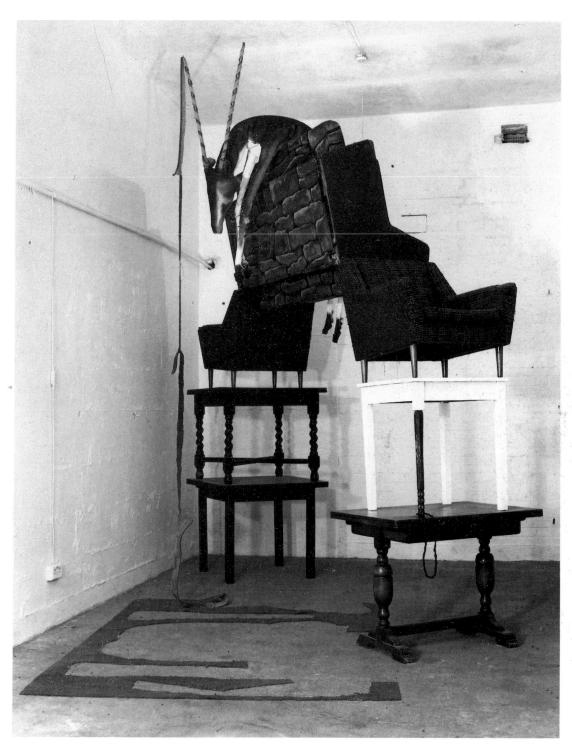

Pl. 121. Bill Woodrow, *Stone Wall*, 1984, Collection of Gerald W. and Jean W. Bush, Concord, Massachusetts (cat. no. 50)

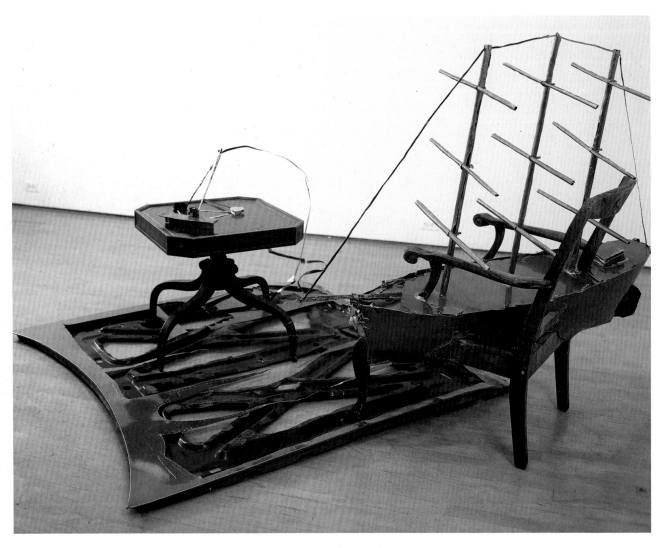

Pl. 122. Bill Woodrow, *Ship of Fools, Captain's Table*, 1985, Collection of Marsha Fogel, New York, Courtesy Barbara Gladstone Gallery, New York
(cat. no. 51)

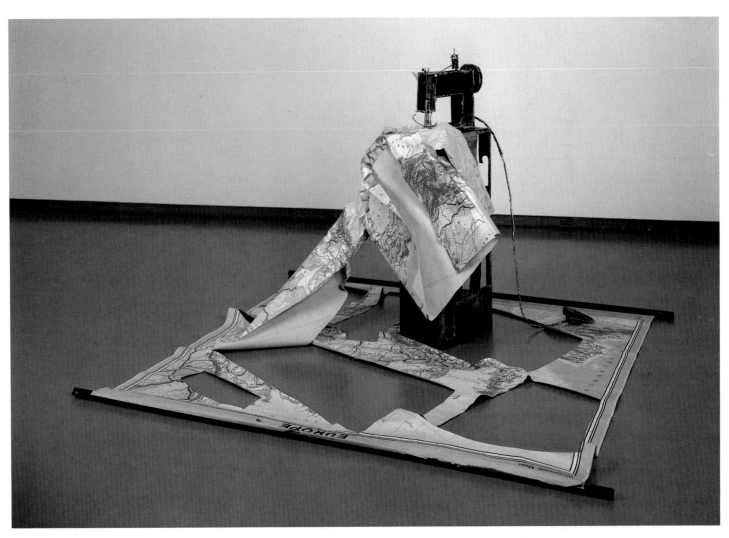

Pl. 123. Bill Woodrow, *Winter Jacket*, 1986, Collection of Anne MacDonald Walker, San Francisco (cat. no. 52)

Checklist
of the Exhibition

Tony Cragg
British, b. Liverpool, 1949

1.
Stack, 1975/87
Wood and found objects
Approx. 182.8 x 182.8 x 182.8 cm (72 x 72 x 72 in.)
Reconstructed for exhibition
See plate 7

2.
Postcard Union Jack, London, 1981
Plastic
250 x 400 cm (98½ x 157½ in.)
Leeds City Art Gallery, England
Plate 13

3.
Axehead, 1982
Mixed media
81.3 x 462.3 x 317.5 cm (32 x 182 x 125 in.)
Courtesy Marian Goodman Gallery, New York
Not illustrated

4.
New Stones, 1982
Plastic
500.4 x 182.9 cm (197 x 72 in.)
Courtesy Marian Goodman Gallery, New York, and
Lisson Gallery, London
Plate 15

5.
Circles, 1985
Mixed media
185 x 300 x 300 cm (72⅞ x 118⅛ x 118⅛ in.)
Fonds Régional d'Art Contemporain, Ile de France
Plate 17

6.
New Figuration, 1985
Plastic
271.5 x 530 cm (106⅞ x 208⅝ in.)
Courtesy Art & Project, Amsterdam
Plate 18

7.
Shell, 1986
Wood and plastic
152.4 x 243.8 x 182.8 cm (60 x 96 x 72 in.)
Collection of Elaine and Werner Dannheisser,
New York
Plate 19

8.
Città, 1986
Painted wood
176.8 x 304.8 x 213.4 cm (69⅝ x 120 x 84 in.)
Collection of John and Mary Pappajohn,
Des Moines, Iowa
Plate 20

Richard Deacon
British, b. Bangor, Wales, 1949

9.
If the Shoe Fits, 1981
Galvanized and corrugated steel
152.5 x 331 x 152.5 cm (60 x 130⅞ x 60 in.)
Saatchi Collection, London
Plate 35

10.
Art for Other People No. 5, 1982
Laminated wood
106.7 x 106.7 x 183 cm (42 x 42 x 72 in.)
Saatchi Collection, London
Plate 32

11.
Art for Other People No. 9, 1983
Galvanized steel
53 x 34 x 11 cm (21 x 13⅜ x 4½ in.)
Saatchi Collection, London
Plate 33

12.
Out of the House, 1983
Galvanized steel and linoleum
122 x 61 x 152.5 cm (48 x 24 x 60 in.)
Saatchi Collection, London
Plate 36

13.
Tall Tree in the Ear, 1983-84
Galvanized steel, laminated wood, and canvas
375 x 250 x 150 cm (147⅝ x 98½ x 59 in.)
Saatchi Collection, London
Plate 37

14.
Art for Other People No. 11, 1984
Linoleum and zinc
91.4 x 101.6 cm (36 x 40 in.)
Private Collection, Basel
Plate 34

15.
The Eye Has It, 1984
Stainless and galvanized steel, brass, cloth, and wood
61 x 304.8 x 121.9 cm (24 x 120 x 48 in.)
Arts Council of Great Britain, London
Plate 38

16.
Turning a Blind Eye No. 2, 1984-85
Laminated wood and cloth
182.9 x 381 x 152.4 cm (72 x 150 x 60 in.)
High Museum of Art, Atlanta, 20th Century Art Acquisition Purchase Fund
Plates 39, 40

17.
Listening to Reason, 1986
Laminated wood
226.1 x 609.6 x 579.1 cm (89 x 240 x 228 in.)
Courtesy Marian Goodman Gallery, New York, and Lisson Gallery, London
Plate 41

Barry Flanagan
British, b. Prestatyn, Wales, 1941

18.
pdreeo, 1965
Cloth, plaster, ink, and resin
106.7 x 45.7 x 45.7 cm (42 x 18 x 18 in.)
Collection of Alex Gregory-Hood, London
Plate 42

19.
four casb 2'67, ring l 1'67, rope (gr 2sp 60) 6'67, 1967 (replica, 1986)
Cloth, rope, linoleum, sand, and plastic
Uprights each h. 182.8 cm (72 in.); ring dia. 182.8 cm (72 in.)
Trustees of the Tate Gallery, London
See plate 44

20.
Pile 3, 1968
Cloth
32 x 52 x 48 cm (12½ x 20½ x 19 in.)
Trustees of the Tate Gallery, London
Plate 46

21.
The House at Seano, 1974
Sandstone
17.8 x 24.1 x 30.5 cm (7 x 9½ x 12 in.)
Collection of Nikos Stangos and David Plante, London
Plate 50

22.
Ubu of Arabia, 1976
Hornton stone, acrylic, and canvas
109 x 73.5 x 35.5 cm (43 x 30 x 14 in.)
Collection of Agnes and Frits Becht, Naarden, The Netherlands
Plate 53

23.
Vessel (in Memoriam), 1980
Bronze with gilt
59 x 44.5 x 71.4 cm (23¼ x 17½ x 28⅛ in.)
The Museum of Modern Art, New York, Gift of the American Art Foundation
Plate 57

24.
Carving No. 11, 1981
Marble
40.6 x 58.4 x 35.5 cm (16 x 23 x 14 in.)
Private Collection, Akron, Ohio
Plate 56

25.
Soprano, 1981
Bronze with gilt
87.6 x 48.3 x 71.8 cm (34½ x 19 x 28¼ in.)
Arts Council of Great Britain, London
Plate 58

26.
Leaping Hare on Crescent and Bell, 1983
Bronze and copper
121.9 x 94 x 60.9 cm (48 x 37 x 24 in.)
San Francisco Museum of Modern Art, Madeleine Haas Russell Fund Purchase
Plate 59

27.
Baby Elephant, 1984
Bronze
174 x 106.7 x 62.2 cm (68½ x 42 x 24½ in.)
The Art Institute of Chicago, Twentieth Century Discretionary Fund and the Barbara N. and Solomon B. Smith Fund
Plate 60

Richard Long
British, b. Bristol, England, 1945

28.
A Line Made by Walking England 1967
Photograph
Public freehold
Collection of the artist, Courtesy Anthony d'Offay Gallery, London
Plate 63

29.
27 MARCH 1971/ 5 fifteen minute even walks on Dartmoor./ MOORLAND/ MARSH/ WOODS/ ROAD
Map with paper, typescript, and pencil
40.6 x 40.6 cm (16 x 16 in.)
Collection of Mr. and Mrs. Robert J. Dodds III, Pittsburgh, Pennsylvania

30.
A Circle in Ireland 1975
Photograph
Public freehold
Collection of the artist, Courtesy Anthony d'Offay Gallery, London
Plate 66

31.
Minneapolis Circle 1982
Slate
Dia. 975.4 cm (384 in.)
Walker Art Center, Minneapolis, Justin Smith
Purchase Fund
Plate 73

32.
Twelve Hours Twelve Summits 1983
Map and printed text
83.8 x 114.3 cm (33 x 45 in.)
Collection of Gilbert and Lila Silverman, Detroit
Plate 75

33.
Wind Stones 1985
Printed text
104 x 157 cm (50 x 62 in.)
Collection of the artist, Courtesy Anthony d'Offay
Gallery, London
Plate 80

34.
Gray Slate Line, 1986
Slate
L. 340 x w. 168 cm (134 x 66 in.)
Courtesy Sperone Westwater, New York
Not illustrated

David Nash
British, b. Esher, England, 1945

35.
Wall Leaner, 1975
Oak
H. 137.2 cm (54 in.)
Sandie Barker Associates, London
Plate 85

36.
Three Clams on a Rack, 1976
Beech and oak
83.8 x 157.5 x 61 cm (33 x 62 x 24 in.)
Solomon R. Guggenheim Museum, New York, Gift
of Mr. and Mrs. Jacob M. Kaplan
Plate 87

37.
Three Dandy Scuttlers (Chorus Line), 1976
Beech and oak
160 x 76.2 x 243.8 cm (63 x 30 x 96 in.)
Collection of Mr. and Mrs. W. Riker Purcell,
Richmond, Virginia
Plate 88

38.
Cracking Box, 1979
Oak
61 x 61 x 61 cm (24 x 24 x 24 in.)
Sheffield City Art Galleries, England
Plate 100

39.
Running Table, 1980
Oak
167.6 x 304.8 x 121.9 cm (66 x 120 x 48 in.)
Collection of the artist
Plate 101

40.
Ash Branch Cube, 1981
Ash
248.9 x 152.4 x 96.5 cm (98 x 60 x 38 in.)
Collection of the artist
Plate 102

41.
Black Column, 1983
Sycamore
Approx. h 335.3 x 40.6 x 40.6 cm
(132 x 16 x 16 in.)
Collection of the artist
Plate 105

42.
Three Long Boats, 1985
Chestnut
71 x 101.6 x 406.4 cm (28 x 40 x 160 in.)
Collection of the artist
Not illustrated

43.
Crack and Warp Column, 1986
Elm
198.1 x 61 x 61 cm (78 x 24 x 24 in.)
Collection of the artist
See plate 104

Bill Woodrow
British, b. near Henley, England, 1948

44.
The Long Aspirator, 1979
Concrete and vacuum cleaner
L. 243.8 cm (96 in.)
Private Collection, London
Plate 109

45.
Hoover Breakdown, 1979
Dismantled vacuum cleaner and painted wood
121.9 x 121.9 x 61 cm (48 x 48 x 24 in.)
Private Collection, London
Plate 110

46.
Twin-Tub with Chainsaw, 1981
Washing machine
88.9 x 76.2 x 66 cm (35 x 30 x 26 in.)
Private Collection, London
Plate 115

47.
Armchair and Washing Machine with Bobo Mask,
1982
Armchair, washing machine, and metal stand
Dimensions variable
Private Collection, London
Plate 116

48.
A Passing Car, A Caring Word, 1982
Automobile door and mattress
Dimensions variable
Private Collection, London
Plate 117

49.
The Empty Spoon, 1983
Shopping cart and electrical appliances
200 x 200 x 200 cm (78¾ x 78¾ x 78¾ in.)
Beijer Collection, Stockholm
Plate 118

50.
Stone Wall, 1984
Four tables, two chairs, sofa, bamboo, wire, and
paint
Dimensions variable
Collection of Gerald W. and Jean W. Bush, Con-
cord, Massachusetts
Plate 121

51.
Ship of Fools, Captain's Table, 1985
Automobile hood, table, chair, and paint
134.6 x 195.6 x 213.4 cm (53 x 77 x 84 in.)
Collection of Marsha Fogel, New York, Courtesy
Barbara Gladstone Gallery, New York
Plate 122

52.
Winter Jacket, 1986
Metal trunk and wall map
131 x 215 x 184 cm (51⅝ x 84⅝ x 72⅜ in.)
Collection of Anne MacDonald-Walker, San
Francisco
Plate 123

Artists' Biographies

By Dennis Alan Nawrocki

Tony Cragg

Born in Liverpool in 1949, Tony Cragg attended the Gloucester College of Art and Design (1969-70) and the Wimbledon School of Art (1970-73) before studying at the Royal College of Art from 1973 to 1977. Though the configurations and media of his sculpture have expanded and diversified over the years, Cragg has worked from the outset with found objects. A temporal work from 1970, *Combination of Found Beach Objects*, for example, consisted of objects discovered along the seashore and placed on a chalked grid. In other works from the early 1970s, wood predominated in pieces that either sprawled on the floor or were composed in piled and stacked arrangements. "Stacks," a series initiated in 1975 and re-created from time to time since then, were comprised of wood and found objects, and built *in situ*.

In 1978 Cragg began to deploy bright, colorful plastic debris in geometric formats arranged on the floor. At first rectangular in shape and organized in zones of color, they gave way in 1979 to the first imagistic floor pieces — *Red Skin* (Stedelijk Van Abbemuseum, Eindhoven) and *Aeroplane* (Galerie Bernd Klüser, Munich). These works were followed in 1980 by wall pieces that, by 1981, incorporated a variety of materials (metal and wood in addition to plastic) and a mixture of contrasting colors to depict various figurative types: policemen, goalkeepers, cowboys, as well as the artist himself.

Since 1984 free-standing sculptures in the round have appeared: some involve combinations of utilitarian items (a chair, table, suitcase) with plastic pipe or stone; some, more architectonic, are composed of geometric wood forms of varying heights wedged together in compositions suggestive of houses or mountainous landscapes.

Cragg has lived in Wuppertal, West Germany, since 1977. He teaches at the Düsseldorf Kunstakademie. In 1985 Cragg was one of six finalists chosen for the Turner Prize, awarded annually by the Tate Gallery to the person who, in the opinion of the jury, "has made the greatest contribution to art in Britain in the previous twelve months."

Tony Cragg: Selected One-Person Exhibitions

1979
Lisson Gallery, London

1980
Arnolfini Gallery, Bristol, England

1981
Whitechapel Art Gallery, London (exh. cat.)
Le Nouveau Musée, Lyon/Villeurbanne, France

1982
Badischer Kunstverein, Karlsruhe, West Germany
(exh. cat.)
Rijksmuseum Kröller-Müller, Otterlo (exh. cat.)

1983
Kunsthalle Bern, Switzerland (exh. cat.)

1984
Louisiana Museum of Art, Humlebaek, Denmark
Kölnischer Kunstverein, West Germany (exh. cat.)

1985
Kunsthalle Bern, Switzerland (exh. cat.)
Société des Expositions du Palais des Beaux-Arts de
Bruxelles (traveled to ARC/Musée d'Art Moderne
de la Ville de Paris) (exh. cat.)
Kestner-Gesellschaft, Hanover, West Germany
(exh. cat.)

1986
The Brooklyn Museum, New York
Matrix, University Art Museum, University of
California, Berkeley (traveled to La Jolla Museum of
Contemporary Art, California) (exh. cat.)

Tony Cragg: Selected Group Exhibitions

1977
Battersea Park, London, "Silver Jubilee Exhibition
of Contemporary British Sculpture"

1979
Stuttgart, West Germany, "Europa – Kunst du 80er
Jahre"

1980
Venice, "XXXIX Biennale di Venezia" (exh. cat.)

1981
Whitechapel Art Gallery, London, "British Sculp-
ture in the Twentieth Century, Part Two: Symbol
and Imagination 1951-80" (exh. cat.)

1982
Kassel, West Germany, "Documenta 7" (exh. cat.)
Kunstmuseum Luzern, Switzerland, "Englische
Plastik Heute/British Sculpture Now" (exh. cat.)
Kunsthalle Bern, Switzerland, "Leçons des Choses"
(traveled to Musée d'Art et d'Histoire, Chambéry,
France; Maison de la Culture, Chalon-sur-Saône,
France) (exh. cat.)

1983
John Hansard Gallery, The University, South-
ampton, England, "Figures and Objects: Recent
Developments in British Sculpture" (exh. cat.)
ARC/Musée d'Art Moderne de la Ville de Paris,
"Truc et Troc/ Leçons des Choses" (exh. cat.)
Hayward Gallery and Serpentine Gallery, London
(organized by the Arts Council of Great Britain),
"The Sculpture Show" (exh. cat.)

Tate Gallery, London, "New Art" (exh. cat.)
The British Council, London, "Transformations:
New Sculpture from Britain" (traveled to XVII
Bienal de São Paulo, 1983; Museo de Arte Mod-
erna, Rio de Janeiro, 1984; Museo de Arte
Moderna, Mexico City; Fundação Calouste
Gulbenkian, Lisbon) (exh. cat.)

1984
The Museum of Modern Art, New York, "An Inter-
national Survey of Recent Painting and Sculpture"
(exh. cat.)
Arts Council of Great Britain, London, "The British
Art Show: Old Allegiances and New Directions
1979-1984" (traveled to City of Birmingham Mu-
seum and Art Gallery, England, 1984; Royal
Scottish Academy, Edinburgh, 1985; Mappin Art
Gallery, Sheffield, England; Southampton Art Gal-
lery, England) (exh. cat.)

1985
The British Council, London, "The British Show"
(traveled to Art Gallery of Western Australia, Perth;
Art Gallery of New South Wales, Sydney;
Queensland Art Gallery, Brisbane; The Exhibition
Hall, Melbourne; National Art Gallery, Wellington,
New Zealand) (exh. cat.)
Hayward Gallery, London, "1985 Hayward An-
nual" (exh. cat.)
Tate Gallery, London, "The Turner Prize 1985" (exh.
cat.)

1986
Palacio de Velázquez, Madrid (organized by The
British Council), "Entre el Objeto y la Imagen: Es-
cultura británica contemporánea" (exh. cat.)

Tony Cragg: Selected References

Jones, Ben. "A New Wave in Sculpture: A survey of
recent work by ten younger sculptors." *Artscribe* 8
(Sept. 1977): 16.

Morgan, Stuart. "Tony Cragg." *Artforum* 19, 12
(Oct. 1980): 86.

Ponti, Lisa. "Tony Cragg." *Domus* 611 (Nov. 1980):
50-51.

Biggs, Lewis. "Tony Cragg." *Arnolfini Review*,
May-June 1980: unpag.

Cooke, Lynne. "Tony Cragg at the Whitechapel."
Artscribe 28 (Mar. 1981): 54-55.

Celant, Germano. "Tony Cragg and Industrial Pla-
tonism." *Artforum* 20, 3 (Nov. 1981): 40-46.

Cuvelier, Pascaline. "Le Système anglo-panique des
objets, Tony Cragg: objets perdus." *Libération*,
May 4, 1982: 24-25.

Maubant, Jean-Louis. "Découpage/Collage à pro-
pos de Tony Cragg." *Cahiers du Cric* (Le Nouveau
Musée/NDLR) 4 (May 1982).

Winter, Peter. "Tony Cragg: Puzzlespiel und Super-
zeichen." *Kunstforum* 62 (June 1983): 56-65.

Rogozinsky, Luciana. "Tony Cragg." *Artforum* 23, 7
(Mar. 1985): 107.

Kirshner, Judith Russi. "Tony Cragg, Richard Dea-
con." *Artforum* 23, 10 (Summer 1985): 113.

Lamaître, Isabelle. "Interview with Tony Cragg."
Artefactum 2, 11 (Nov.-Dec. 1985/Jan. 1986): 7-11.

Pohlen, Annelie. "Tony Cragg." *Artforum* 24, 9
(May 1986): 148-49.

Richard Deacon

Born in Bangor, Wales, in 1949, Richard Deacon attended the Somerset College of Art, Taunton, in 1968-69 before moving to London. There he studied at St. Martin's School of Art (1969-72), the Royal College of Art (1974-77), and the Chelsea School of Art (1977-78). Deacon's sculptures of this period (1975-78) were rectilinear structures of wood and plaster. Growing dissatisfied with their obvious constructed appearance, however, he ceased making sculptural objects; instead, while in the United States from 1978 to 1979, he made pots and drawings. Upon his return to London, he made a group of works that employed swelling, curvilinear forms (fabricated at first from laminated wood) which have characterized his work to the present. New materials, of humble origin, such as galvanized steel, linoleum, and tarpaulin, were also introduced. Moreover, the application of poetic titles has paralleled Deacon's adoption of suggestive, biomorphic shapes. A number of sculptures — *If the Shoe Fits* (Saatchi Collection, London) of 1981 was the first named work — bearing titles such as *For Those Who Have Ears*, *For Those Who Have Eyes*, *The Heart's in the Right Place*, and *Tall Tree in the Ear* allude both through words and conformation to organic forms. In addition, an ongoing series of comparatively small works is provocatively entitled "Art for Other People."

In 1984 Deacon was one of six artists selected as finalists for the Turner Prize, awarded annually by the Tate Gallery to the person who, in the opinion of the jury, "has made the greatest contribution to art in Britain in the previous twelve months."

Richard Deacon: Selected One-Person Exhibitions

1978
The Gallery, Brixton, London

1980
The Gallery, Brixton, London

1981
Sheffield City Polytechnic Gallery, England

1983
The Orchard Gallery, Londonderry, Northern Ireland (exh. cat.)

1984
Riverside Studios, London
Fruitmarket Gallery, Edinburgh (traveled to Le Nouveau Musée, Lyon/Villeurbanne, France) (exh. cat.)

1985
Tate Gallery, London (exh. cat.)
Serpentine Gallery, London

Richard Deacon: Selected Group Exhibitions

1981
Institute of Contemporary Arts, London, "Objects & Sculpture" (traveled to Arnolfini Gallery, Bristol, England) (exh. cat.)

1982
Kunstmuseum Luzern, Switzerland, "Englische Plastik Heute/British Sculpture Now" (exh. cat.)

1983
John Hansard Gallery, The University, Southampton, England, "Figures and Objects: Recent Developments in British Sculpture" (exh. cat.)
Tate Gallery, London, "New Art" (exh. cat.)
Hayward Gallery and Serpentine Gallery, London (organized by the Arts Council of Great Britain), "The Sculpture Show" (exh. cat.)
The British Council, London, "Transformations: New Sculpture from Britain" (traveled to XVII Bienal de São Paulo, 1983; Museo de Arte Moderna, Rio de Janeiro, 1984; Museo de Arte Moderna, Mexico City; Fundação Calouste Gulbenkian, Lisbon) (exh. cat.)

1984
The Museum of Modern Art, New York, "An International Survey of Recent Painting and Sculpture" (exh. cat.)
Merian Park, Basel, Switzerland, "Skulptur im 20. Jahrhundert" (exh. cat.)
Arts Council of Great Britain, London, "The British Art Show: Old Allegiances and New Directions 1979-1984" (traveled to City of Birmingham Museum and Art Gallery, England, 1984; Royal Scottish Academy, Edinburgh, 1985; Mappin Art Gallery, Sheffield, England; Southampton Art Gallery, England) (exh. cat.)
Tate Gallery, London, "The Turner Prize" (exh. cat.)

1985
The British Council, London, "The British Show" (traveled to Art Gallery of Western Australia, Perth; Art Gallery of New South Wales, Sydney; Queensland Art Gallery, Brisbane; The Exhibition Hall, Melbourne; National Art Gallery, Wellington, New Zealand) (exh. cat.)
Solomon R. Guggenheim Museum, New York, "Transformations in Sculpture: Four Decades of American and European Art" (exh. cat.)
Museum of Art, Carnegie Institute, Pittsburgh, "Carnegie International" (exh. cat.)
Grande Halle de La Villette, Paris, "Nouvelle Biennale de Paris"
The Douglas Hyde Gallery, Trinity College, Dublin, "The Poetic Object: Richard Deacon, Shirazeh Houshiary, Anish Kapoor" (traveled to Arts Council Gallery, Belfast, 1986) (exh. cat.)

1986
Palacio de Velázquez, Madrid (organized by The British Council), "Entre el Objeto y la Imagen: Escultura británica contemporánea" (exh. cat.)
Louisiana Museum of Art, Humlebaek, Denmark, "Sculpture: 9 artists from Britain"

Richard Deacon: Selected References

Deacon, Richard. "Notes on a Piece of Sculpture." *Journal from the Royal College of Art* 1 (Jan. 1977): 54-57.

Cooke, Lynne. "Carolyne Kardia at Felicity Samuel, Richard Deacon at The Gallery, Brixton." *Artscribe* 24 (Summer 1980): 53-54.

Walker, Caryn Faure. "Richard Deacon Talking with Caryn Faure Walker." *Aspects* 17 (Winter 1982): unpag.

Cooke, Lynne. "Richard Deacon." *Art Monthly* 64 (Mar. 1983): 16-17.

Donnelly, Micky. "Richard Deacon — Sculpture." *Circa* 11 (July-Aug. 1983): 23-25.

Cooke, Lynne. "Richard Deacon at Riverside Studios." *Art in America* 72, 8 (Sept. 1984): 225.

Deacon, Richard. "Statements: Richard Deacon." *Link* 39 (July-Aug. 1984): 6.

Deacon, Richard. *Stuff Box Object 1971/2*. Cardiff: Chapter (Cardiff) Ltd., 1984.

Bickers, P.E. "A Conversation with Richard Deacon." *Art Monthly* 83 (Feb. 1985): 17-18.

Newman, Michael. "Richard Deacon: la face des choses." *Art Press* 90 (Mar. 1985): 26-31.

Deacon, Richard. [Statement.] *Kunstforum* 79 (May-June 1985): 79.

Kirshner, Judith Russi. "Tony Cragg, Richard Deacon." *Artforum* 23, 10 (Summer 1985): 113.

"Blind, Deaf and Dumb." *Building Design* (London), Oct. 4, 1985: 17-23.

van Hensbergen, Gijs. "Richard Deacon: Organische constructies." *Metropolism* (Amsterdam) 3 (1985): 16-21.

Barry Flanagan

Born in Prestatyn, Wales, in 1941, Barry Flanagan studied architecture and sculpture at the Birmingham College of Arts and Crafts in 1957-58; from 1964 to 1966 he was enrolled in the sculpture course at St. Martin's School of Art, London. Flanagan's sculptural oeuvre has unfolded through several distinct phases. Exhibited in his first one-person show at the Rowan Gallery, London (1966) was a cone of sand from which four handfuls had been scooped from the top to create a hollow. Also among his earliest works (c. 1967-68) were colored hessian sacks filled with paper, foam, or sand whose titles signal their casual and provisional nature: *Heap, Stack, Bundle,* and *Pile.* Variously described as process art, antiform, or Postminimalist, Flanagan's use of unorthodox materials in ephemeral arrangements challenged the nature of sculpture as something fixed, permanent, and rigid.

After visits to Italy in 1973 and 1974, Flanagan began to make works in marble and stone. These sculptures, many composed of two or more small and minimally incised chunks of stone, were also assembled (frequently stacked) to achieve their final form.

Flanagan's most familiar and picturesque image, the lithesome, leaping bronze hare, made its first appearance in 1979, and since then has been cast in stances as varied as prancing, dancing, balancing, and boxing. Moreover, their bases, as witty and unexpected as pyramids, bells, anvils, and cricket stumps, both emulate and mimic conventional pedestals. Recently, Flanagan has introduced elephants, horses, unicorns, and cougars into his art. Flanagan's sculpture, though evolving from nontraditional to traditional media and techniques, nevertheless continues to be marked by objects and images both unexpected and magical.

In 1982 Flanagan was Great Britain's sole representative at the Venice Biennale.

Barry Flanagan: Selected One-Person Exhibitions

1966
Rowan Gallery, London

1969
Museum Haus Lange, Krefeld, West Germany

1974
The Museum of Modern Art, New York
Museum of Modern Art, Oxford, England

1977
Stedelijk Van Abbemuseum, Eindhoven, The Netherlands (traveled to Arnolfini Gallery, Bristol, England; Serpentine Gallery, London) (exh. cat.)

1980
New 57 Gallery, Edinburgh (exh. cat.)

1982
Venice, "XL Biennale di Venezia" (traveled to Museum Haus Esters, Krefeld, West Germany; Whitechapel Art Gallery, London) (exh. cat.)

1983
Musée National d'Art Moderne, Centre Georges Pompidou, Paris (exh. cat.)

Barry Flanagan: Selected Group Exhibitions

1965
Institute of Contemporary Arts, London, "Between Poetry and Painting"

1967
Paris, "5e Paris Biennale" (exh. cat.)

1969
Solomon R. Guggenheim Museum, New York, "Nine Young Artists: Theodoran Foundation Awards" (exh. cat.)
Kunsthalle Bern, Switzerland, "When Attitudes become Form" (traveled to Kaiser Wilhelm Museum, Krefeld, West Germany; Institute of Contemporary Arts, London) (exh. cat.)

1970
Institute of Contemporary Arts, London, "British Sculpture out of the Sixties" (exh. cat.)

1971
New York Cultural Center, "The British Avant-Garde"

1972
Hayward Gallery, London, "The New Art" (exh. cat.)

1974
Royal College of Art, London, "Sculpture Now: Dissolution or Redefinition?" (exh. cat.)

1977
Hayward Gallery, London, "1977 Hayward Annual" (exh. cat.)

1978
Stedelijk Museum, Amsterdam, "Made by Sculptors" (exh. cat.)

1981
Whitechapel Art Gallery, London, "British Sculpture in the Twentieth Century, Part Two: Symbol and Imagination 1951-80" (exh. cat.)

1982
c.a.p.c., Musée d'Art Contemporain, Bordeaux, "Arte Povera, Antiform" (exh. cat.)
Kassel, West Germany, "Documenta 7" (exh. cat.)
Martin-Gropius-Bau, West Berlin, "Zeitgeist" (exh. cat.)

1983
Tate Gallery, London, "New Art" (exh. cat.)

1984
Arts Council of Great Britain, London, "The British Art Show: Old Allegiances and New Directions 1979-1984" (traveled to City of Birmingham Museum and Art Gallery, England, 1984; Royal Scottish Academy, Edinburgh, 1985; Mappin Art Gallery, Sheffield, England; Southampton Art Gallery, England) (exh. cat.)
Kettle's Yard Gallery, Cambridge, England, "1965 to 1972 — When Attitudes Became Form" (traveled to Fruitmarket Gallery, Edinburgh) (exh. cat.)
The Museum of Modern Art, New York, "An International Survey of Recent Painting and Sculpture" (exh. cat.)

1985
The British Council, London, "The British Show" (traveled to Art Gallery of Western Australia, Perth; Art Gallery of New South Wales, Sydney; Queensland Art Gallery, Brisbane; The Exhibition Hall, Melbourne; National Art Gallery, Wellington, New Zealand) (exh. cat.)
Museum of Art, Carnegie Institute, Pittsburgh, "Carnegie International" (exh. cat.)

1986
Palacio de Velázquez, Madrid (organized by The British Council), "Entre el Objeto y la Imagen: Escultura británica contemporánea" (exh. cat.)

Barry Flanagan: Selected References

Flanagan, Barry. "A Letter and some submissions." *Silâns* 6 (Jan. 1965): unpag.

Baro, Gene. "Animal, Vegetable and Mineral." *Art and Artists* 1, 6 (Sept. 1966): 63.

"British Artists at the Biennale des Jeunes in Paris" (with statement by Barry Flanagan). *Studio International* 174, 892 (Sept. 1967): 85, 98-99.

Harrison, Charles. "Barry Flanagan's sculpture." *Studio International* 175, 900 (May 1968): 266-68.

Flanagan, Barry. "An old New York letter." *Studio International* 177, 911 (May 1969): 208.

Flanagan, Barry. "A literary work." *Studio International* 178, 913 (July-Aug. 1969): 4.

Richard Long

Baro, Gene, and Flanagan, Barry. "Sculpture made visible: Barry Flanagan in discussion with Gene Baro." *Studio International* 178, 915 (Oct. 1969): 122-25.

Flanagan, Barry, and Fuller, Peter. "Barry Flanagan: sculptor." *Connoisseur* 174, 701 (July 1970): 210.

Adams, Clive, and Flanagan, Barry. "Barry Flanagan." *Arnolfini Review*, July-Aug. 1977: unpag.

Cooke, Lynne. "Barry Flanagan at the Whitechapel and at Waddington." *Art in America* 71, 3 (Mar. 1983): 167.

Francblin, Catherine. "Barry Flanagan – la sculpture en état d'apesanteur." *Art Press* 68 (Mar. 1983): unpag.

Kirshner, Judith Russi. "Barry Flanagan." *Artforum* 23, 10 (Summer 1985): 112.

Richard Long, who studied at the West of England College of Art in Bristol from 1962 to 1966 and at St. Martin's School of Art, London, from 1966 to 1968, was born in 1945 in Bristol, where he still resides. In 1967, while still at St. Martin's, Long first used the walk – an activity that has consistently remained at the core of his art – in a work entitled *A Line Made by Walking England 1967* and documented by a photograph. Another memorable outdoor work the next year consisted of inscribing a giant "X" on a meadow by snipping off the heads of flowers. The first actual journey Long made and commemorated with a map and photograph was a 1967 walking and hitchhiking trip from London to the summit of Ben Nevis in Scotland and back again.

Initially associated with the international Earth Art movement of the late 1960s, Long exhibited in the 1969 "Earth Art" exhibition at the Andrew Dickson White Museum, Cornell University, Ithaca, New York, with, among others, Jan Dibbets, Hans Haacke, Robert Morris, and Robert Smithson. There, in his first work executed abroad, he arranged on a sloping hillside a rectangle composed of twelve stones gathered from a local quarry. A year earlier, in his first one-person show at the Konrad Fischer Gallery in Düsseldorf, he filled the gallery with parallel lines of twigs (laid end to end) collected from the Leigh Woods near Bristol. Thus, early in his career, the fundamental activities of his art – both in museums and galleries and outdoors – were established.

Whether made in England or abroad, Long's work may take the form of walks, stone and stick sculptures, photographs, maps, texts, artists' books, or mud wall works. Using simple, elementary forms – lines, circles, or spirals – Long's earthbound, floor-hugging sculptures have an unobtrusive, contemplative presence. Created in Africa, Australia, South America, Canada, Japan, Iceland, and the United States, and composed of elements – stone, sticks, slate, mud – drawn from sources as far flung as the River Avon, the Little Tejunga Canyon (California), or Piedmont (Italy), they reveal a sensibility engaged in a continual dialogue with the natural world.

A notable feature of Long's art has been the artist-designed books (rather than traditional catalogues) that have accompanied many of his exhibitions from 1970 to the present. Works of art in their own right, they provide an evocative distillation of the exhibition as well.

Chief among the recent "new" developments of Long's oeuvre have been the River Avon mud wall works inaugurated in 1981. Circular in shape and composed of the artist's hand- or finger-prints, these emblematic works have a precedent in the clay spirals of Long's footprints made in the early 1970s. Through his physical and emotional involvement with the natural world, Long effects a merging not only of art and nature but also of man and nature.

In 1976 Long was chosen to represent Britain at the Venice Biennale. In 1984 he was one of six artists selected as a finalist for the Turner Prize, awarded annually by the Tate Gallery to the person who, in the opinion of the jury, "has made the greatest contribution to art in Britain in the previous twelve months."

Richard Long: Selected One-Person Exhibitions

1968
Konrad Fischer Gallery, Düsseldorf

1969
Museum Haus Lange, Krefeld, West Germany

1971
Museum of Modern Art, Oxford, England
Whitechapel Art Gallery, London

1972
The Museum of Modern Art, New York

1973
Stedelijk Museum, Amsterdam (exh. cat.)

1974
Scottish National Gallery of Modern Art, Edinburgh (exh. cat.)

1976
Venice, "XXXVII Biennale di Venezia" (exh. cat.)

1977
Kunsthalle Bern, Switzerland (exh. cat.)

1979
Stedelijk Van Abbemuseum, Eindhoven, The Netherlands (exh. cat.)

1980
Fogg Art Museum, Harvard University, Cambridge, Massachusetts (exh. cat.)

1981
c.a.p.c., Musée d'Art Contemporain, Bordeaux (exh. cat.)

1982
National Gallery of Canada, Ottawa (exh. cat.)

1983
Arnolfini Gallery, Bristol, England (exh. cat.)

1984
Dallas Museum of Art (exh. cat.)

1985
c.a.p.c., Musée d'Art Contemporain, Bordeaux
(exh. cat.)

1986
Solomon R. Guggenheim Museum, New York (exh.
cat.)

Richard Long: Selected Group Exhibitions

1969
Andrew Dickson White Museum, Cornell University, Ithaca, New York, "Earth Art" (exh. cat.)
Kunsthalle Bern, Switzerland, "When Attitudes become Form" (traveled to Kaiser Wilhelm Museum, Krefeld, West Germany; Institute of Contemporary Arts, London) (exh. cat.)

1970
Museum of Contemporary Art, Chicago, "Evidence on the Flight of Six Fugitives"

1971
Solomon R. Guggenheim Museum, New York, "Guggenheim International" (exh. cat.)
New York Cultural Center, "The British Avant-Garde" (exh. cat.)

1972
Kassel, West Germany, "Documenta 5" (exh. cat.)
Hayward Gallery, London, "The New Art" (exh. cat.)

1974
Royal College of Art, London, "Sculpture Now: Dissolution or Redefinition?" (exh. cat.)

1976
Corcoran Gallery of Art, Washington, D.C., "Andre/Le Va/Long" (exh. cat.)

1977
The Art Institute of Chicago, "Europe in the Seventies: Aspects of Recent Art" (traveled to Hirshhorn Museum and Sculpture Garden, Smithsonian Institution, Washington, D.C.; San Francisco Museum of Modern Art; Forth Worth Art Museum; Contemporary Arts Center, Cincinnati) (exh. cat.)

1979
Museum of Contemporary Art, Chicago, "Concept, Narrative, Document" (exh. cat.)

1981
Whitechapel Art Gallery, London, "British Sculpture in the Twentieth Century, Part Two: Symbol and Imagination 1951-80" (exh. cat.)

1982
Kassel, West Germany, "Documenta 7" (exh. cat.)

1983
Tate Gallery, London, "New Art" (exh. cat.)
Hayward Gallery and Serpentine Gallery, London (organized by the Arts Council of Great Britain), "The Sculpture Show" (exh. cat.)

1984
Yale Center for British Art, Yale University, New Haven, Connecticut, "The Critical Eye" (exh. cat.)
Tate Gallery, London, "The Turner Prize" (exh. cat.)
Arts Council of Great Britain, London, "The British Art Show: Old Allegiances and New Directions 1979-1984" (traveled to City of Birmingham Museum and Art Gallery, England, 1984; Royal Scottish Academy, Edinburgh, 1985; Mappin Art Gallery, Sheffield, England; Southampton Art Gallery, England) (exh. cat.)
Kettle's Yard Gallery, Cambridge, England, "1965 to 1972 – When Attitudes Became Form" (traveled to Fruitmarket Gallery, Edinburgh) (exh. cat.)

1985
The British Council, London, "The British Show" (traveled to Art Gallery of Western Australia, Perth; Art Gallery of New South Wales, Sydney; Queensland Art Gallery, Brisbane; The Exhibition Hall, Melbourne; National Art Gallery, Wellington, New Zealand) (exh. cat.)
Museum of Art, Carnegie Institute, Pittsburgh, "Carnegie International" (exh. cat.)
Solomon R. Guggenheim Museum, New York, "Transformations in Sculpture: Four Decades of American and European Art" (exh. cat.)
Hayward Gallery, London, "1985 Hayward Annual" (exh. cat.)

1986
Palacio de Velázquez, Madrid (organized by The British Council), "Entre el Objeto y la Imagen: Escultura británica contemporánea" (exh. cat.)

Richard Long: Selected References

Glueck, Grace. "Richard Long." Art in America 58, 5 (Sept. 1970): 41.

Harrison, Charles. "Richard Long." Studio International 183, 940 (Jan. 1972): 33-34.

Celant, Germano. "Richard Long." Domus 511 (June 1972): 48-50.

Field, Simon. "Touching the Earth." Art and Artists 8 (Apr. 1973): 15-19.

Fuchs, Rudi H. "Memories of Passing: A Note on Richard Long." Studio International 187, 965 (Apr. 1974): 172-73.

Marcelis, Bernard. "Richard Long: Beauté et ambiguité du Land Art." Domus 601 (Dec. 1979): 48-49.

Foote, Nancy. "Long Walks." Artforum 18, 10 (Summer 1980): 42-47.

Craig-Martin, Michael. "London. Richard Long at Anthony d'Offay." Burlington Magazine 122 (Nov. 1980): 791-92.

Fisher, Jean. "Richard Long." Aspects 14 (Spring 1981): unpag.

Poinsot, Jean-Marc. "Richard Long: construire le paysage." Art Press 53 (Nov. 1981): 9-11.

Paoletti, John T. "Richard Long." Arts Magazine 57 (Dec. 1982): 3.

Geddes-Brown, Leslie. "The Long March of Richard Long." Sunday Times (London), Mar. 27, 1983.

Biggs, Lewis. "Richard Long." Arnolfini Review, Apr. 1983: unpag.

Cooke, Lynne. "Richard Long." Art Monthly 66 (May 1983): 8-10.

Long, Richard. "Richard Long replies to a critic." Art Monthly 68 (July-Aug. 1983): 20-21.

Rogozinsky, Luciana. "Richard Long." Artforum 22, 1 (Sept. 1983): 85.

Hall, Carol. "Richard Long." In Art in the Land: A Critical Anthology of Environmental Art, ed. Alan Sonfist. New York: E.P. Dutton, 1983: 34-37.

Stewart, Nick. "Richard Long, Lines of Thought: A Conversation with Nick Stewart." Circa, Nov.-Dec. 1984: 8-13.

Beardsley, John. Earthworks and Beyond: Contemporary Art in the Landscape. New York: Abbeville Press, Inc., 1984: 40-44.

David Nash

David Nash was born in Esher, England, in 1945 and studied at the Kingston College of Art (1963-64, 1965-67); Brighton College of Art (1964-65); and the Chelsea School of Art, London (1969-70). Since 1967 Nash has lived and worked in and around Blaenau Ffestiniog in North Wales. Fundamentally a sculptor in wood, in the late 1960s Nash constructed tall (some as high as 30 feet), complex, architectonic wood towers that survive now only in photographs. In 1970 his art underwent a drastic simplification: eschewing elaborate structures, Nash began making simple objects out of found wood (often dead or diseased trees) by crudely shaping with an ax (*Nine Cracked Balls* [1970, Collection of the artist]), or splitting and tying (*Roped Oak Tripod* [1971, no longer extant] and *Arch* [1972, Collection of the artist]), rudimentary processes that have informed his work to the present. Left unfinished, the wood continues to expand and contract, crack and split, as it dries and ages.

Nash has also made numerous "artworks on the land" at various sites, from the countryside around Blaenau Ffestiniog to Grizedale Forest in Cumbria, Wales, and with the Rijksmuseum Kröller-Müller in the Hoge Veluwe. Nash made his first planting at Cae'n-y-Coed, a small plot of land near Blaenau Ffestiniog, in 1977. Titled *Fletched Over Ash Dome*, it consists of twenty-two trees planted in a circle that are cut and bent over at ten-year intervals until a domed space is achieved, a process that will take thirty years. Other live plantings, such as *Willow Ladder*, *Bramble Ring*, and *Sweeping Larch Enclosure*, have been rooted at various sites in Wales. Residencies to live and work in Grizedale Forest (1978) and Yorkshire Sculpture Park (1981) have provided Nash with ideal sites and conditions in which to create both living and nonliving sculptures. Other venues of shorter duration have included Yugoslavia (1978), the United States (1980, 1983, 1985), Japan (1982, 1984, 1985), Australia (1985), and The Netherlands (1982, 1985).

Nash inaugurated in 1979 a continuing series of dramatic, albeit short-lived, works, namely the "Stoves and Hearths" — symbolic of human presence and settlement. Erected in various locales both in England and abroad, these chimney or stovelike structures have been built out of wood, slate, stone, bamboo, snow, or peat; when ignited, depending on the materials, they may consume themselves in the ensuing fire.

Nash's participation in exhibitions has resulted in several artist-designed books that contain photographs and drawings of his projects. Among them are *Briefly Cooked Apples* (1973), *Loosely Held Grain* (1976), *Fletched Over Ash* (1978), *Wood Quarry* (1982), *Sixty Seasons* (1983), *Elm Wattle Gum* (1985), and *Tree to Vessel* (1986).

David Nash: Selected One-Person Exhibitions

1973
Queen Elizabeth Hall, St. William's College, York, England

1976
Arnolfini Gallery, Bristol, England (exh. cat.)

1978
AIR Gallery, London (exh. cat.)

1980
Southampton University Gallery, England

1982
Oriel Gallery, Cardiff (exh. cat.)
Rijksmuseum Kröller-Müller, Otterlo (exh. cat.)
Yorkshire Sculpture Park, Bretton, England (exh. cat.)

1983
Third Eye Center, Glasgow (traveled to Fruitmarket Gallery, Edinburgh; Mostyn Art Gallery, Llandudno, Wales; Glynn Vivian Art Gallery and Museum, Swansea, England; City Museum and Art Gallery, Stoke-on-Trent, England) (exh. cat.)
The Douglas Hyde Gallery, Trinity College, Dublin

1984
Nagisa Park No. 2, Moriyama City, Shiga, Japan, 1984 (traveled to Tochigi Prefectural Museum of Fine Arts, Tochigi-ken; the Miyagi Museum of Art, Sendai, 1985; Fukuoka Art Museum; Sogetsu Kaikan, Tokyo) (exh. cat.)

David Nash: Selected Group Exhibitions

1975
Hayward Gallery, London, "The Condition of Sculpture"

1976
Serpentine Gallery, London, "Summer Exhibition"

1978
Fruitmarket Gallery, Edinburgh, "Edinburgh Arts '77 Exhibition: Part One" (exh. cat.)

1980
Solomon R. Guggenheim Museum, New York, "British Art Now: An American Perspective" (traveled to San Diego Museum of Art, California; Telfair Academy of Arts and Sciences, Inc., Savannah, Georgia; Archer M. Huntington Art Gallery, University of Texas, Austin; The Royal Academy, London) (exh. cat.)

1981
Whitechapel Art Gallery, London, "British Sculpture in the Twentieth Century, Part Two: Symbol and Imagination 1951-80" (exh. cat.)

1983
Hayward Gallery and Serpentine Gallery, London (organized by the Arts Council of Great Britain), "The Sculpture Show" (exh. cat.)

1984
The Museum of Modern Art, New York, "An International Survey of Recent Painting and Sculpture" (exh. cat.)

1985
Hayward Gallery, London, "1985 Hayward Annual" (exh. cat.)
Solomon R. Guggenheim Museum, New York, "Transformations in Sculpture: Four Decades of American and European Art" (exh. cat.)
Rijksmuseum Kröller-Müller, Otterlo, "Sjoerd Buisman/David Nash" (exh. cat.)

1986
Kettle's Yard Gallery, Cambridge, England, "Landscape — Place, Nature, Material"

David Nash: Selected References

Chapman, Hilary. "David Nash – the reconstruction of awareness." *Arts Review* 29 (Feb. 3, 1977): 86.

Jones, Ben. "A New Wave in Sculpture: A survey of works by ten younger sculptors." *Artscribe* 8 (Sept. 1977): 15-16.

McPherson, Allan. "David Nash: interviewed by Allan McPherson." *Artscribe* 12 (June 1978): 30-34.

Adams, Hugh. "The Woodman." *Art and Artists* 13 (Apr. 1979): 44-47.

Nash, David. "David Nash" in "Grizedale Forest Sculpture." *Aspects* 7 (Summer 1979): unpag.

Hughes, Robert. "From Sticks to Cenotaphs." *Time* 115 (Feb. 11, 1980): 65.

Schaff, David. "British Art Now, at the Guggenheim and Beyond." *Art International* (Mar.-Apr. 1980): 66-71.

Nash, David. "David Nash." *Aspects* 10 (Spring 1980): unpag.

King, Dave. "Recent Developments in Wood Sculpture." *Aspects* 14 (Spring 1981): unpag.

Oliver, Cordelia. "David Nash." *The Guardian* (London), Jan. 25, 1983.

Macmillan, Duncan. "David Nash: Brancusi Joins the Garden Gang." *Art Monthly* 65 (Apr. 1983): 7-9.

Bill Woodrow

Beardsley, John. *Earthworks and Beyond: Contemporary Art in the Landscape.* New York: Abbeville Press, Inc., 1984: 44-50.

Davies, Peter, and Knipe, Tony, eds. *A Sense of Place: Sculpture in Landscape.* Sunderland, England: Ceolfrith Press, 1984: 56, 75, 87, 95, 101-107.

Nelson, Frederick J. "David Nash." *New Art Examiner* (Chicago) (Summer 1985): 74.

Van Den Abeele, Lieven. "David Nash: Nature as the only Reality." *Artefactum* 3, 13 (Apr.-May 1986): 19-23.

Bill Woodrow, born near Henley, Oxfordshire, in 1948, studied at the Winchester School of Art (1967-68), St. Martin's School of Art, London (1968-71), and the Chelsea School of Art, London (1971-72). Although he had a one-person show as early as 1972 (of juxtapositions of photographs and objects) at the Whitechapel Art Gallery, London, and participated in a group exhibition at the Museum of Modern Art, Oxford, he did not create another body of work for several years. When he again obtained a studio in 1978, however, he began to utilize found, discarded objects as raw material for his sculptures. At first he embedded household appliances in another object or in plaster or concrete; in a subsequent series he "demanufactured" them – that is, an appliance was disassembled into its constituent parts and spread out on the floor.

In 1980-81 he began a new body of work in which one or more nonfunctioning objects was fashioned from another, usually larger, and formerly functional object (a bicycle cut from the metal skin of a spin-dryer was the first). The secondary, dependent element or elements remained attached to the original component via an "umbilical cord" of metal or fabric. Increasingly complex arrangements of several host objects with dependencies have frequently been grouped into three-dimensional, life-size "still life" assemblages. All materials used are in the main scavenged from the streets surrounding Woodrow's London studio or, alternatively, from the proximate locale of an exhibition, whether it be in Brussels, Genoa, Brisbane, Amsterdam, Toronto, New York, or Chicago. (Often, as Woodrow becomes familiar with an area, one or more works will refer to specific characteristics of that site.) Through these works formed from the detritus of a throwaway society, Woodrow comments satirically or ironically on contemporary life and culture.

Bill Woodrow: Selected One-Person Exhibitions

1972
Whitechapel Art Gallery, London

1979
Kunstlerhaus, Hamburg, West Germany

1980
The Gallery, Brixton, London

1981
New 57 Gallery, Edinburgh

1982
Kunstausstellungen, Stuttgart, West Germany
Galerie 't Venster Rotterdamse Kunststichting (exh. cat.)

1983
Museum van Hedendaagse Kunst, Ghent, Belgium
Museum of Modern Art, Oxford, England (exh. cat.)

1984
Musée de Toulon, France (exh. cat.)

1985
Kunsthalle Basel, Switzerland (exh. cat.)
Institute of Contemporary Art, Boston
La Jolla Museum of Contemporary Art, California (traveled to Matrix, University Art Museum, University of California, Berkeley) (exh. cat.)

1986
Butler Gallery, Kilkenny Castle, Kilkenny, Ireland
Fruitmarket Gallery, Edinburgh (exh. cat.)

1987
Kunstverein, Munich (exh. cat.)

Bill Woodrow: Selected Group Exhibitions

1972
Museum of Modern Art, Oxford, "Platform '72"

1981
Institute of Contemporary Arts, London, "Objects & Sculpture" (traveled to Arnolfini Gallery, Bristol, England) (exh. cat.)
Whitechapel Art Gallery, London, "British Sculpture in the Twentieth Century, Part Two: Symbol and Imagination 1951-80" (exh. cat.)

1982
Kunsthalle Bern, Switzerland, "Leçons des Choses" (traveled to Musée d'Art et d'Histoire, Chambéry, France; Maison de la Culture, Chalon-sur-Saône, France) (exh. cat.)
Kunstmuseum Luzern, Switzerland, "Englische Plastik Heute/British Sculpture Now" (exh. cat.)

1983
John Hansard Gallery, The University, Southampton, England, "Figures and Objects: Recent Developments in British Sculpture" (exh. cat.)
ARC/Musée d'Art Moderne de la Ville de Paris, "Truc et Troc/ Leçons des Choses" (exh. cat.)
Hayward Gallery and Serpentine Gallery, London (organized by the Arts Council of Great Britain), "The Sculpture Show" (exh. cat.)
Tate Gallery, London, "New Art" (exh. cat.)
The British Council, London, "Transformations: New Sculpture from Britain" (traveled to XVII Bienal de São Paulo, 1983; Museo de Arte Moderna, Rio de Janeiro, 1984; Museo de Arte Moderna, Mexico City; Fundação Calouste Gulbenkian, Lisbon) (exh. cat.)

1984
The Museum of Modern Art, New York, "An International Survey of Recent Painting and Sculpture" (exh. cat.)

P.S.1, Long Island City, New York, "Salvaged"
Arts Council of Great Britain, London, "The British
Art Show: Old Allegiances and New Directions
1979-1984" (traveled to City of Birmingham Museum and Art Gallery, England, 1984; Royal
Scottish Academy, Edinburgh, 1985; Mappin Art
Gallery, Sheffield, England; Southampton Art Gallery, England) (exh. cat.)

1985
The British Council, London, "The British Show"
(traveled to Art Gallery of Western Australia, Perth;
Art Gallery of New South Wales, Sydney;
Queensland Art Gallery, Brisbane; The Exhibition
Hall, Melbourne; National Art Gallery, Wellington,
New Zealand) (exh. cat.)
Mackenzie Art Gallery, Regina, Saskatchewan,
"Space Invaders" (exh. cat.)
Museum of Art, Carnegie Institute, Pittsburgh,
"Carnegie International" (exh. cat.)
Grande Halle de La Villette, Paris, "Nouvelle Biennale de Paris"

1986
Palacio de Velázquez, Madrid (organized by The
British Council), "Entre el Objeto y la Imagen: Escultura británica contemporánea" (exh. cat.)
Louisiana Museum of Art, Humlebaek, Denmark,
"Sculpture: 9 artists from Britain"

Bill Woodrow: Selected References

Lawson, Thomas. "Bill Woodrow." *Artforum* 20, 4
(Dec. 1981): 81.

Newman, Michael. "Bill Woodrow." *Art Monthly*
53 (Feb. 1982): 19-20.

Collier, Caroline. "Bill Woodrow, Lisson Gallery."
Flash Art 106 (Feb.-Mar. 1982): 59-60.

Roberts, John. "Car Doors & Indians." *ZG* 6 (Apr.
1982): unpag.

Cuvelier, Pascaline. "Le Système anglo-panique des
objets, Bill Woodrow: objets trouvés." *Libération*,
May 4, 1982: 24-25.

Livingstone, Marco. "Bill Woodrow at the Lisson."
Artscribe 41 (June 1983): 42-43.

Cueff, Alain. "Bill Woodrow: La Conduite du matériau." *Artistes*, June 16, 1983: 29-34.

Francis, Mark. "Bill Woodrow: Material Truths."
Artforum 22, 5 (Jan. 1984): 34-38.

Gould, Trevor. "Roland Brener, Bill Woodrow." *Parachute* 35 (June-Aug. 1984): 38-40.

Pokorny, Rita. "Bill Woodrow, a talk." *Neue Kunst
in Europa* 4, 1 (June 1984): 10-11.

Baker, Kenneth. "Bill Woodrow." *Artforum* 24, 7
(Mar. 1986): 125-26.

Photography Credits